Consumed

Consumed

A Sister's Story

Arifa Akbar

S

SCEPTRE

First published in Great Britain in 2021 by Sceptre
An Imprint of Hodder & Stoughton
An Hachette UK company

1

A CIP catalogue record for this title is available from the British Library

Hardback ISBN 9781529347524
eBook ISBN 9781529347531

Typeset in Sabon MT by
Palimpsest Book Production Ltd, Falkirk, Stirlingshire

Printed and bound in Great Britain by Clays Ltd, Elcograf S.p.A.

Hodder & Stoughton policy is to use papers that are natural,
renewable and recyclable products and made from wood grown in
sustainable forests. The logging and manufacturing processes are expected
to conform to the environmental regulations of the country of origin.

Hodder & Stoughton Ltd
Carmelite House
50 Victoria Embankment
London EC4Y 0DZ

www.sceptrebooks.co.uk

For Fauzia

O sister! Ismene dear, dear sister Ismene! . . .
There is no pain, no sorrow, no suffering, no dishonour
We have not shared together, you and I.

Antigone, Sophocles

Contents

I

What Is Lost

I

Departure, 2016

Three summers ago, my neighbour was told that her ovarian cancer had reached the terminal stage. Rosalind Hibbins emailed the occupants of the building about it matter-of-factly, as was her way, but when I went downstairs to see her she seemed instantly changed by the news. She was in her late sixties and had always been an indomitable woman, as strong and sturdy as the boulders she brought home from her stone-carving workshops, which had become a passion since retirement. In the days that followed, she seemed made of air, white-haired and fragile, her eyes watery bright, her voice catching on itself in croaks and quivers.

A couple of months before Rosalind's diagnosis, my sister, Fauzia, had died suddenly, leaving me suspended between shock and disbelief. She had been shuttling back and forth to acute hospital wards in North London with an illness her doctors couldn't diagnose, but we didn't believe Fauzia was going to die and she couldn't have believed it either. She had been worrying about her cats and college assignments, sending texts and paying bills from her hospital bed. She had not been preparing for death, like Rosalind.

I was left reeling, so I had to muster all my courage when Rosalind called from her hospice and said she'd like to see me. I followed my *A–Z* around the twisting backstreets of Belsize Park to find the hospice. It was set back from the road and obscured by trees, as if in hiding. I had grown up nearby, in Primrose Hill, without ever realising it was there. Inside, Rosalind asked if Fauzia had been alone when she died. It was

the thing she was most afraid of, she said, and it made me think about how my sister might have felt, with no one she knew around her in the early hours of the June morning when blood had started to pour into her brain and collect in a fatal haemorrhage. Rosalind must have sensed my distress because she tried to comfort me.

'Don't hold on too tightly. She'll come back to you.'

I nodded, though it didn't seem as if Fauzia had gone away, exactly. My mother thought she heard sobs from the bedroom, in her home, where Fauzia had lain for weeks before dying in hospital; and she noticed the appearance of a squall of black scratches on a wall, which looked as if the plaster had been stabbed at with a scalpel. The patch had grown and spread from behind the pine sideboard in the living room in the months after my sister had died, my mother said. I was quick to dismiss it but I felt my own hauntings. At night, she appeared in my dreams, most often in our mother's first-floor Primrose Hill council flat in which we'd grown up.

Three days after she died, a black cat with almost exactly the same white markings as Fauzia's first cat, Blue, was sitting outside my home in Kentish Town; my head was bowed so I didn't see it until I was close to it. It bounded towards me, as if it had been waiting, and moved to follow me inside with such certainty that I was rattled and quickly shut the door. For weeks after her death it seemed as if Fauzia floated around in my home too, and the flowery smell of her skin in her final days at hospital rose off the small pieces of furniture I had taken from her housing-association flat. I felt her swirling around me, in the wispy curls of white smoke that began appearing in my peripheral vision late at night when I was at my lowest ebb. I saw her ahead of me on the streets, disappearing around a corner as I quickened my pace to catch up. And then, a few weeks after her funeral, a friend from my old secondary school in Highgate, which Fauzia and I had attended, ran up behind

me and said, 'I've just seen your sister on Kentish Town Road. She was holding two children.' I hadn't seen the friend for years and had to tell her it couldn't have been Fauzia, half believing that it was.

Her coming back, if this was what it was, gave me some comfort but I also felt a certain dread. What would I say to her if we collided on a street corner? What would she say to me? Perhaps she would remind me of my failings as a sister or ask me to stop picking over the details of her life and death. I have come to think that the opposite of Rosalind's words might be true. 'Don't hold on too tightly or she'll always stay.' I wonder if I'll ever allow Fauzia to fly away and find her freedom from this world or whether she will be forced to stalk the earth, a few streets ahead of me and in the creeping corners of my dreams. But it is only once the unfinished business of her death has been resolved that I can stop clutching onto her. Until then, she hovers across all my horizons.

Fauzia's illness was still an unsolved mystery until the day before she died. In the spring of 2016, between April and June, she was rushed to hospital twice and each time she stayed in the intensive care unit for days on end. Her doctors conducted tests, drew up hypotheses, disproved them, and called in more doctors until her medical team became engorged with expertise but no closer to a diagnosis. We kept our faith in them; the Royal Free, a leading teaching hospital in North London, had us on more than one occasion: my mother from breast cancer, twice; my father when he had an internal bleed complicated by his frontal-lobe dementia.

Just months before my sister's admission, the hospital had treated a nurse who had contracted the Ebola virus in an ongoing, high-profile case. I felt sure her life would be saved from whatever was attacking her body. She was in the best possible hands. But Fauzia's illness stumped all her doctors. As

she lay sedated in her final days, we watched her heart racing on the life-support machine and it seemed as if she were running, trying to flee her fate in her sleep.

The mystery of her illness remained even as we were told to gather around her bed in the intensive care unit. Afterwards, when my mother and I prised out the needles that the nurses hadn't taken from her neck and wrist, she continued to bleed. My mother, a British Pakistani Muslim who practises her faith quietly but assiduously, whispered the Quranic surah *Yaseen* in her right ear and told me she had seen a tiny black pearl slip out from under Fauzia's eyelid – a single jewel of a tear – which she had caught in the palm of her hand just before it disappeared, along with my sister's soul. It was a sign, she said, a parting gift from her firstborn child, who was also the first to die.

My mother has always seen visions, especially at her most fraught. Sometimes she will ring me up to recount a dream, gingerly, as if she is giving me forewarning of calamity. In early 2016, about five months before my sister's death, she told me she was visited by a tall, thin, shadowy figure, covered with polka-dots and standing over her bed, just for a moment before it disappeared. I waved it away as a dream but she insisted what she had seen was real. 'Maybe you *felt* it was real,' I said to her, but privately it terrified me. The creepy detail of the polka-dot dress reminded me of stories about unruly young poltergeists who stalked adults. Maybe by then I, too, was gathering a sense of something awful about to happen but was determined to dismiss it as imagination. After Fauzia died, my mother told me she had been in a polka-dotted dress when she went into hospital for the last time.

If my mother dealt with Fauzia's death through signs and premonitions, I was stuck in paranoid disbelief. I could see nothing of death in Fauzia as the bright red bubbles of life streamed out of her veins when we removed the needles. A

horrible kind of magical thinking gripped my mind in the early days after her death. It looked to me as if her medical team had been running down rabbit-holes and coming back up none the wiser. Now, in my distressed state, I wondered if she was dead at all or if the doctors had misjudged this too, assuming death when she was in a deep slumber, like a modern Gothic Sleeping Beauty.

Six months earlier, Fauzia had begun complaining of chest pains and heavy night-sweats to her GP but her X-rays had come back clear. Then her face swelled. She was taken to A&E at University College London Hospital, a spitting distance from her flat on Warren Street, and tested first for jaundice and then for meningitis. She was given the all-clear but doctors said she had a 'blood infection' they couldn't yet identify. She discharged herself, growing impatient with their investigations, but was unable to breathe properly a few days later and was taken to the Royal Free's intensive care unit – she fought with the ambulance crew to go there because she saw it as her family hospital. She was given steroids and appeared to get better so they discharged her after eleven days. But she was back in intensive care the following month, in May, for two weeks this time, weaker than ever with inflamed lungs, slurred speech and strange behaviour, which we were later told was due to brain-swelling. She was so ill that doctors put her into an induced coma and carried out more investigations. Still no diagnosis.

On the morning of Friday, 9 June 2016, we got a phone-call. Fauzia had had a brain haemorrhage in the early hours of the day. We were to assemble around her bed. I jumped on my bike, knowing it would take me exactly twelve minutes to cycle from my home in Kentish Town to the hospital on Pond Street, but I had woken up with a headache that hung over my eyes, like lead, and the journey took me longer than it should have. I saw the curtains drawn around her bed and the ward sister watching over it.

A doctor took us into a side room and told us what had happened in a slightly shaking voice. The haemorrhage had started at around 5 a.m., apparently. Some hours later, after a brain scan, they realised it had been catastrophic but they still couldn't name her illness. I wondered if it was a deadly new virus that lay on the outer reaches of medical science. Beyond Ebola or Zika or anything that was known. My younger brother, Tariq, then forty-one, was there, along with my mother and sister-in-law, Mary.

'How big was the haemorrhage?' asked Tariq.

'Around the size of an orange,' the doctor said, which meant it had left no chance of recovery. In circumstances like these, they kept the patient on a ventilator for twenty-four hours, he added.

'Why?' I asked.

They could only declare someone dead after twenty-four hours in such circumstances, he said.

'Might she recover in that time?' I asked.

'No,' he said.

'So is she alive or dead?' I said.

'It's an interesting question, philosophically,' he said, and began talking about the grey area between life and death, though it was now clear to us that my sister, at the age of forty-five, had died in a prominent London hospital from an unknown illness.

In the week leading up to her death, when they were still testing her in the hope of reaching a diagnosis, they had told us she had HLH – a syndrome in which the immune system aggressively attacks itself – but that this was often caused by an underlying illness, which I later found out was associated with infectious or inflammatory diseases. I began to trawl back over the last few months to remember how, at one point, her doctors thought she might have been poisoned by her aromatherapy bath oils and asked me to fetch every tincture and ointment from her bathroom, which I did, though I was baffled by this line of enquiry.

Three days before her death, I saw a large machine beside her bed and was told they were looking for possible pregnancy. One doctor had taken us into the same side room in the week she died and said, 'Do *you* have any idea what it might be?'

Now they didn't even seem to know what to call her death. We were left dazed by what this doctor told us. Fauzia was not officially dead and not alive either. However surreal it sounded, the semantic limbo gave me twenty-four hours of hope. I was still holding out for the unforeseen. If her illness had been so mysterious, her recovery could be too. All of the circumstances reached beyond the ordinary towards the unprecedented, so why couldn't a miracle happen now? I turned to my mother, the believer in all unseen matter, and put it to her, but she looked small and silent, already sunken by grief.

The next day I was the first to arrive. Fauzia had been moved from the open ward to a private area. I took this as a positive sign. Look, I thought, she has her very own airy room, and one that felt profoundly peaceful, though its spacious silence seemed bottomless and unfamiliar, like the cool, deep inside of a well. The temperature dropped as I entered. Nurses weren't bustling in and out. There were fewer machines around her. If she were awake, she would love this serenity, I thought, after all the thrum and bustle of the shared ward and the uncontained aggression of the intensive care nurse who had been overseeing her for the last few days.

A friendly male nurse greeted me and told me to put on the kind of protective plastic clothing required to contain contagion – a PPE precaution that would become ubiquitous a few years later during the Covid-19 pandemic but which was unfamiliar at the time. I had no idea she was in the room alone because she was being isolated. I did as I was told, thinking again that this was usual practice. The nurse and I got chatting and I told him how they still didn't know what was wrong with Fauzia. He looked down at the medical notes and told me that there *was* a diagnosis.

'A diagnosis?' It seemed unbelievable that her elusive illness had been pinned down overnight, just as my sister had entered the holding-cell between life and death.

'Didn't you know?' the nurse said, looking confused.

'No,' I said, wanting to tell him about the months of mystery, the doctors' infinite tests and the family's helplessness.

'TB,' he said. 'She died from tuberculosis.'

They had, I was later told, discovered it from retesting her spinal fluid from a lumbar puncture they had administered on Fauzia's back when she was still alive. Then, they had found nothing of concern, but they had not been looking for TB because they hadn't thought of it as a possibility. But it had been there all along – 'disseminating', we were later told, from her lungs to other organs through her blood or lymphatic system.

Questions began to rise: when had they retested Fauzia's spinal fluid – after her haemorrhage or before? Why hadn't they thought of TB when they saw her lungs were inflamed? An infectious-diseases doctor had stood by her bedside and told me that TB had made a comeback in recent times – so why wasn't it considered by the army of specialists who had been tending her? And was it just an awful coincidence that they had found a diagnosis the day before they switched off her ventilator? A few hours after Fauzia had her haemorrhage, we were told her death would be referred to the coroner's office for a post-mortem, presumably because of the lack of a clear, unified diagnosis, but her medical records also make mention of the fact that she died of a 'notifiable disease' (required by law to be reported to a government authority), after the TB was discovered a day later. Either way, the coroner felt no need to investigate her case. Would we have felt more reassured if it *had* been? It was evident that her doctors had tried hard to discover a cause for her deterioration, but the fact that her illness wasn't identified until too late left our minds buzzing with suspicion.

Fauzia had had a difficult life, dealing with long-term depression and an eating disorder that came on in her early teens. It had ravaged much of her life, and brought with it the harsh bureaucracies of the medical and psychiatric professions. She had often spoken of feeling that the system was letting her down or failing to understand her – a system, she claimed, that seemed set on distrusting and disbelieving her because of her mental health.

Now it turned out that she had been as unlucky in death as in life. Here was a diagnosis coming a day after the TB infection had already travelled up her spine and exploded in her brain. How had this happened? My then seventy-two-year-old mother – a quietly spoken woman with an imperfect understanding of English – had accompanied Fauzia, who became easily agitated with doctors and nurses. Had this had any bearing on how they had listened and responded to her? I had seen her become occasionally impatient with all the needles, oxygen cylinders and repeated questions, and she had also missed a follow-up appointment after being discharged from the Royal Free's intensive care unit the first time around: by that time, she was too weak to do anything but sleep and was convinced she was out of danger because the hospital had sent her home.

I didn't speak in any depth to Fauzia's medical team until her second stay at the Royal Free, but I had put all my trust in the system. I was sure they would save her, and my mother was there to oversee things, I reassured myself. Something else had stopped me getting involved, though. As teenagers Fauzia and I had been so close. I had witnessed her spiral into a black depression and acute eating disorder, which brought cycles of binge-eating followed by purging; I had felt a growing responsibility to make her better. But I left home for university just as she was worsening and carried on living my life as she slid into serious mental illness. A part of me had always held myself responsible for failing to stay and find a solution for her. Now

I was afraid that I was being called upon to take responsibility for her, that it would prove too much and I would fail again.

When my mother phoned to tell me Fauzia had been rushed to A&E the first time in April 2016, my sister and I hadn't been speaking to each other. We had argued on and off for decades, but we had had a big fight a few years earlier after which we had stopped talking altogether. The fall-out was over something small but it rippled back to buried grievances from early childhood, which left us both positioning ourselves as a victim of the other 'oppressor' sister. But the moment I got the call from my mother, I felt an urgent need to break the silence between us. I was horrified when I saw her swollen face, her eyes barely able to open. But she looked happy to see me after our long estrangement, and I was relieved to be reunited with her. We took a photograph while she was still on a hospital gurney: her face bloated in illness, mine hollowed in distress. I have my arm around her and we are smiling wanly. Thank God, I thought, when she was discharged. We had been given another chance at being sisters. This time we would do better.

2

Arrival, 1970

Until I was five years old, my parents shuttled back and forth between London and Lahore, trying to decide where to live. I was born in London but they returned to Pakistan in April 1975, when I was three, hoping to resettle there. We stayed for two and a half years and there is a photograph of my sister and me from this time, my favourite picture of us as children. We are sitting on the concrete rooftop bench at my paternal grandparents' house and the photo is a black-and-white copy, but the original picture captured all the colours of that summery day.

Fauzia would have been six or seven. I remember the moment it was taken because I was full of childish glee at being photographed, although I can't remember who held the camera or why they took the photo. Both Fauzia and I were led up to the large, flat roof, and told to sit on the bench. We are dressed identically in green, flowery *shalwar kameez*. My smile is wide and my face is shining. I remember Fauzia trying to teach me how to fold my arms for the picture. I couldn't get the hang of it and eventually held my elbows in imitation. For so long, I thought the photo must have been taken on a special day, like Eid, until my mother explained that all the dresses she had brought from England and stored in a drawer had been stolen. 'Only your clothes were taken from our room, nothing else,' she said. Her parents had heard about the bizarre robbery and sent over the matching outfits that my sister and I are wearing.

This Kodak print is what I placed with Fauzia, inside her coffin. It is the picture that contains a fleeting but vital sense of childhood and of us as sisters. In Lahore we were living in

a large house that teemed with uncles, cousins, paternal grand-parents, cooks and cleaners. Guests came and went daily and we were lost among the churn of sociability. We ran riot, roaming the grounds, climbing trees and tearing down fruit. In the heat of the summer months, we slept on the roof. Occasionally, we were dressed up and taken to weddings, which took place under circus-style marquees and passed in a blur of sparkly outfits and huge vats of wedding biryani.

At the time, my grandparents were a far stronger presence in our lives than our parents, who barely featured at all. My grandmother was an ancient woman in a white *shalwar kameez* whom I only ever remember seeing seated. She would have taken up her place at the *charpoi* at the foot of the garden by the time we woke up, and she spent the day watching over the sprawl of grandchildren as we played. It was clear that she was the head of this household, sending out commands to her sons, who were living in different quarters of the enormous house, and bossing their wives around. She spoke in flamboyant, old-fashioned Urdu, giving my sister and me the names of Persian princesses and approximating us with stardust and moonlight. My grandfather was very different. We didn't know it then but he was in his seventies and starting to show signs of the dementia that would slowly swallow him, just as it would my father decades later. Whereas she commandeered forces around her from her fixed position on the *charpoi*, he seemed to opt out of adult life and preferred to be part of the gang of children that ran amok in the grounds.

We had just one month of schooling in Lahore in all our time there. My sister and I were put in the same class, and I stuck close to her. We sat at the back of the room and I was confused by the rows of silent children and the hectoring adult at the front. I was glad that we stopped going. The feral freedom in being left to play all day is what made this part of my child-hood so idyllic, but we didn't learn how to write and didn't

speak a word of English until we returned to London. Afterwards, I found out that our mother had enrolled us because we were of school age and she didn't want her daughters to fall behind. But someone in the family had decided that the household didn't need the extra expense of schooling us: it was enough that a local imam came to our home to teach us the Arabic alphabet, so we could start reading the Quran, though we barely progressed with that either.

I was the more confident sister, effusive and always taking a lead in the elaborate play-acting with our posse of cousins. I would be the teacher, they would be my students, and my sister would sit among them, though. I barely remember Fauzia speaking in anything other than a whisper in my ear.

The picture of us on the roof was taken in 1977, in the politically fractious time leading up to Zulfikar Ali Bhutto's arrest and his hanging, two years later. We remained oblivious to these bigger tensions. Occasionally, the street outside would erupt in a shoot-out and we'd be ushered into the corners of dark rooms until the vendetta had spilled its blood, but we had no idea what this violence meant. Money was becoming a political issue inside our household, although, again, we stayed oblivious to that tension. My father wasn't earning anything while his brothers were all contributing to the running of the house. My sister and I were told abruptly that we were going back to England, and I remember feeling appalled by the news that we would be leaving our life in Lahore behind.

Moving to North London in December 1977 contained its own slow-burn trauma. We had been removed from the extended family and found ourselves thrust into poverty. The technicolour life of Lahore was lost, and all turned black and white. London was cold and unwelcoming. Fauzia and I could speak only Urdu, and I remember those early years filled with furtively spoken words when we were in public. Teachers at our Primrose Hill

primary school advised our parents to stop speaking to us in Urdu so we could catch up in our education.

They tried to follow the advice, although they never stopped speaking Urdu to us or between themselves, but they encouraged us to incorporate English into our conversations with them, which felt forced and unfair to me. I didn't want Urdu to stop being my primary language, in the home or outside it: I was being asked to replace sounds and letters that felt vigorous – *gh* and *kh* sounds formed like a soft growl and *r*s rolled around the palate – with a language that disabled so many parts of my mouth. Now, words didn't emanate from the back of my throat but from the shallows of my mouth, close to the lips, to make tepid sounds, none as satisfyingly guttural as Urdu. I had always been talkative but my new world, and new language, left me silenced for a while.

It must have been worse for Fauzia, who at seven was far more fluent in Urdu than I. My brother was only three at the time – too young to be as confused by the switch – but my sister and I carried on speaking Urdu to each other for as long as we could, staging sulks and mini-rebellions when our parents insisted otherwise. Eventually, haltingly, we did as we were told. We became fluent quickly enough, but the adopted English language recalibrated my sense of self, and perhaps dimmed it. I became shy, uncertain, a passive watcher of the world rather than the confident child I had been in Pakistan. I still thought in Urdu, though, up to my early teens, translating words before speaking them aloud, or finding myself unable to reach for the exact equivalent in English.

Of all the things we left behind in Lahore, our mother-tongue felt to me like one of the biggest losses, but by my late teens the balance had tipped so much that I was acutely aware of my attenuated vocabulary and grammar in Urdu. When I *did* speak it, I felt myself using the simple, crude cadences of a language acquired – and abandoned – in childhood. My parents saw what

had happened and tried to encourage us to speak more Urdu, but in our second, more effective, rebellion, we refused to switch back and the new dynamic was set: they spoke to us in either Urdu or English, we responded only in English.

We didn't grow up watching the Bollywood films that might have kept us connected to Urdu or Hindi (the two languages are almost identical, when spoken, though they have separate scripts) and to the South Asian side of our cultural identity. We had no television or video recorder at first, or the money to install a satellite dish to watch the Indian channels on which the films could be seen in the 1980s. When I came to them in my twenties I found so much to dislike. It wasn't just that the basic storyline of each was almost always the same – a romance, an impediment to it and a plot propelled towards a wedding – but that there was nothing to grasp outside the love story. They seemed bloated by song and dance too, and I couldn't see a version of the late 1970s Lahore I had left behind: many of the films made at that time were set in India with stars in Western dress or saris and they spoke English alongside Hindi. Even now I find it hard to sit through an entire film. So many feel like extended pop videos, and the lovers are so little changed from those of the 1980s – the same clichés who rarely diverge from conventional gender norms, the men brawny and handsome, the women throwing out arch, over-the-shoulder glances, their ultimate ambition still marriage.

But one film, *Mughal-e-Azam*, seemed different when I watched it, partly because it was based on a legend local to Lahore. My mother had heard the story, growing up in the city, and had told us as children. Directed by K. Asif, it marked a landmark moment in Indian cinema because it was the first really splashy, big-budget Bollywood movie to be made. When it was released in 1960, it had been almost two decades in the making. A large-scale Mughal-era historical epic about star-crossed lovers in sixteenth-century Hindustan, the story revolves around a prince's power struggle with his father, which bears

Oedipal undertones and is played out through the central, illicit, love affair. Prince Salim (later Emperor Jahangir) falls in love with a courtesan and dancer named Anarkali. Unfortunately for them, Salim's father, Emperor Akbar, declares war on his son when he tries to make this dancing girl his wife. Emperor Akbar triumphs on the battlefield and Anarkali pays the ultimate price when he orders that she must be entombed inside a wall, effectively buried alive. This is how legend has it, though the film gives her a kinder fate – the emperor stages her death, so that his son believes Anarkali has died, but she is secretly banished from court, along with her mother.

There is an ancient outdoor market within Lahore's walled 'inner city' named after Anarkali, to which my mother was taken as a girl and which I visited with her on my first trip back since leaving in 1977. I was 27 and until I went to Anarkali, I was vaguely disappointed with the city. I had not expected it to be so changed from my memories of it: now it had air-conditioned shopping malls that resembled multistorey car parks and were as cold as fridges inside, along with Dunkin' Donuts and McDonald's on every other street corner. Anarkali market, by contrast, seemed timeless and ancient, with its complex grid of narrow cobbled streets, donkeys, traditional street food and colourful grime. The further I travelled inside, the more it seemed I was returning to another era: there were lamplit streets, period buildings with crumbling façades and tradesmen who looked like medieval figures, with their anvils, iron hammers and saws. On one street corner, I saw a man with tiny birds crammed into a cage, their feathers a rainbow of colours.

'What is he doing with the birds?' I asked my mother.

'He's selling them,' she said, and told me that buyers could pay for the release of one bird on whose freedom a wish was made, if one needed making.

Those scenes and sights seemed disconnected from the rest of

the city, a frozen capsule of time in which modern Lahore disappeared and the city's multi-faith, superstitious past revealed itself.

I recognised this past Lahore in *Mughal-e-Azam* when I saw it, although the film captured only lost grandeur, not grime. Its aesthetics bewitched me too: every scene in the three-hour epic is a visual feast. Asif originally filmed it in black-and-white with just a few colour scenes, but it was rereleased in 2004, after his death, fully coloured. This is the version I watched over and over again, and now I wonder if there is something in the colour – so artificial that it seems of another, too-brightly remembered world – that chimes with me and my own technicolour memories of 1970s Lahore. Every inch of the set is ornate, men and women are heavily laden with jewellery, and the palace is a psychedelic fantasy, with turquoise and cerise chandeliers and backdrops that glint with gold. Turbans are embossed with gaudy gems, elephants wear jewel-studded coverings, and when the central characters cry, their tears twinkle, as if they are shedding diamonds.

Its two stars, Dilip Kumar and Madhubala, who became cinema icons on the film's release, look iridescent in their costumes. There are the most sensational set-pieces, too, with troupes of Kathak dancers, vast choruses singing folk music accompanied by sitars, *dhol*s and magnificent choreography. The Hindustani never once diverts to English, and is filled with such lyrical richness that I can't understand everything being said even now, but it bears all the majesty of the ancient Urdu my paternal grandparents spoke when I was five.

When I read around the making of the film, I discovered it was conceived in 1944, just three years before the end of British colonial rule. Sectarianism between Hindus, Muslims and Sikhs was rising to fever pitch in the lead-up to the Partition of 1947, which delineated new boundaries between an independent India and a freshly created Islamic Republic of Pakistan, but we never glimpse even a hint of those tensions in the film. It is a period

drama determined to present a nation in total religious harmony: we see the Muslim Anarkali on a prayer mat, but we also hear devotional Hindu songs, and see Salim's Hindu mother, Queen Jodha Bai, enacting her own rituals.

It is not the knowledge that this film was developed against the real-life rumblings of Partition that strikes a chord with me, but its presentation of the past as a reassuring fantasy of unity, with all the bigger tensions that might have existed between Hindus and the imperial court of Muslim Mughals airbrushed away.

Everything about *Mughal-e-Azam*'s Lahore, and Hindustan, is disconnected from the politics of its present and the dangerous religious factionalism that was stirring as the film was being made. Watching it again now, I find myself making new associations – thinking of the Lahore of my childhood as I have remembered it, with its luscious colours that bleach out when we come to London. There is a yearning for wholeness in these memories, and perhaps even a nostalgic glossing of the less pleasant bits. And just as the film was later coloured, in a way that rendered it too bright to be real, I wonder if I have touched up my child memories and romanticised Lahore to make it our 'perfect' first home, before the trauma of immigration, when I have long since known that my grandparents' house was riven with family tension and casual bullying, my mother its primary victim. I might not have understood it at the age of four and five, and it did not touch me directly, but I imagine my sister would have picked up on it, and I see how our time in Lahore could not have been the pocket of perfect childhood happiness it seems to have become in my mind.

Fauzia's standing in the household was different from mine, my mother tells me. No one ever said it to her directly, but she was seen to be more our mother's child. While my brother and I were spoiled and adored, oblivious to the greater adult dramas, Fauzia was most likely absorbing the tensions that

subtly, wordlessly, cast her alongside our mother. But, I think, at least she had the cushion of an extended family around her, with allies in it: her cousins, some sympathetic aunts, and the maternal grandparents to whom she was close. Once we arrived in London, she lost all that protection.

We have family photographs from our return to London in the late 1970s. We are often at Golders Hill Park, or on Hampstead Heath, where our father took us for walks. In *these* pictures, my sister and I look pale and mournful, as if we have suffered a bereavement. Our colourful outfits are gone: we are bundled up in overcoats and our eyes are downcast with dark circles around them. I am usually in my father's arms, looking listless, and my younger brother holds his hand. My sister stands nearby, a slight gap between her and the rest of us. The distance reminds me that, for Fauzia, it was not simply a case of happiness in Lahore and sadness in London.

Since she died, I have thought back to that time in our grandparents' home and I begin to remember some of the difficult things in her childhood that I had allowed myself to forget. The uprooting of migration was not Fauzia's biggest trauma. That had already happened to her at the age of one and maybe it had begun metabolising, creeping into her little girl's face, by the time of the photograph on our grandparents' rooftop in Lahore. I have questioned whether I had the right to leave the picture in her grave. It represents my certain happiness, not hers. Where I emanate sure, uncomplicated contentment, she looks wistful. Her eyes are sad, although I may have imagined that, given all that came afterwards.

Fauzia was born in 1970 and the only one of the three of us children to be born in Pakistan. I came two years later, in London, and my brother two years after me. Fauzia's early life was far less settled than mine. She didn't meet our father until she was thirteen months old because he was in London, trying to find a job before sending visas and air tickets for my mother

and their new-born to join him. They arrived in London on 23 October 1971. My mother had finally been sent the visas and she boarded a plane with Fauzia for their new lives abroad, full of excitement. They landed at Heathrow to find that my father was late, so they waited in the arrivals lounge with their suit-cases. My mother was dressed in a new *shalwar kameez* and Fauzia in a party frock. He arrived in a car he had borrowed from a friend, and when he saw Fauzia he reached out to hold her, but she, not knowing who he was, cried and clung to our mother. He asked our mother why she was crying and tried again, but Fauzia turned her face away. After that his mood changed and he spoke sternly to her in the car, telling her *chup* – be quiet – when she wouldn't stop crying.

Her tears don't seem particularly out of place to me – she was a baby, who suddenly found herself in unfamiliar surround-ings. Our father, to her, would have been a stranger in whose arms she might not have felt safe. Maybe he felt rejected in that first meeting, but it couldn't, and shouldn't, have set the tone of their relationship. Some years after her death, I tune into a radio programme, which speaks of a moment in the *Iliad* when Hector is saying goodbye to his wife, Andromache, just before he leaves for war. They are on the ramparts and Andromache has brought their infant son, Astyanax, with her. Hector is in full armour and the child begins to cry, scared by his father's fearsome helmet. It is only fleetingly mentioned on the radio and I look it up afterwards to find a small but tender scene in Homer's epic, bringing the parents closer together and providing some light relief. This was what Fauzia's crying might have been, I think. A child afraid of a helmet, a mother and father making light of it, a moment of bonding, not of setting apart.

Perhaps for my father, Fauzia's birth was tied up with the complications around his arranged marriage to my mother. He was thirty-seven; she was twenty-five. By the time he was intro-duced to her, he was a charming older man, who hadn't exactly

made much of his life, though he had had great adventures travelling around Europe, working in New York for a time, and living a footloose lifestyle working as a sales rep for airlines like Pan Am and Alitalia. In his twenties, he had trained as a cadet in a military academy in Kakul, Pakistan, which he had apparently loved, but he was dismissed for ill-discipline just six months before he would have become an officer. After that he did a stint in the police force but left before it developed into a career. He came from a big, emotionally expressive family of ten siblings (eight of whom survived beyond childhood) and he had been his mother's 'favourite' child, perhaps even spoiled by the special attention.

My mother was the opposite, happier listening than drawing attention to herself. Strangely, my earliest memories of her are nearly always in a flower-power print dressing-gown, which had a large, frilled collar and trailed down to the floor. In it, she looked like one of David Hockney's languidly fashionable women from the 1960s and 1970s, posing poolside in a kaftan. The dressing-gown was a flamboyant garment for my mother to have worn, with her quiet, cautious nature, but I see from family photographs that her clothes were always bold, as if she were expressing a hidden part of her personality through them. My sister inherited my mother's fashion sense and many of her clothes had the same daring quality.

My parents had a bad marriage, maybe made more fractious by the stress and isolation of immigration. I remember, as a child, hearing their suddenly raised voices in the home and the pall of dread that collected around these moments. When we'd run to whichever room they were in to see who was shouting at whom and why, we would be ushered away, but the fight would continue. My mother was often left in loud tears while my father stormed out of the house. One of us would usually begin crying too, although we didn't know why – we were just absorbing the distress around us. For hours afterwards, baleful

silences hung between them and were often still there when we sat down for dinner. The reasons for the arguments are lost to me, and it is almost an effort of will to recall anything specific because they were so frequent – loud, alarming outbreaks of melodrama, whose words I stopped hearing, or tried to. What were they arguing about all the time? Who was more concilia- tory, and who made up first? If I strain to remember, the arguments seemed to be about the past, tracking back to Lahore and the circumstances around their marriage. They would be questioning why they had married, who had facilitated the arrangement and who, ultimately, was to blame for it.

My father would return mealy-mouthed to my mother so that I came to feel he was guilty of something I was too small to understand. She would respond to the apology with injured silence, but for a while afterwards they would be friends again, until the next bust-up. I can't now return to these fogged-up memories with any reliability at all. All I can say is that my parents seemed to disagree about everything and to be in gladi- atorial combat with each other for much of my childhood, though they stayed together for more than thirty years, until my father got frontal-lobe dementia in 2003 and was taken into hospital first, then a nursing home.

Maybe part of the problem was the difference in upbringing: my father's family were Muslim landowners in Shimla, a hill station in India. In the mass two-way migration sparked by Partition – Hindus and Sikhs leaving Pakistan for India, many Indian Muslims for West and East Pakistan (the latter became Bangladesh) – my father's family were forced to flee their home. They travelled by train to Pakistan and my father, Khawaja Muhammad Akbar, was sixteen by then, old enough to feel a rupturing of his Indian identity. The fracture of leaving Shimla seemed to have stayed with him for long afterwards and was on an entirely different scale of trauma to the loss we felt on coming to London from Lahore: where we acquired a combined

identity as British Pakistanis, his was an enforced abandonment of one nationality for another. Now he was no longer Indian but Pakistani, he was told, and his home was not the place in which he had spent his carefree childhood.

My father told us that neither he nor his parents felt at home in Lahore: the climate was different, they had lost all their friends, neighbours, properties, income, and felt stranded in a country that they were being told to call their own. He saw himself as being from Shimla, always, and felt pride in that identity, but not in his second, adopted one. He left Pakistan as soon as he was old enough to travel the world and explore the West.

My mother, Bela, came from a far more straightforwardly Pakistani background. She was geographically rooted in the land that would become the new nation of Pakistan three years after she was born in 1944. Lahore, a Punjabi city already inside the boundary, was likely to have absorbed the building nationalism in a way that Shimla – with its distinct mountain culture – may not have done. Her childhood was stable, with no migration and no confusion over her Pakistani identity. Until she got married, she lived a sheltered life, rarely leaving Lahore except for summer trips to the northern hills of Murree, and feeling only triumph at the formation of Pakistan. When she came to London, she carried her nationalism with her, giving us Pakistani flags as children, teaching us the national anthem, and forever comparing the better life, and brighter culture, of Lahore to the colourless foreign city she had been brought to, however willingly she had come. I remember jumping up and down with these fluttering green-and-white flags and chanting *Pakistan Zindabad* (Long Live Pakistan), as she had taught us, for years after moving to London. Just as Shimla remained my father's home, she spoke of Pakistan as hers for decades after having left it. The precious internal landscape of 'home' cannot be rooted out or replaced so easily, though we can come to embrace

it as a multiple, and I suspect my mother now considers it to be both London and Lahore.

My parents' differing views of Pakistan became another point of contention between them, and my father's equivocations might have been compounded by fear when he moved to Britain and saw Fascist groups, like the National Front, targeting people of Pakistani heritage in the 1970s and 1980s. He didn't want to call himself Pakistani in public, and would lie when he was asked, variously calling himself Turkish, Iranian, even Indian. He urged my mother not to wear *shalwar kameez* in public, and she complied for some years but then insisted on wearing traditional Pakistani clothes whether he liked it or not.

I have asked my mother why she agreed to marry my father in the first place – she could easily have decided that he wasn't for her after meeting him. She says that important things about his past were kept from her. Her mother, Shireen, and my father's eldest sister, Jamsheeda, had been friends, and it was these two women who introduced my father and mother to each other. Jamsheeda, a loyal older sister acting on behalf of my father, had apparently done something of a hard sell and made him sound far more successful and settled than he was. My mother tells me that, decades later in London, Jamsheeda, a devout woman, apologised for her part in the arrangement and the hurt it had caused.

My mother only found out afterwards that my father had been previously married, that he had no job in London and no professional qualifications. If the twenty-five-year-old Bela had felt beguiled by the promise of marrying an older man who would whisk her away to show her the world, she must have felt sorely cheated by the reality. Much worse, she also realised my father was still holding on to the memory of his first wife, Lise Hass.

Lise was German and far older than him. The age gap almost exactly mirrored that between my mother and father in reverse.

Lise was fortyish when she met my father, who was twenty-five. She was born in 1920 and raised on a pig-farm in Bremen, before settling in West London, presumably some time after the Second World War. Lise could have remained in my father's past had he not brought her with him, but she became a ghostly presence, a kind of succubus, in my mother's marriage, draining the life out of it. I remember my father talking about Lise openly when I was a child, though I was too young to understand the context or tone. I realise now that I shouldn't have known about this German wife at all, especially at that age, and I wonder why he felt the urge to mention her.

Lise and my father married and lived together for seven years. She couldn't have children because she had been 'sterilised', my father told us. That was the word he used. We didn't ask what it meant but I remember – perhaps wrongly – that he suggested it was tied to the war, and the Third Reich. I may have bolted on this detail in an attempt to make sense of how a German gentile came to London and married a dark-skinned man almost half her age. I imagined her as a rebel or refusenik, who was punished by the Nazis for some serious disobedience.

Whatever brought her to Britain, and to my father, the sight of them as a couple must have been an anomalous one in early 1960s Hammersmith, a stone's throw from Notting Hill, where a riot had been sparked a few years earlier by the sight of a mixed-race couple having a domestic dispute. Notting Hill had exploded in racist violence after a Jamaican man, Raymond Morrison, and his white Swedish wife, Majbritt Morrison, were seen arguing outside Latimer Road tube station on 29 August 1958. A white gang closed in around them to defend Majbritt, although she made clear she didn't need their help. A scuffle broke out and, by the following day, mob violence was in full flow. When I read about them, I feel an odd relief that my father and Lise remained unscathed in their marriage amid the race hate of that time.

In the late 1960s, my father came under pressure from his family to leave Lise. He was the oldest son of four and his parents felt that the stain of this non-Islamic marriage was ruining prospects for their other three, as yet unmarried, sons. The brother to whom he was closest came to see him in London and, the way my father described it, convinced him to go back to Lahore. He was told that their mother was ill, and once he was back, his passport was taken from him. This led to his abandonment of Lise Hass and his marriage to Bela Rasheed Akhtar. That is the story he told us when we were children.

Years later, when I was in my early thirties and working as a news reporter at the *Independent* in London, I looked up Lise Hass in the public records office and found a marriage certificate. My father is listed as a milk factory worker and she as a child-minder. They were married at Hammersmith Register Office and their witnesses were Lise Hass's father – a man called Adolf – and her brother, Friedrich. I also found Lise's death certificate, which reveals something of the life she lived after my father left her. I detect sadness in it, unless I am projecting that onto the few facts I have. She divorced my father but kept her married name – my father's name – until her death at the age of eighty-two, and moved only five minutes away from the Hammersmith home in which they had lived together. Was she staying local in the hope he would return to her one day? Did she never remarry because she was heart-broken, or did my father leave her so embittered that she was put off marriage for the rest of her life?

The year of her death is listed as 2004, and it is frustrating to know that I was in London at that time. Had I thought to investigate this part of my father's life earlier, I could simply have knocked on her door and introduced myself to her. All the mysteries around their marriage could have been solved if she had let me in. But then again, there had been no reason to do so, until my father started mentioning her again, just at the

onset of his dementia. He had stopped speaking of Lise by the time I was in my early teens, so I had forgotten about her, and I must have assumed that he had forgotten about her, too. But now it seemed as if his scrambled memory was dragging her back into the present. The illness came on in his early seventies after he retired from British Rail where he had been a train conductor.

However dismal a job it seemed, with its low pay, long hours and gruelling night-shifts, he seemed satisfied. He got to travel every day and stop off in beautiful spots, he told us, listing suburbs and seaside resorts, and letting us play with his torch and whistle as children. His easily contented nature was one of the things my mother found frustrating. She came from a family of professionals but here was a man – her husband – who was happy collecting tickets on a train, even when his wages barely made ends meet. He showed no ambition and did not apply for a promotion at British Rail even when he was offered a chance.

Everything remained improvised and unplanned. Even family day trips had a chaotic, impromptu quality. I remember being taken to Edinburgh for a holiday but having to catch a sleeper train not long after we arrived because our father hadn't taken into account the length of the journey, and that we couldn't afford to spend the night in a hotel.

After retirement, my father gradually stopped going out and took to sitting in a corner of his room, jotting down secret words in his railwayman's diary. He began accusing my mother of poisoning him and refused to eat anything she cooked, until he became pale and emaciated. My mother was so concerned by his inexplicable behaviour that she went to talk to his GP and found out he had written letters to the doctor's surgery, as well as to the council, apologising for wrongdoings in his past and asking to be removed from his home. He was admitted to the Royal Free after he took an overdose of painkillers, and kept on close watch by nurses because he repeatedly spoke of wanting to die. He was moved into a locked ward for some time, and

after that, to a series of unkempt care homes in London, until he finally settled in a nursing home just around the corner from my flat in Kentish Town.

His frontal-lobe dementia was relatively rare at the time it was diagnosed, in 2003, and made him difficult to manage: he would melt into sudden tears, which shocked us all. He lost so much weight that he looked as if he would snap – nothing like the robust father I had known. It also made him aggressive at times and he would shout for hours on end. When we were first told he wouldn't be allowed to come home, it felt like a bereavement to me. I had always been the closest to him. I gathered up all his things at home and found his British Rail diaries, which had stark daily entries repeating the same statements in shaky handwriting: 'A bad day today'; 'Another bad day'; 'Terrible'.

We all felt the tragedy of his illness, including my mother, who took freshly cooked food to his ward at the Royal Free every day. And then, some months in, just as my mother and I were entering the ward, a nurse stopped us, smiling, and said, 'Which of you is Lise?' She looked from me to my mother.

'Why?' I said.

'Well, it's just that your father keeps asking for her.'

I looked at my mother uneasily and her expression was inscrutable, but I knew it must have rankled. Even if Lise was dead – and we agreed she must surely be dead when we spoke about it afterwards – she was still casting a shadow. I was shocked that my father's dementia had led him back to Lise Hass. Later, he began to mistake the nurses on the ward for her, we were told, though he never spoke of Lise in our presence. I felt for my mother and I also felt for him. It seemed as if he – they – had been in the wrong marriage and in the wrong life for over three decades.

I asked my father about Lise more than once but he'd become confused. 'Is she living in Lahore now?' he'd say, but more often, he stayed silent when I mentioned her. I vaguely remember a

defaced photograph from my childhood that might have been of the two of them. It was not displayed in the family album but tucked among a stash of loose photos in a drawer. In it, a tall, ruddy woman in a jumpsuit sat on a park bench with a very young version of my father. Everything in the photograph was intact apart from the woman's face, which had been scribbled out with piercing strokes of green ink. Beneath the pen marks, I could make out the faint shape of her features. The picture seemed like contraband when I found it and it has long since disappeared. I expect my mother or father threw it away. But the image lingers. What was it about this seemingly ordinary woman with her bowl of brown hair and pleasant but unremarkable face that was so unforgettable to my father and to whom my mother could never compare?

I began my fact-finding mission soon after, excavating marriage and death certificates, asking my mother what she knew of Lise, and speaking to my father's brother, now in Texas, who had come to London in the 1960s and met Lise. What I got was a series of clashing narratives. My mother repeated the stories I had already heard about Lise, but my uncle had a different version of her life: her family were not Nazis, he said, and she wasn't 'sterilised'. She had suffered from endometriosis and got a hysterectomy as a result.

This uncle, who also has dementia now, had told my father that their mother was ill and that he should return to Lahore immediately – which my father said marked the end of his marriage to Lise. Once he was in Lahore, he was convinced to abandon her. My uncle said that my father and Lise were forever arguing, that she had met a Polish man soon after my father left her, and probably ended up living with him for the rest of her life even if she didn't marry again.

One story confounds the truth of the other and I am surprised by how such recent history can become so quickly contested. Several of the narrators are now locked inside their own heads,

unable to defend their version of events. Had I asked sooner, I might have got answers. My uncle can't verify or deny anything because of his dementia. My father can't either, and while I realise that his dementia has stripped him of so many aspects of his former life and dignity, some small part of me feels that it has let him off the hook and allowed him to bypass a necessary reckoning.

After my mother fell pregnant with Fauzia, my father left for Britain, promising to call them both over once he had set up a home. So Fauzia spent the first year of her life with our mother and her maternal grandparents, unaware of her father's existence. My mother remembers her as a happy, healthy baby, delighted by her place in a household that lavished her with love, though she has also alluded to her own anxiety that my father would forget them and she would languish as a failed wife and single mother. I'm not sure how much of this worry Fauzia picked up as a baby, but at some point, she must have become confused about her father or overtly oblivious of him: my mother says they put a picture of him on the mantelpiece to which they would point, and say, 'Dad'. She learned to point at it too and say, 'Dadda'.

In August 1987, our maternal grandmother – our *nani-jaan* – died of ovarian cancer in Lahore. We hadn't seen her since emigrating a decade earlier and I had a vague memory of a kindly, bookish woman with silver hair. Our occasional visits to my mother's family while we were in Lahore were sedate, with none of the exciting commotion of our father's family household. I remember my mother received her death as sad but expected news. Six months earlier she had gone to Lahore, knowing her mother's cancer was incurable. Now she mourned quietly and out of sight.

Fauzia wrote a letter of condolence to my mother's youngest sister, my aunt Nilofar: 'It was so painful to hear the news,'

she tells Nilofar. 'I know that you must be feeling a lot of sorrow at the loss of Nani-jaan. I don't really know how to cheer you up but I know that, given time, the pain will eventually ease and that you will be left with wonderful memories of your dear mother.' Fauzia would have been seventeen, and I can't remember her telling me, or any of us, that she had written to Nilofar, but it makes sense that she did. This was her first family and she was, in turn, their adored grandchild. No complicating sister or brother had yet entered the scene.

When I was born, it was very different for my father. He couldn't stop marvelling at me, I'm told. Perhaps he saw me as the firstborn because he was there for my birth, not thousands of miles away as he had been for Fauzia's. In these early years, my father seemed to decide that I was the more lovable child, and rather than hiding his favouritism, he made it explicit. He told me, volubly, that I was adored and special. In early family pictures I am always in his arms or by his side. A certain positioning seemed to take place in the contrasts he set up between Fauzia and me. I was the daughter who could do little wrong. She was the problem child long before she had done anything wrong. To her, he was a stern and tyrannical father who never missed an opportunity to point out a failing. To me, he was an abundantly loving and forgiving one. When I think about the two of us as children, alike in many ways, though Fauzia was the more striking – taller, stronger, sportier, with large, dark features – it is hard to understand his decision to love me more extravagantly, and to show her, just as extravagantly, his distant, disapproving side.

Why did my father need to draw one daughter close and push another away? I think back to the stories I have heard about my father's childhood and of his mother's coddling of him. One uncle told me long ago how her adoration confirmed his place at the centre of the family, as its 'hero'. That same uncle said he had regarded my father as 'special' too but I detected a hurt

in his tone, even though he was well into late middle-age by then, and I wonder if this is how favouritism works: a child's unparalleled status is conferred arbitrarily by the parent and reflected back in the eyes of all the siblings who can never match up. That inheritance is what my father seems to have brought to us. Perhaps he saw it as a natural function of parental love, but it was reproduced with a bare-teethed, Darwinian brutishness in our smaller and more isolated family circle. I remember the picture of Lise, with her ordinary, rubbed-out features, and I wonder if her phantom place in our lives was about positioning, too. However plain or imperfect she might have been, she had been deemed the incomparable, favoured first wife while my mother was positioned at the opposite end. Similarly, Fauzia was confirmed as the daughter of lesser worth as I came into the world and cemented my status as the most loved.

When my brother was born two years after me, my mother says that my father was pleased to have a son, and a great fuss was made of him, but his arrival didn't dismantle my primacy in my father's eyes. The dynamic seemed set. My brother became a welcome addition to the family, and our parents encouraged him to do the things he felt drawn to – he was taken to a football academy after he showed ability at school, and then to the cricket club when he changed his mind about football. But I remember him as a happy, mischievous youngest child, who was largely left to his own devices. We got on as a gang of three. Tariq played with us both, though we bossed him around and, as the middle child, I spent much more time with him than Fauzia did in our early childhood because of the narrower age gap between us. Despite my sister's position in the family, among the three of us she remained our big sister and held the natural authority of the eldest child.

There is a photograph of Fauzia and me as children that unsettles me. Fauzia must have been about four. We were living in rural Cambridgeshire where my brother would later be born.

The picture is a black-and-white image of the two of us sitting at the bottom of the stairs in our house; she has her arm around me and looks as if she is cowering from something or someone. Neither of us is smiling. My mother's silhouette throws an oversized shadow on the opposite wall as she takes the picture, which adds to its foreboding. I can't remember anything about it, but now I wonder if the invisible monster that is making Fauzia cower is our father. Was he standing just out of the frame of the picture? Was she trying to protect me in some way, or was she cleaving to me in fear?

I grew up on stories of his random cruelties towards her as a baby: of him making her mouth bleed by sticking his fingers into it and pulling at her cheeks, of shaking her and making her run alongside him, even when she grew breathless and tearful. My mother worried about leaving him alone with Fauzia while she went shopping, spending the trip in a fever and rushing to be home again. But these are stories told to me by my mother rather than memories I hold, so I try to draw out more details.

'How was he horrible to Fauzia?' I ask my mother.

He would take any opportunity to tell her off, pull her hair, and say he couldn't bear looking at her. Sometimes he refused to eat at the same table as her, so she would have to wait until he had finished. She would be blamed for the smallest misdemeanour – if something was spilled or broken – and told that my misbehaviour or my brother's was her doing because she was the eldest and had set a bad example. My mother remembers an instance in which Fauzia came home late after school one day, at the age of fifteen, and he punished her by hitting her on her bare thighs. An aunt from Lahore was visiting and was shocked by his violence. Fauzia would more often be punished by being sent to her room and left there for hours. And just as the extended family in Lahore had wordlessly defined her as more our mother's child, so he emanated the same sense that Fauzia was not enough like him and too much like the wife he

belittled with blunt-edged taunts and insults when he was in one of his rages.

I ask my mother why Fauzia was targeted in this way and she tells me it began as a campaign against *her*, in my father's family home when he was in London and she was pregnant with Fauzia in Lahore, waiting to join him. It was orchestrated by my paternal grandmother and Fauzia was caught in its crossfire.

'But these were the very people who helped to arrange your marriage. Why would they turn against you – and your child – so suddenly?' I ask.

That was how it worked sometimes, she tells me. Young brides left their homes to enter those of their new extended family with only the value of their dowry. They found themselves alone and, in her case, with no defenders and no recourse to separation or divorce because of the cultural stigma it carried at the time. The power was never on the side of the bride but on that of the family she married into, and this family effectively became a mob.

Some of it was about money, she explains. These in-laws expected her to keep bringing in money from her family, but she refused to lean on her parents' wealth. Whatever other reasons for my mother's definitive casting out, she believes that my father's inexplicable anger towards Fauzia was led by his family's bigger resentment of *her*. There are no conflagratory set-pieces of remembered violence from that time, or later, when we moved to London. My father just continued to treat Fauzia differently. I know now that his behaviour amounted to verbal and emotional abuse, but I couldn't have named it as such then, especially in the face of his very different treatment of me. I find it difficult to use the word 'abuse' even now, and it feels like I am betraying his unfailing love and loyalty towards me, but it is correct to use it. It still alarms me that family abuse can be so selective, that one sister can remain untouched while

the other is so terrorised. The charges against Fauzia were so insistent, every day and unrelenting that they became normalised in our home. The emotional cruelties sank beneath the surface of family life so unpicking them now, or seeing them clearly, becomes impossible. My father's distrust of Fauzia – which seemed so much like dislike – insinuated itself into daily life. I suspect this is how some domestic abuse works: in pinpricks, pinches and a tsunami of micro-aggressions. It is what makes it so pernicious and it is no less monstrous than outright punches or scenes of bone-breaking violence.

My sister became the unworthy one. No reason was given because abuse is not reasonable. She was just not good enough. Part of her trauma came from the lack of an explanation, I think. If I replace the memory of that child Fauzia with one of my brother's two young daughters, I feel an almost physical alarm at the idea of anyone – let alone a father – jibing at them or undermining their delicate and mutable sense of themselves. It is not surprising that, when she was old enough, Fauzia began saying quietly to me that she suspected she wasn't originally a part of the family, that she had somehow been separated from her own, loving one.

My mother has recounted the stories about Fauzia's daily indignities with tears in her voice over the years and I have asked her again and again why she didn't leave. She had nowhere to go, she says. She was lost in Britain, unable to navigate the system and entirely reliant on my father. She felt controlled by him, too, for part of our childhood, she adds. What was most bewildering for her was his volatility, which contained an enormous capacity for love alongside a suddenly flammable anger. He would be full of warmth for her one minute, then shouting, spilling over with insults the next. His anger was immense, she says, and he would most often round on her when no one else could see or hear him, cutting her down with hurtful and demeaning words. After that, penitence, apologies and charm

offensives, until the cycle repeated itself. But if he had continued to be such a tyrant, why had she not returned to Pakistan with Fauzia in tow? I have asked, and she talks about the cultural stigma of marital separation again, which would have made pariahs of her parents and of her.

'What about Fauzia?' I have wanted to say, but bitten my tongue. Instead I say it to my sister-in-law, Mary, some years after Fauzia has died, as we mull over what my mother has said to us about this part of her past. Mary, a Memphis-born American and mother of my two nieces, moved to London when she married my brother more than a decade ago. Immigration, even for her, she says, was discombobulating. It brought isola-tion and fear, but my mother would surely have contended with a bigger cultural shock, she points out, alongside my father's aggressions. To Mary, it is clear that my mother was left immo-bilised in her marriage and unable to find a way out. 'You have to see your mother within the broader system to understand her lack of power,' she says. 'Look at all the women still stuck in controlling relationships today. The blame doesn't lie with them. It lies in the system that traps them.'

I mull over her words, but it is not until I am watching *Mughal-e-Azam* again that they make better sense during a scene in which Emperor Akbar is about to leave for the battle-field, head to toe in armour, after declaring war on his son. His guards present him with his sword, but he is surprised that it is not his wife, Queen Jodha Bai, who is handing it to him, as she has always done before a battle. He confronts her and she says she can't bear to give him the weapon that may kill their son. He is stony in the face of her maternal anguish and forces her to make a choice, to pin her allegiance to him or to their son, Salim, lacing his words with barely veiled threats and reminders of her reliance on his power. In the end, she picks up the sword and gives it to the emperor, but it is clear that this has not been a choice for Jodha Bai. She knows she has no

standing in society without the emperor. The Mughal court is run as an absolute patriarchy and she is low in the pecking order, even as its queen.

I think of the power that other, more openly defiant mothers have had in ancient stories in which husbands have committed great wrongs. There is Clytemnestra in Aeschylus's *Oresteia*, who kills Agamemnon because he has sacrificed their daughter, Iphigenia, to win the war against Troy. But she is herself killed by her avenging son, Orestes, to restore patriarchal order. There is Medea, too, in Euripides' bloody tragedy: she uses her children as instruments of revenge against her betraying husband, Jason, by murdering them. These women are arguably no more powerful than Emperor Akbar's wife, though they certainly exert their enraged sense of injustice. We do not live in fifth-century BC Greece or sixteenth-century India, of course, but just how far have we come since those stories were conceived? Aren't we still living inside a system – a patriarchy – in which the state cedes greater power and control to men? Women, and mothers, sometimes stay in abusive marriages because they feel they have no choice, just as Jodha Bai does, even when their children become embroiled in the violence. Jodha Bai is walled in by larger forces, as Anarkali was, and my mother too.

Even if I resent my mother's inability to leave a marriage that was harming her elder daughter, I remember her defending Fauzia, shouting at our father to leave her alone. There were other gestures made, too small and subtle to name. Maybe they came in glances towards Fauzia when our father was speaking harshly or in body language that showed an intention to put herself in the way of any violence. At the time, they didn't seem brave enough, but over the years I sensed a refusal, or resistance, that was quietly determined. Maybe this is what the actor and playwright Heidi Schreck refers to as 'covert resistance' in her lecture-like play *What the Constitution Means to Me*. It speaks of how radical the American Constitution was in its origins but

how abysmally it fails migrants, Native Americans and particularly women, now. She glides between talking about the big, legislative loopholes and macro-structures that leave women unprotected, and the women in her own family, particularly her grandmother, Betty, an immigrant from Germany, who suffered violent domestic abuse at the hands of her second husband.

Schreck tells us that her grandfather, Dick, beat not only Grandma Betty but also her six children, and he raped Schreck's sixteen-year-old aunt. We are carried in a certain direction by the story, horrified by Dick's actions, but there is a shocking turn when Schreck's mother and aunt tell the police what he has done, and Grandma Betty, too terrified to testify against him, tells the police that Schreck's mother and aunt are lying. In this moment, Betty is so fully her husband's victim that she becomes his defender. 'I have struggled my whole life to forgive Grandma Betty for not protecting my mom,' says Schreck, but in the next breath she tells us that Betty was not only a victim but also a fiercely protective mother, who gave her life to her children and grandchildren. She was among those women who simply couldn't afford to get up and leave, says Schreck, so instead she chipped away at her husband in almost imperceptible ways. What seemed like passive, victim-like behaviour contained 'invisible acts of bravery' and covert pushbacks.

Jodha Bai at least voices her disapproval at a father going to war with his son, even if she is forced to hand over the ceremonial sword that may kill him. Her words poke at the emperor's conscience, and we see him tormented about waging war on Jahangir. In some ways, the film shows him to be controlled by, and in service to, the imperial forces of a bellicose patriarchy too, though he is its representative head and can hardly be called a victim.

But many men are cogs in the system and some suffer for it. My father could be seen as an aggressor *and* a victim. He had a wife in Lise Hass and a home in London, but was pulled away

from both and pressured into a marriage he clearly didn't want. Who was the greater victim in the marriage? My mother, undoubtedly, but I know I am building a too binary study of their relationship. I am placing snippets of received information next to blurry childhood memories to create a jigsaw with parts missing. I run the risk of jamming pieces together wrongly.

A small, seemingly bureaucratic niggle has already cropped up that gives rise to bigger doubts. I wanted to spell my mother's name as 'Baila' in these pages because that is how she spelled it before she came to London. I have assumed that my father forced her to change it to the more Anglicised 'Bela', which she began using when she came to Britain and which she uses to this day. That explanation fits with my understanding of him, and of her, from that time, so I seek to liberate her name and restore its cultural 'authenticity'. But when I tell her this she says, 'No,' and laughs. Her name had always been Bela until a cousin in Lahore told her it should be spelled the other way, so she reluctantly changed it. On arriving in London, she found the opportunity to reinstate the original. 'Oh,' I say, and wonder what else I am unwittingly misrepresenting. Even for someone of Pakistani heritage, it is easy to start leaning on an over-simplified narrative of overbearing Pakistani husband, undermined Pakistani wife, but their marriage was so much more complex and, to me, unknowable.

It never stopped being combative, but my mother became louder and stronger in it, and the balance of power began to shift. By the time I was in my mid-teens, she had turned into a more commanding figure. My father no longer fell into rages, she would often have the last word, and he would be the one sinking into silent sulks. After an argument in which he had once again been beaten into submission, he would tell me how unhappy he was. 'Never get married,' he'd say.

I'd try to smooth things over, telling him he should try harder to keep the peace.

'I should never have got married,' he'd say again, which became a sad refrain over the decades, ever more powerless in its repetitions, right up until he got dementia at the age of seventy-three.

I can't say how the power shifted so definitively, and neither can my mother when I ask her. She simply gathered her strength over the years, she says. She found an Asian Women's Centre, in North London, and speaking to the women there helped her understand what had been happening in her marriage. She threatened to divorce my father, but he said he would never agree to it and I think it left him scared because, for all his talk of marital misery, he was almost entirely dependent on her. Slowly, she began leading the family, making the big decisions, while he gradually fell into retreat. Perhaps he felt ground down or maybe he regretted the tyranny of his early years in marriage. More and more, I would find him in their room, sitting on a stool in a far corner. Behind him was a small cupboard in which he kept all his things, from his work uniform to his most treasured photographs of Shimla. The rest of the house, it seemed, was hers.

There are more stories my mother tells me of my sister's childhood: of my father buying her a bag of sweets at the age of three or four and leaving her sitting on a playground swing by herself, eating confectionery and hoping he would come back to collect her. He would, of course, always return, but I feel sickened when I think of my sister on the swing, learning to staunch her fear of abandonment with a bag of sugar. Is this when food became a proxy for love? It might be crude to relate her eating disorder to a moment on a swing as an infant, but might a pattern have begun to form then? Another version of my father emerges as I think of his relationship to Fauzia in her early years, but he seems to be a part of her childhood, not mine.

Some aggressions were more inexplicable than others. I remember how one Christmas Fauzia had won a drawing competition at Primrose Hill library. She had been entered by our school at the age of eleven and when she won her painting became a thing of collective pride. It was an intricate Christmas scene, every inch of the paper covered with a festive riot of reindeer, hills, snow, which the school displayed behind glass. She had, by then, become known as a promising artist: teachers encouraged my parents to push her further, so my mother praised her work and put it forward for prizes, which she won. There was excitement when she was finally allowed to bring the Christmas picture home and we Blu-tacked it to her bedroom wall. One day, as the two of us were talking, our father came into the room and tore it down in a sudden fit of anger. We might have been behaving raucously but what he did felt spurious and vindictive to me. It was the first time I felt the shock of seeing this 'other' father emerge from behind the loving one of my childhood. Fauzia didn't cry or complain. Maybe she was already learning to wall up her feelings in the face of his hostilities.

Did he regret leaving Lise and marrying Bela? Was he taking out his rage on the daughter whose birth only committed him further to his new, derailed life? It is hard to believe that the people you love, who love you, can be monstrous. It is hard to see the monster father when he is not being a monster to you. It seems too illogical. Still, my heart hardened a little towards him following Fauzia's death, but it is not as simple as that either. I have seen him suffer in the past fifteen years with his dementia. He is alone now, visited at his nursing home by no family members other than me. He is only reminded of his wife and other children from the photographs I have placed in frames on his walls. It seems to me as if he is paying penance. Sometimes he curses himself, using the same words – useless, freakish – that he used to describe Fauzia behind her back as a child. But now even his powers of speech are becoming impeded, often reduced

to shapeless sounds, and he is increasingly stranded in silence. He can't express his suffering and I can't ask him if he loved his firstborn.

In some ways, his locked-in state makes any account of his actions unfair. I am painting pictures of him that he can't challenge or correct. He was an exceptional father to me, filling me to the brim with self-belief. He was big-hearted, sociable, and had a charisma that drew others to him; he made friends everywhere he went. He was popular even among my primary-school classmates, an excellent storyteller with a humour that appealed to children. As we set off on a school trip to the countryside, he gave us small, clear plastic bags and told us to bring him back some fresh country air. He raced us in the park and told jokes.

There are parts of him I recognise in myself and in Fauzia: keenness to please, adventurousness and an easy contentedness that I have inherited and am relieved to have done so over my mother's restless ambition – a continual pushing for more – and her anxiousness. There is his blind optimism, too, which is not just a welcome counterpoise to my mother's worrying but contains a reckless hope that has served me well in life, staving off expectations of defeat, against the odds. However many times he messed up, he continued to think he wouldn't fail next time. And his anger, so destructive to family life but that, as a more abstract inheritance, has mobilised me at critical moments.

It would be easy to build an alternative narrative to the 'monster father': that he was simply not as close to Fauzia as he was to me; that he was there to support her in adulthood; that he spent hours entertaining us as children, telling us stories and making us laugh, taking us for long walks across Hampstead Heath, teaching us to do handstands against trees and filling our lives with nature in the middle of the city. He loved us in different ways, he might say. And such was the effect of his love on me that I went into the world with self-assurance, as all

children should. I felt an absence of envy towards others – especially other women – maybe because it was not *my* role as a sister to feel envious. I have scoured for memories of his uncontrolled temper towards me and I can't summon up a single incident. There is only kindness, encouragement and understanding. All of these facts mitigate against the catharsis of outright condemnation. Whatever the source of his complicated relationship with Fauzia, it is buried wordlessly inside him for ever, and perhaps it is eating away at him.

When Fauzia died, I went to see him at his nursing home and told him I had some news. He was watching TV and didn't look at me when I sat down. I switched off the TV to claim his attention but he continued to look at the blank screen, not meeting my eyes. I told him what had happened and waited for him to speak but he carried on staring, his expression unchanged, so I assumed he was lost in his inner world and hadn't heard me. But in subsequent months, he began asking me if Fauzia had died, then telling me she had, sometimes matter-of-fact, sometimes disbelieving. Nothing more has come. At least he knows, I think, but I wonder what sadness or guilt lies in the recesses, beyond language.

As children, Fauzia and I had our sisterly fights, though these had subsided by the time we were teenagers. They were usually short-lived, but one particular fight stands out. It was just before bedtime one winter when I was around nine and we were sharing a room. We must have been quarrelling fiercely because I remember my mother trying to shut down the argument by giving us each our hot-water bottles and switching off our bedroom light. It worked to the extent that we both quietened. But out of the darkness my sister screamed so loudly that I felt something catastrophic had happened. Our light was snapped on again and my father ran to Fauzia, who was in paroxysms of pain. He removed her covers to find that her hot-water bottle

had burst and the skin along her legs had been stripped off by the boiling water. She told me later that she had been so angry she had squeezed the bottle. An ambulance was called and she was rushed to hospital.

My father made it clear that he held me responsible for what had happened. I remember the sting of his judgement, but what sticks more in my mind is the moment Fauzia was brought home: I had my head poked out of the window, waiting for her to return, filled with fear for her. She emerged from an ambulance on crutches, her legs bandaged. What puzzled me was how happy she looked. She smiled widely as our father helped her along the road and into the house. By the time she got to our bedroom, she seemed euphoric.

'Do you want to see?' she said to me, when we were alone in our room. She unravelled a piece of the bandage to show me skin wrinkled with burns and streaked with red, watery blisters. It was clear that our fight was forgotten and that I had been forgiven for whatever I had said or done to her in place of this greater event. Her euphoria has stayed with me and it dismays me to contemplate its meaning. In pain, she got special attention from the world, and from our father. She told me how the hospital had attended to her, and it was clear that our father had been desperately upset to see her suffer. In her teens and early adult years, she became openly self-destructive and – finally – captured the family's sympathies. Did she learn then that pain had its rewards? That if she couldn't be loved simply for being herself, she could if she suffered? Everything that came afterwards seemed to be connected to a bigger chain of harm: a lifetime of misery predetermined in childhood.

3
Hampstead, 1977

My mother and I are standing on a corner of Hampstead High Street. It is a cold morning but the usual crowd swarms the pavement cafés and trendy crêperie stall at the top of the drag: ruddy-faced couples in wax jackets, horsy mums wheeling state of-the-art prams, tousle-haired teenagers in Prada trainers. Hampstead basks in its privilege and today these people look flinty-eyed and obnoxious with wealth to me. We have stopped a block from the top of the hill, opposite a period house, at 67 Hampstead High Street.

It is above a smart row of chi-chi boutiques and high-street chains. We are staring up towards the third-floor windows of the house in which we lived. My mother hasn't been here for over forty years, even though she only lives a thirty-minute walk away. I have been afraid to suggest we come here for fear of dredging up the past, but her face is flushed and she looks excited.

This was where we lived in the first fugitive year of our life after returning to London from Lahore in 1977. My parents had run out of savings and we were homeless. A Pakistani friend had told my father about a derelict house that was occupied by squatters but had an empty room on its third floor, which became ours. Outside, the street throbbed with wealth. Inside, we had two single beds with broken springs between us. The house was in a state of disrepair and covered with thick layers of filth. There was no hot water or heating, only a tap that dripped brown water. My mother collected the droplets painstakingly and heated them on a single hob before we could drink the water or cook with it. We only had the kettle, the hob and a

toaster. My mother remembers an Indian woman living down-stairs who had a disabled daughter, and whose husband was training to become a doctor. We would all take it in turns to use the house's decrepit bathroom. Fauzia and I were enrolled in the primary school up the road and my mother washed the same clothes every night for us to wear the next morning. The walls of the room were so damp they felt spongy. Another room downstairs, which my sister and I sneaked into though we were banned from venturing there, was filled with wires, pipes and peeling asbestos.

'Where's the front door?' I ask my mother.

She tells me it is on a side-street and begins walking purpose-fully to a cobbled gully around the corner. This side road is impossibly twee, with charming flower baskets and cute coloured doors. My mother gasps quietly as we come to the powder-blue door of number 67 and begins to tell me of the staircase at the entrance. She is right: when I look through the letterbox, I see it, long and steep, as well as a row of bikes, which suggests the building is still divided into flats. My mother is animated, telling me how she would drop off my sister and me at school every morning, already wondering how she would feed us when we got home. Her face looks feverish and her eyes are glistening. It is as if she has stepped through a portal and is back on this street corner in the wintry depths of early 1978, when she was a young mother of three children, unable to speak English and living a life of secret poverty in the midst of Hampstead.

She starts recounting vivid details of that time: the warm bread smells from the bakery at the corner of the street, the peeling paint of our front door, and the well-dressed neighbours, who never noticed her creeping presence. She talks of how isolated she felt in this cold new land and of her shock at the crippling poverty. She had never experienced anything like it and felt acute loneliness, with no one to speak to in all the hours we were at school and our father searched for work. All

the while, she had to remain furtive, never drawing attention to herself, stealing in and out of the house so we would not be caught living illicitly in a disused property.

I vaguely remember learning to become invisible too. My sister and I were forbidden to look out of the window for fear of being discovered. It was imperative for us to remain hidden. I often felt cold and hungry but it was such an everyday feature that it was as if cold and hunger were ordinary aspects of childhood. One day, I was given a banana at school and such was my delight that I felt it too special to eat straight away. I wanted to prolong ownership of it so I put it into the pocket of my coat, which hung in the cloakroom. But when I went to collect my coat, the banana had gone and I felt devastated by its loss. Our father would take us for walks around the streets of Hampstead in the evenings, away from our poky room for a few hours, and we would peer into other people's homes as we went, even when we were told not to stare. These walks confirmed our state as outsiders: we were looking in on a warm world of plenty, our nose pressed up against its window, our wonder and yearning mixed with mild offense. Now I see how our early impoverishment left us with a profound and existential sense of non-belonging, maybe more so than our cultural difference, and long after we stopped being poor. The stark contrasts of that year – between our world inside this battered home and the abundant privilege outside it – sank beneath my skin so that now, more than forty years on, I feel an enduring contempt for money but also the shame of that former poverty.

After six months of squatting, we were discovered by the council and housed on an estate in Primrose Hill, an expensive North London postcode that sits at the bottom of Hampstead and was then filled with bohemian academics, not the multi-millionaire celebrities and bankers who live there now. The flat was bare and remained empty at first. For years, I remember

feeling its cold drafts because there was no heating or furnishings that might insulate against the cold. Our appetites were always sharp, our plates always cleaned. And for years after that, when we did not have to ration the heating as strictly and could eat as much as we liked, I still felt the former poverty as a muscle memory or a miasma, never quite left behind, so that I flinched at the sight of food being thrown away, and felt anxious at lights that remained on in an empty room. My mother and father bought us beds but slept on flattened cardboard boxes until they could afford to buy a bed for themselves. Slowly it filled with furniture, but if it began to look like a home, my sister and I remained scared of its chilly corners, and Fauzia told me she had seen two old women knitting and muttering in our bedroom one night.

An elderly woman had lived in the flat before we moved in, and died of breast cancer there, or so my parents were told, though they never passed that on to us as children. All the same, Fauzia wasn't the only one who saw old women in different states of wretchedness drifting through the rooms. My mother saw a pair of small, disembodied feet slowly limping up the stairs; my brother was coming up the stairs one night when he saw an old woman slumped on the landing. I never glimpsed anything, but I felt as if I were being observed by something unseen whenever I was alone and to me it felt malevolent. Perhaps we were all traumatised from the experience of homelessness. Whatever the basis for our fear, we projected it into the dark spaces of this new home. For a while, we saw phantoms in every room.

My mother and I stop meandering along the high street and sit down in a café. We have been going over beginnings and endings ever since Fauzia's death and we continue to chew over the same old questions now. Where did she pick up the TB? She hadn't been abroad for decades, and even then she had ventured only to France, Greece and Spain in her early twenties. Had it been

in Pakistan and, if so, why was it only her who was infected and not the entire family? Could it really have lain asleep in her system for over four decades before stirring lethally to life in 2016? How likely was this and how unlucky did you have to be for it to happen? We simply didn't know, and Fauzia's doctors had said they couldn't tell us.

But now, after our trip to our first, dirt-infested home, we wondered whether Fauzia had picked up the infection there. It seems strange to think of poverty and TB festering quietly in the heart of Hampstead, but perhaps it shouldn't. An infectious-diseases consultant at the Royal Free had told us that 'Hampstead bankers are getting it' as he stood over Fauzia's deathbed. It struck me as an odd thing to say, as if he were offering us misplaced bourgeois reassurance that the disease was not only for 'poor' people – but perhaps it was just a statement of fact and not snobbery. It certainly seemed as if he was suggesting that TB needn't only be embedded in poverty. I found out afterwards that, although it may not be the case in every instance, tuberculosis *is* much more likely to affect the socially deprived, just as it had done in the eighteenth and nineteenth centuries, although even then it was not exclusive to the poor.

Signs of its existence can be traced back to the prehistoric age and it was not uncommon in Ancient Egypt. But its upward trajectory as a European epidemic began in the latter part of the seventeenth century. By the end of the eighteenth century, it was so ubiquitous that you hardly needed a doctor for a diagnosis. It was causing 25 per cent of all deaths at its peak in eighteenth-century Europe, and by the turn of the nineteenth century the global death rate was estimated to be seven million a year, says the physician, Frank Ryan, in *Tuberculosis: The Greatest Story Never Told*. It tore through communities and ravaged entire families.

After 1850, it gradually declined but, even so, there was a growing fear that the disease might destroy Western civilisation,

with London and New York becoming two of the worst affected areas, according to Dr Ryan. By the nineteenth century, private sanatoria had been built for TB patients. But it was not until the Public Health (Tuberculosis) Act of 1921 that local authorities in Britain really began to build state-funded sanatoria in large numbers. These were regarded as fearful places from which you often never returned, isolated sites of death where patients would take strict bedrest for a year at a time.

Dr Ryan describes how TB rates rose again in Western Europe at the beginning of the First World War, and had doubled by its end in 1918. By 1920 the disease presented such a threat that delegations from thirty-one countries gathered at the Sorbonne in Paris and swore to unite and fight it. The pattern repeated itself in the Second World War, when housing shortages and the Blitz pushed people into overcrowded spaces, while the evacuation of city children led to its spread to the countryside. It was the same for every nation involved in the conflict, and by the 1940s it was killing not just the poor but leaders, scientists, artists, writers.

After my sister's death, I discovered that Hampstead was studded with historical landmarks connected to TB, some at an uncanny proximity to our family history. In the nineteenth century, a TB hospital was opened on Hampstead High Street, and when I looked it up, I was astonished to find that it had stood less than twenty doors down – a two-minute walk – from our Hampstead squat. There is scant information on it but I found online local-history accounts: in 1850 a group of wealthy men convened a meeting in Hampstead to discuss the care of the poor who were infected with TB in the area. Hampstead's dry, bracing air and open, green views were believed to be beneficial to sufferers in the earlier stages of the illness, so it was decided that a hospital should be opened in the vicinity. The North London Hospital for Consumption and Diseases of the Chest was established in a mansion at 85–6 Hampstead

High Street in 1860. That building was owned and occupied by Clarkson Stanfield, a landscape and theatrical scenery artist who painted some sets for his friend Charles Dickens's live performances. Fauzia would have liked that, I think to myself, and decide to tramp up the hill to see what has become of it. The hospital took in its first four patients on 5 May 1860, and it had two rooms for paying patients, but the rest of its accommodation was for those who could not afford to finance their treatment themselves.

A restaurant now stands where two-thirds of the hospital would have been, but this part of the building was demolished to make way for Prince Arthur Road, which I walk along. At its end is a handsome white Grade II-listed building named Stanfield House with a plaque above its door. I watch the still house, wondering how many untold stories are trapped between its walls. Who were the impoverished and ill admitted to the hospital? Which of them survived? I walk away dissatisfied, thinking if there could be something here that connects the story of my sister, and our poverty, with Hampstead's past.

In 1877, the hospital committee bought three acres of land further up the hill in Hampstead, towards its steep, thin-aired summit, and a much larger TB hospital was opened in 1881, to which patients from Hampstead High Street were transferred. The former Mount Vernon Hospital is ten minutes' walk from number 67 Hampstead High Street and I am out of breath when I arrive. The Heath was called the 'lungs of London' in the nineteenth century for its big green spaces and there are still plenty now. I stand in a clearing to see miles and miles of the city unravelling below. The sky is large and tranquil from this vantage point, full of flutter and birdsong, even on this bustling weekday. I have read about the hospital and know that it has long since been turned into a gated community of luxury flats, but I am still disappointed when I see the large wall obscuring everything except the top part of the building. A hawkish porter

looks out from a cabin by its gates, which I don't dare approach. It is still in a kind of quarantine, I think. I peer at the long narrow windows and turrets inside, then past them to a thicket of trees at the far side of the grounds. I have read that patients would be led to the garden so they could look across Middlesex and the Surrey Hills and I see the signs of a gap in the foliage where that view may still waver. This is where they would be encouraged to inhale from London's 'lungs' in the hope that the Heath's air would cure them.

I forget about Hampstead and its history of TB until two years after Fauzia's death, when a friend suggests we take a trip to Keats House in Hampstead. It sounds like tourism to me but I go along with the idea just to see my friend and catch up with her over lunch afterwards. I have always known that the poet died of TB, that he was young and desperately poor, but these few facts feel entirely disconnected from Fauzia. And, of course, they *are*, except that I feel a shift when I get there and realise that it's too close to home, despite the distance of more than a century between Fauzia's death and John Keats's. I have cycled to the house and I am alarmed to discover how near it is to other, past 'houses' in my sister's life: it is a very short walk from the Royal Free, or, if you walk the other way, you arrive at the corner of the High Street. It takes another few minutes after that to reach our first, abject, Hampstead home, at number 67.

A looping film in a basement room narrates the facts around Keats's all too brief life. He moved into this house in 1818, just after his brother, Tom, died of consumption – the pair had lived together and Keats had nursed Tom in the final throes of his illness, right up to his death, aged nineteen. It was a time when one out of three Londoners was killed by TB and the move to this part of Hampstead after Tom's death must have seemed like a new beginning to Keats. Many of his friends lived in the area. After moving in and falling in love with Fanny Brawne, whose family lived in the same house with only a dividing wall

to separate them, he realised – after coughing up arterial blood – that he, too, had contracted the infection: 'That drop of blood,' he knew, 'is my death-warrant.' This is what the film explains and I feel my discomfort rising. Unlike Keats, I hadn't nursed my sister. She had met her death alone. I don't feel like dawdling after the reel has finished, but my friend is walking through every room, marvelling at the low ceilings of the scullery and at the four-poster bed that colonises most of Keats's bedroom. He wrote much of his poetry here in a race against his death.

On a wall opposite the bed there is a portrait of Keats drawn by his friend Joseph Severn at his deathbed. It is a melancholy black-and-white image of the poet's face in the final throes of the disease. His hair is dishevelled and his cheeks are hollow. It is an image I have seen before, in books. It seems so much of another time and place, yet I think of Fauzia as I stare at it, of her hair fanned out on the hospital pillow, her deathly fatigue and pale fragility. I want to keep staring at the picture and I also want to turn around and walk away. Keats's deathbed image, his unerring sibling loyalty and the artistic dimension to his illness all hit a nerve in a faint but significant way. The various parts stay disconnected until some years later when I go to Rome and stand inside the actual room in which Keats died. Then the past begins to inform the present, and my sister's story starts making more sense.

Fauzia's TB seemed obvious in hindsight, when I began reading around the illness. Symptoms include chest pains, breathlessness, night-sweats, as well as coughing, weight-loss and fever. Fauzia had had them all, speaking of waking up on bedsheets at home that were drenched wet, and becoming so breathless in hospital that she was wired up to oxygen at times. Her mysterious illness had not been the unnamed, uncharted virus I had imagined it to be. Neither was it a throwback to another era. Until the infectious-diseases consultant at the Royal Free told me that TB

had made a comeback, particularly in London, I had thought it to be a historic scourge, now extinct in the West and containing the kind of tragic romance connected to the too-early deaths of Chopin, D. H. Lawrence, Chekhov, the Brontës, as well as Keats. I had no idea that the world was in the midst of a resurgent pandemic – and a 'pandemic' is what many experts call it – or of the contemporary complexities of its return. Until Fauzia died, I had encountered the illness only in literary consumptives, in the novels of Thomas Mann and Charles Dickens.

What I did know was that this ancient disease had been feared, glamorised, mythologised and stigmatised over the ages. 'The fantasies inspired by TB in the last century, by cancer now, are responses to a disease thought to be intractable and capricious – that is, a disease not understood – in an era in which medicine's central premise is that all diseases can be cured,' wrote Susan Sontag in *Illness as Metaphor* (1978). She examined the 'sentimental fantasies' built around the illness, which were multifarious and contradictory: TB was a symbol of squalid, working-class poverty and an emblem of upper-class refinement. It brought on spells of euphoria and hyperactivity but languor too. It conferred powers of seduction, was thought to exacerbate sexual desire and make death more beautiful. It romanticised sickly femininity, sparked a fashionable cult of thinness and supposedly sharpened the senses of tubercular artists, writers and musicians, granting them greater emotional authenticity and imagination. The medical professions built their own mythologies in the eighteenth and nineteenth centuries, variously relating the disease to heredity or temperamental predisposition, as if it came inscribed in a sufferer's DNA.

Although the illness has lost its cultural mystique and lustre, a certain unbudgeable medical mystery seems to remain. This is a disease that can frequently change its character and can be difficult to diagnose, I was told, though doctors are usually alert to greater incidence in South Asian populations, in cities

such as London, and among those living on the margins of society.

My sister's TB was complex and this was why it had confounded her doctors, we were told. It was not the most common strain, called pulmonary TB, but 'miliary' – or disseminated – tuberculosis, which is most prevalent among babies and children. It begins in the lungs but spills over and is piped around the body, with the ability to attack multiple organs. At its most deadly, it can cause a form of meningitis, which happened with Fauzia.

In *Tuberculosis: The Greatest Story Never Told*, Dr Ryan calls it a protean menace:

> Why should it follow such a malignant course in one person while sparing another? Chance, timing, circumstance, age at exposure, duration and severity of exposure, natural powers of resistance – all of these and more are known to play some part. But more often there is no apparent reason: it is simply a mystery.

And yet, earlier in his book, Dr Ryan writes about saving a patient with miliary TB, which leaves me hovering over the page in shock and wonder. He describes how in 1982 a young woman, aged nineteen, was admitted to his ward with a mystery illness. She had discharged herself from hospital six months earlier, even though she was running a fever and was warned against leaving by her doctors:

> Now she was back with a recurrence of that same illness, gaunt and wasted, with a temperature of 104 degrees Fahrenheit. As I examined her, she asked me if she was dying. Indeed she was. She was suffering from miliary tuberculosis, the most deadly form of the disease . . . I am glad to say that, given the cure, within three days her temperature was normal and she went on to make a full recovery.

I read the passage again and again, overcome by the sense of a miracle occurring. I wonder how that woman felt, returning from the precipice, and where she is now – how she has lived out her extra life. I think of tracking down Dr Ryan, asking him about his diagnosis, her recovery. I keep staring at the page in awe. I realise I am grateful to him, but I feel the sting in it too. It is a story so short, so crisp in its telling, that the difficulty in diagnosis is not even mentioned. It took three days to pull that nineteen-year-old back into life. Three days.

Fauzia hadn't coughed blood into her handkerchief as the poets and artists had once done. And yet – yet – an association had popped into my head when I had spoken to a friend in the week leading up to her death. 'It's as if she has consumption,' I had said, barely understanding what I meant by the word. My friend, a medical journalist, was the one who had mentioned TB in a conversation weeks earlier, and I had dismissed it outright. It sounded so unlikely, so remote, though now the old-fashioned term for the disease had crept back into my consciousness. But I ignored it: if Fauzia had had TB, her doctors would surely have figured it out, and if it had occurred to a medical journalist it would surely have occurred to them.

I'm not sure of the order of things on her last day at the hospital but at some point they found us an imam who could read a Quranic prayer by Fauzia's bedside. After that I left the room, and when I came back a doctor was sitting beside her. He was the first we had seen since the diagnosis and I asked him how the medical team had not thought it could be TB until it was too late. He shrugged his shoulders, telling me he was just a duty doctor, but somewhere along the line his manner changed, perhaps soon after he discovered I was a journalist. He began speaking of the great composers who had featured TB in their works, men like Puccini and Verdi, as if this were a death of which to feel proud. His words carried the opposite

implication, too – that TB was a shameful illness that had to be re-spun as the stuff of high culture to make my sister's a more respectable death. He spoke with such pomposity about the composers that I was staggered into silence and couldn't set the record straight: we weren't ashamed of my sister's illness at all. We didn't need to approximate her dying with high art. Opera couldn't legitimise this tragedy or lessen our shock. We were just thunderstruck that she had died from an illness that might have been cured with a course of antibiotics, had she been diagnosed in time.

4
Sisters Then, 1987

I remember Fauzia at thirteen as a quiet sister in the downstairs box-room, at a remove from the rest of the family upstairs. She was no trouble at home or at school. That changed overnight when one day she didn't come home after school. Evening drifted into night and she remained missing. When I woke up the next morning, our parents were frantic with worry. She returned later that day and it transpired that she had spent the night with a school-friend. I remember feeling confused as to why Fauzia hadn't told any of us or phoned to say she was safe.

There was a great hullabaloo when she got home. My father shouted and scolded but she offered no defence. By now, he had become less bullying yet he was still a hard and distant father to her – my life outside school remained virtually unmonitored while she was watched closely. It puzzled me in this instance that she didn't explain herself, but, all the same, his anger *had* to be a mistake, I thought, because she really was the untroubled sister then, or so she seemed, and I wasn't willing to believe that this was an act of deliberate defiance.

Now, if I had to locate a moment when things shifted, this would be it. Fauzia was redefining her position in the family and her night out was a mark in the sand – an end to her quiet obedience, the start of a progressively bigger stand that resembled a teenage rebellion at first, but then a great protest, which seemed to be fuelled by a never-ending rage and a never-ending sense of injustice. It was aimed at both parents but especially our father, then turned to the world, as if she blamed the universe, too, for failing to protect her in childhood.

From that moment, Fauzia began to misbehave. First, it was restricted to school. My parents were called into the year head's office to discuss her unruly behaviour in the classroom. I was in the year below her, and I'd occasionally pass her in the corridor. She had taken to spending hours putting on make-up every morning, but she still seemed far from a troublemaker to me. I felt aggrieved for her. I was convinced that the teacher who had made a complaint about her behaviour was picking on her, and when Fauzia returned from the meeting, she, too, was angry that our parents hadn't defended her but had sat in the year head's office, nodding.

Some years after her overnight disappearance, when she was sixteen, she was moved upstairs to share a bedroom with me, while my brother was sent downstairs to the box-room. We had shared a bedroom before but this was when we started to become each other's allies. The ardent friendship I formed with Fauzia at this time would set the mould for friendships with other highly expressive, highly troubled women in years to come, although they never matched up to our unassailable sibling bond. All those troubled friends would eventually overwhelm me, and I'd end up feeling as if I was carrying their trauma. The original sisterly friendship with Fauzia wasn't like that. It seemed to exist in its own precious world where our love and care for each other were in perfect balance.

When we became roommates we started discussing all the ways in which our parents had failed us and counting their shortcomings: she spoke of our father's unkindness towards her, and how differently he had treated me. She thought our mother had failed to protect her, even though in early life she had seen her as her only friend and ally. I began to understand how different her childhood had been from mine and I nodded, expressed my outrage, as she described it. At this point, Fauzia held our father responsible for her place in the family, not me. She also described her increasingly low moods, her suddenly

descending depressions, how she felt stuck with all her prospects narrowed, although she was getting good marks at school and nothing outwardly untoward had happened to her. Still, she said she couldn't find a way out of the rut she was in. I remember her saying, 'Help me, Arifa,' often. The plea for help changed as she became more despairing. 'I'm just depressed,' she'd say, and 'It's hard to explain it.'

We'd speak for hours and sometimes come up with an action plan for her future, which seemed to leave her uplifted, but she would be feeling bleak again the next day. In the times I persisted in offering what I thought were solutions to her problems, she'd say, 'You don't understand,' and gradually she became more resigned: 'You can't help me, Arifa. Nobody can.' Still she carried on describing her panic, confusion and sadness. In his biography of cancer, *The Emperor of All Maladies*, Siddhartha Mukherjee, reflects on the power of this kind of speaking:

> To name an illness is to describe a certain condition of suffering – a literary act before it becomes a medical one. A patient, long before he becomes the subject of medical scrutiny, is, at first, simply a storyteller, a narrator of suffering – a traveller who has visited the kingdom of the ill. To relieve an illness, one must begin, then, by unburdening its story.

Fauzia's storytelling didn't relieve her of her illness but I think it helped her define it to herself.

This need to describe suffering, not just as a way to explain and understand illness but also, obliquely, to share its solitary endurance, appears in so many literary accounts of sickness, from Virginia Woolf's 1926 essay 'On Being Ill', which argues for sickness to be regarded as a worthy subject of literature, to Hilary Mantel's powerful writing on her endometriosis, and reflects: 'I am fascinated by the line between writing and physical survival', in a 2010 piece for *London Review of Books*. The

record I have found the most unforgettable is Fanny Burney's searing recollection of her mastectomy in France in 1811, in the days before anaesthesia, which she wrote about the following year. It is simply called 'Account from Paris of a Terrible Operation' and it remains one of the most eye-watering records of pain I have read. The procedure is bluntly described, and contains a butcher's precision. She writes of having her flesh pierced with steel and sliced away by seven men dressed in black. A knife was 'plunged into the breast,' she says, 'cutting through veins – arteries – flesh – nerves' as her breast was quartered, removed, and the bone beneath scraped of its flesh while she lay pinned down and wide awake.

There is a note of anger in Burney's story: she speaks of how the lead doctor issues military-style commands and tries to shoo her female nurse away. 'I resisted all that was resistible,' she continues, but also admits she felt powerless. In some ways, her record of events is a reclamation of power. Naming her illness and giving expression to her experience was an immense act of courage in the nineteenth century, particularly of a largely female cancer that still carried cultural squeamishness until fairly recently. I came across her record about a decade ago, not realising that Burney was in fact unburdening herself to her older sister, Esther, in a twelve-page letter, though it was not for Esther only but to be passed around the family. She writes down every last jaw-clenching detail even while tacitly questioning her desire to remember the ordeal and why its telling should feel so necessary:

> My dearest Esther, not for days, nor for Weeks, but for Months I could not speak of this terrible business without nearly again going through it! . . . – even now, 9 months after it is over, I have a head ache from going over the account! & this miserable account, which I began 3 Months ago, at least, I dare not revise, nor read, the recollection is still so painful.

I recognise the trauma of its telling in her fast-flowing sentences – which seem like a series of hot gasps – and the breathless effort to get them out. Between the lines, I sense Burney's need for a witness, or even a companion through the remembered ordeal. 'Look, sister,' she seems to be saying, 'I can't believe this terror befell me. I can't believe I endured it. Can you?'

During these years, there was no other company I preferred to Fauzia's. She became my closest friend and first companion, a knowing, supportive older sister whose warmth I took for granted but whose pain I felt as my own. I would horse around with my brother, but if I needed advice or reassurance I would go to Fauzia. Despite her depression, she had bottomless optimism when I needed to feel more confident about myself in the world. '*Of course* you can do it, Arifa,' she'd say, in a sure voice, when I felt uncertain. 'Why would you even question yourself?'

Ever since leaving Lahore, I had had a child's awareness of how reduced our family unit had become. We were alone and unmoored in this cold new climate, having left all our loved ones behind. My closeness with Fauzia made me feel more anchored. She helped me negotiate the world, talking me through my university application form in a motherly way, then dressing me up as stylishly as she could and accompanying me to my Cambridge University entrance interview, which I bungled out of sheer panic at being among people I felt were far superior to me.

As the younger sister, I was in awe of her imagination and boldness. I was less audacious in all things – a passive observer of the world where Fauzia seemed an energetic part of it. She followed fashion, dyed her hair and had a series of swanky Saturday jobs in Hampstead, while I lacked her sociability and drive, and would rather have hidden away. But we bonded over books, and her tastes shaped mine to create a language of intimacy between us: talking about a certain novel or artist

became a way of defining ourselves to each other, and to ourselves. It is why the arts feel so much a part of the business of making sense of the world to me now and it is perhaps why, after Fauzia's death, paintings, plays and books did not so much soothe me as help me understand her death, and my grief, which felt more necessary than finding consolation.

After reading a book or watching something on TV that chimed with her, Fauzia would spend hours describing its plot, characters, and how it left her feeling. Much of our closeness was built in this way. She was tireless in her enthusiasm, and I remember listening with rapt attention.

Sometimes, I would feel no need to watch or read what she had described because she had done so in such vivid detail, and I had listened with just as much intensity. Other times she would urge me to, so that we could talk about it afterwards.

I fell in love with the dark surrealism in Dennis Potter's *The Singing Detective*, a television drama about a man immobilised by a skin disorder, which combined his lurid fantasy life with flashbacks to childhood trauma, and which she described breathlessly to me. After that, *Brimstone and Treacle* and *Blackeyes*, which I loved just as much. And when I read her copy of Margaret Atwood's *The Handmaid's Tale*, I found it refreshing that a white Canadian writer had chosen to base a story about religious fundamentalism, bigamy, and the state-sanctioned torture of women in the West. Atwood seemed to be saying that it was too easy to imagine civilisation's unravelling 'over there' in the faraway, Conradian territory of African jungles or even the Afghanistan of 1978, which she had visited and which had partly inspired that story.

It was far more disturbing, and interesting, that she based her dystopian vision of Gilead in the sinister, near-future heart of modern-day America. She even exposed the mechanism by which non-Western cultures are 'othered' with her subtle inversions in the book. There is a scene in which Japanese tourists

visiting Gilead gawp at the handmaids and ask if they can take pictures of them. In that moment, the non-Western tourists are the Orientalists, and the American women the exoticised geishas, of sorts. I understood the radicalism in Atwood's project on an instinctive level and felt her feminism to be far more self-questioning than many of her Second Wave contemporaries, who seemed less intersectional, and in whose worlds we felt we didn't belong.

Fauzia and I would take regular trips to the cinema too, mainly to the now non-existent Odeon in Hampstead, which was a few minutes' walk from the Royal Free Hospital. We went with a gang of school-friends who lived in the nearby tower blocks along our street and watched whatever was playing. On one such trip in 1985, we saw *My Beautiful Laundrette*, which was a 15-certificate film. I was only thirteen but my sister went to buy our tickets while I lingered at the other end of the foyer.

I remember the illicit thrill I felt for having been sneaked in and gearing myself up for an 'adult' movie. It was directed by Stephen Frears and written by Hanif Kureishi – I hadn't heard of either – and the tweeness of its opening – credits written inside a washing-machine drum, which changed at every soapy spin – might have lulled me into a false sense of safety. I soon realised there was nothing safe about this film, with its many jagged edges around identity, sexuality, class and race.

It starts as a drama about how to find belonging in Thatcher's Britain – a question asked not only of the British Pakistani family at its heart but of the jobless white skinheads who circle them antagonistically, looking for *their* place in this new, society-less society. It then takes a sensational turn to become a gay love story between Johnny, a white working-class reformed racist played by Daniel Day-Lewis, and Omar, a British Pakistani who has known Johnny since the age of five – long before he started marching in Fascist rallies. Kureishi had dared to base his romance around same-sex attraction at a time when discrimination was still being

enshrined in law: Section 28 of the Local Government Act would be introduced a few years after the film was released in 1988, effectively banning conversations about same-sex relationships in schools and leading to the creation of the LGBTQ campaign group Stonewall. Even more radically, he had intersected National Front racism with mixed-race passion.

Omar, played winningly by Gordon Warnecke, lives with his down-at-heel father but is from a family of businessmen, some of whom speak wistfully about all they have lost in coming to Britain, and wish to be back with their 'own people'. Others are entrepreneurs, who embrace Britishness and keep their eyes firmly to the future, determined to gain greater toeholds into power and affluence in their new home. Some women cover their heads with *dupattas*, others don't. There is Omar's cousin, Tanya, who wears mini-dresses, flashes her breasts and puts her older uncles in their place. She is a restless, rebellious figure who has all the financial privilege and freedom she wants but doesn't know what to do with it, and is shown, in a closing scene, leaving her corner of South London to find a place in the world, alone. I remember the slow-dawning realisation that here, at last, were people I recognised and identified with not because some wore *shalwar kameez*, or for the smattering of Urdu they speak, but because Kureishi had created a family full of inconsistencies and hybridities that were far removed from the flat, clichéd depictions of British Pakistanis that I had hitherto seen on TV and that I have, sadly, kept on seeing since – big, generic Punjabi families who play bhangra music and are forever grappling with the unresolvable issue of arranged marriage.

Omar's dad is shown pinching his son's cheek affectionately in an early scene. 'I'm fixing you up . . .' he says and pauses, then adds '. . . with a job.' In that small pause, I felt sure that Kureishi was obliquely underlining the direction that a film about British Pakistani immigrants is so often expected to take, before steering us away from it. No one in *My Beautiful Laundrette*

is set up in an arranged marriage. No one gets married and no one wants to. Omar's father is a former journalist who has fallen into poverty and alcoholism, living in a poky flat beside a railway line, while his brother, Nasser – Omar's uncle – has made a comfortable, upwardly mobile life for himself in comparison. I recognised these disparities from within my own family: my father worked on the railways and barely made ends meet, while all three of his brothers had migrated to America and accumulated airy homes with swimming-pools and large, lucrative businesses.

As a family, we were culturally stranded in Primrose Hill. There were no other Muslims or people of South Asian heritage on our council estate, and very few in our primary school, or North London neighbourhood. There were pockets of diasporic communities, mainly Greek Cypriot, around us, but the now-thriving British Bangladeshi community in nearby Euston had not yet formed. My mother found the Asian Women's Centre in Kilburn, and began going there every week just to sit with other women who resembled her, but they were mostly British Indians whose first language was Gujarati, a language she didn't understand, although they were able to speak in Hindi together.

My sister met a British Bangladeshi at school and made a British Turkish friend, while my brother played with boys of Cypriot and Irish heritage, and I became friends with two British Caribbean sisters.

Our local area seemed to remain relatively untouched by the buzzing threat of race hate we saw in *My Beautiful Laundrette*, although it was certainly known to us through daily news reports. But no one chased us down the street and there was no outright intimidation or threats. Our Primrose Hill estate was comprised of mostly post-war, white working-class council tenants, many of whom have since been replaced by young middle-class renters. When George and Marjory, the elderly couple from next door,

came around to meet us, they marvelled at the cardamom my mother put in the tea, and never having seen pistachio nuts before, Marjory, attempted to eat them with their shells on, which led to great mirth in our household afterwards.

Whenever my parents came across people of Pakistani heritage, the encounter never bloomed into friendship, although they would always take the first few promising steps towards it. We would be bundled into our tiny Ford Fiesta and driven to the home of someone who had migrated from Multan, or Islamabad, and the day would be filled with a ceaseless flow of food and multiple conversations criss-crossing the room at once. But we rarely returned to the same family more than two or three times. I remember their ambivalent push-and-pull on meeting a new family: all the hope and expectation of finding fellow Pakistanis – *at last* – who they could relate to, quickly dissolving under the strain of mutual judgements and suspicions that arose out of the differences between them. In his 2011 biography *Pakistan: A Hard Country*, Anatol Lieven observes that while Punjabi culture arguably dominates national identity, Punjabis are not all alike themselves, not even in their dialects. He notes the predominance of regional identity, more widely, above one definitive national character: '. . . there is usually a wheel within a wheel, an identity within an identity, which in turn overlaps with another identity'. Such wheels within wheels become more apparent, I think, within immigrant communities in which sameness means everything and difference becomes glaring.

During my first trip back to Pakistan at twenty-seven, I grew restless in Lahore and decided to travel north. I had heard of the grandeur of the Swat Valley in the North West Frontier province which I imagined was the glimmering entry-point to another, more untouched Pakistan, away from the chaos, commercialism and oven-heat of the Punjab. I travelled by bus to arrive in Muzaffarabad, and the mountainous geography was as awe-inspiring as I had imagined, but what surprised me was

how ethnically distinct the Pashtun people of this region were from Punjabis. They spoke Pashto and seemed to have so many more cultural commonalities with Afghans. Some years later, I went to Azad Kashmir where I met communities who spoke only Hindko or Kashmiri. I had, until then, naively thought that Pakistan was made up of a monolithic Punjabi identity, but like many other countries it comprises several different regional cultures all rolled into one.

Some of this explains my parents' inability, or refusal, to connect to a migrant community in Britain. They were no less 'authentically' Pakistani but they either felt like outsiders among those they met or positioned themselves as such, maybe because they felt burned by their failed attempts to return to Lahore and make a life there. They told us they had wanted to stay in Lahore when we were older, and it explains their shuttling to and fro. But some of it, I think, was down to the dissonances between them; their differing relationship to Pakistani identity may have remained too unresolved or disputed for us to become part of a bigger circle. What made us more isolated in Britain was how categorically they separated themselves from the extended family in Lahore. They didn't phone home or organise family trips there.

'Why did you never take us back?' I ask my mother.

She speaks of the lack of money, of never finding the right time, of being too busy just surviving to think of family holidays. But I have come to my own conclusion that, for my mother, it was too painful to return to Lahore and come face to face with those she felt had terrorised her. Their bullying had set a pattern in our home and Fauzia had suffered for it. I wonder how much my mother's family knew, and how supported, or abandoned, she felt by them, but she does not want to talk about this part of her past with me. The odd relation from her side would occasionally phone or come to stay with us in Primrose Hill, sleeping on the living-room floor for a few nights, but we were shy around them and saw them as strangers.

We had only one family in South London to whom we were related. They were from my father's side and we would trek down to Streatham to visit them for the day. The three of us would love seeing their children – a brother and a sister in the 1980s when we went there, and another sister who came along later. They often had relatives staying with them, and the children wore *salwar kameez* where we had grown out of ours and never found the money to have more made. They had a large South Asian Muslim community around them and were more religiously observant too; their mother spoke proudly of her children having read the Quran in Arabic while we had not even started.

My mother didn't see any conflict between her Islamic faith and the idea that her daughters could wear Western clothes or go out into the world and make their own choices; that family seemed to hold more set views on marriage, motherhood and the place of men and women. My father was not an observant Muslim when he married my mother, although he became more practical in his faith over the years, and both parents would speak to us about Islam, but we were left to commit to our own level of interest. The mother of the family in Streatham reminded our parents of their duty to arrange marriages for all three of us and to teach us the Quran. Every time we returned from their home, my parents fell into arguments that would unravel back to the past. My mother felt that my father's family continued to judge her, and now they were judging how she was raising her children. Each visit was followed by charged silences during the car journey home, and our visits to Streatham became rarer, until they stopped altogether. I never lost touch with their two daughters though, who grew up to be devout, unjudging Muslims, and were a comforting presence at Fauzia's funeral.

Slowly we became insular without a bigger community to lean on, and I felt more and more as if our identities were defined by what we were *not*: we were not exactly British, or Pakistani,

and we certainly weren't British Pakistani, a compound identity created for branding immigrants, it seemed to me, and one that suggested a harmonious doubleness when I did not feel rich with two straddled cultures inside me. If I belonged as a teenager, it was in the in-between. One of the biggest revelations in *My Beautiful Laundrette* was that others did, too, and that this place contained its own richness. Omar's family is made up of people who are caught between many not-quite-whole identities. Some characters pray, others get drunk or deal drugs; some are committed communists, others rampant capitalists. Britain is a country 'we love and hate', Nasser says wistfully, and reminds us that both feelings can exist side by side. Much of the film's subtext explores what kind of British Omar wants to be but it also undercuts any singularity and seems to offer the possibility of being more than one thing at once, both or neither, with an identity forever in motion. This was how I felt towards my own sense of Britishness but which I had never before seen reflected back to me in any film or book.

Maybe because of our cultural disconnection, Fauzia and I had no blueprint of how to be, and how to be women. It was made clear that we weren't to follow the Western secular model because we were Muslims, but we weren't necessarily to adhere to the traditionally Pakistani model either. My parents seemed to want freedom for us, but because they could find so little consensus in their own marriage, they didn't define what they meant by it, so we were left to cobble together our own version of womanhood.

When Fauzia and I spoke of our ambitions, marriage, children, home-making never entered the discussion. Perhaps we had been wordlessly warned off by our mother's unhappiness. She subtly pushed us away from all things domestic, insisting that cooking and cleaning were pointless distractions so she was not going to teach us how to make traditional Pakistani food,

even though we were keen to learn. She half-heartedly let us clean up after ourselves, then quietly took those chores back from us. Cooking and cleaning weren't our job, she told us, without ever saying it, and dreams of marriage and motherhood alone were not only misguided but deadly dull in comparison to the bigger lives we might have instead.

Her own wedding in the autumn of 1969 presented itself to us as a defining moment in her life. We saw it through a stack of large black-and-white wedding photos, printed on paper so thick that it felt like glossed cardboard. In some images, our father is in a suit, bow-tie and shiny black shoes, appearing far younger than his almost forty years. He looks straight ahead while our mother's gaze is cast downwards, as was the expected pose for a bride. She has a jewelled *tika* pinned to her hairline, and is dressed in a floor-length wedding *gharara* with a tight bodice and flowing layers of skirt beneath. In many of the pictures, she is surrounded by other women who glitter just as brightly in jewels and glitzy outfits, so that it seems there are infinite potential brides in the picture. Colour and shine bounce off them, even though they are in black-and-white, and they look so much of their time, with big 1960s beehives and heavy strokes of eyeliner. When I see my mother staring out of these pictures, I see a twenty-five-year-old playing the part of a traditional bride, with her demure, downward gaze for the camera, but also an excited young woman, who has bought into the great auspiciousness that the *gharara* and heavy jewellery marked for her future life.

As children, we stared at these pictures in awe, not only because our parents looked so fresh-faced but also because of their ornamental glamour. I have grown up knowing that the 'Asian wedding' is an important day, especially for the bride, but these photos look closer to theatre – a glittery collective performance. I have felt this at 'white weddings' I have attended too, with the virginal frocks and declamatory oaths. There is

73

something very moving about the ancient ritual and ceremony in weddings, Asian or otherwise, but they revel in their anachronisms, too, and brides particularly seem to me to be knowingly playing an outdated part for the day. It makes me think of Angela Carter's ideas around femininity and role play; in *The Invention of Angela Carter*, her biographer, Edmund Gordon, says that Carter viewed femininity as 'part of a culturally choreographed performance of selfhood'. Her characters, he adds, wear their personalities like fancy-dress costumes, and this idea of the feminine as a sparkly outfit that can be put on and taken off at will is a fitting analogy for the gown that women wear to become the archetypal 'beautiful bride', only for it to become redundant the following day when they take it off and leave it in a box for the rest of their lives. But maybe my mother knew better because, the moment her wedding was over, she took the heavy burgundy and gold *gharara* to the tailors in Lahore and had it re-fashioned as a more practical *shalwar kameez* that could be worn in daily life.

There is little of the wedding jewellery left now. My mother says she brought heaps with her as part of her dowry, but when she and my father should have been contributing to the thronging family household in Lahore and were fast running out of funds, she sold almost all of it to pay for our upkeep. She kept back two sets of necklace and earrings for Fauzia and me, one for each daughter on her wedding day, she says. My sister and I would ask her to fetch them occasionally, then open the velvet boxes to see the jeweller's name, 'Fantasia', inscribed inside. One necklace was faux-Egyptian, a geometrically designed choker made of emeralds embossed in gold, and the matching large triangular earrings pulled heavy on our lobes when we put them on. The other was more Mughal-era in style, with myriad gemstones and pearls dripping off a large circular necklace and hooped earrings.

Fauzia and I would stroke the velvet boxes, touch the gems

and discuss which of the two sets we wanted to have when we were old enough. But however beautiful they were, their greater meaning was lost on me. I saw them as exquisite artefacts – a 'fantasia' indeed, and one that so many little girls are brought up to wish for. Fauzia ended up with the set made of seven gemstones while I took the emeralds. Neither of us married, so the jewellery remained in bottom drawers, occasionally brought out in our adult years for fun. Then they were touched, tried on, and marvelled at for the gap that had grown between their original significance on my mother's wedding day and their status now as precious baubles.

We didn't grow up with the prospect of the big Asian wedding on our horizons, though our mother had taken great pains to preserve the beautiful accessories for it. There was little talk of our future lives as brides and no one reminded us of marriage. What is extraordinary is how my mother managed to convey the message – without ever openly saying it – that our only real responsibility, as women, was to find a profession. So it shocked us all when Fauzia told us that she wanted an arranged marriage at the age of eighteen.

Through her teens, Fauzia had become increasingly interested in dressing-up, spending hours experimenting with make-up, poring over fashion magazines, mixing up her look. Where I remained resistant to anything even faintly feminine – I wore androgenous or masculine outfits until my mid-twenties – she embraced all that was feminine as a way, I think, of re-imagining herself. She would come home with flicks and highlights in her hair, then have it chopped off in a 'pixie' cut. *Dynasty*-style shoulder pads were put on one day then ditched the next for Dr Martens and suede waistcoats. She assumed the heavy-lidded look of the New Romantics, then replaced it with lip gloss as shiny as patent leather and long hard lines of blusher. It was an expression of creativity and also teenage experiment: she became *this* kind of woman, then *that*.

Now, it was as if she wanted to play the part of the bride. Perhaps she was testing the family or maybe she wanted to try it on for size. Either way, her request was out of the blue and wholly out of character. When I talked to her about it, she spoke of it as a solution – she was becoming depressed, feeling she could not make clear choices about her future, and this offered a way out of the fog. In *The Handmaid's Tale*, there is a fearsome character called Aunt Lydia, one of the enforcers of Gilead's new regime. She breaks formerly empowered women to turn them into quiet, captive handmaids, and in an attempt at persuasion, she talks to them about redefined notions of freedom. 'There is more than one kind of freedom. Freedom to and freedom from. In the days of anarchy, it was freedom to. Now you are being given freedom from. Don't underrate it.'

Aunt Lydia is little short of a terrorist, with her electric cattle prod and her terrifying physical punishments, but there is a kind of truth in what she says. 'Freedom to' is the autonomous state we all strive for, on principle – freedom to make our own choices, be whoever we want – but maybe 'freedom from' is no less valid as a life choice for some women. In marriage, a woman can be led by a man, protected, cared for while perhaps ceding bigger decisions to him, and then have the lifetime's distraction of raising children. I can see why, to my sister, this surrender might have seemed like an answer, whatever restrictions it brought with it.

But, of course, it would have been a disaster if Fauzia had got married at eighteen – I could see that, even then. She would have rebelled and the marriage would have lasted five minutes. My mother wouldn't brook a discussion and simply said, 'No.' I think she knew the idea was born of desperation but I also think she was so adamantly against it because she had placed all her own lost hopes of a big, adventuring life on us, and an arranged marriage was far from that ambition for her daughters. Now I am grateful that she steered us away from the more

fearful position of seeking 'freedom from' and pushed us towards the 'freedom to' as women, but it brought a scary responsibility with it. Our parents were still often fighting or lost in their own world, so we were mapping out our futures alone, making choices with very little guidance. It was easier for me because Fauzia was holding my hand and leading the way, but who was leading her?

Binge-eating became part of my closeness with Fauzia as a teenager. I don't remember the first time it happened, or why, but I was around fifteen. Until we started bingeing, we had both shown little interest in food and I had always been a thin, fussy eater. Now we began going to the supermarket around the corner in the evenings to buy ourselves the sugary things that would have been regarded as hallowed treats not so long ago. We bought them with our pocket money and borrowed ahead of next week's from our mother. The eating was a very deliberate act of excess: nine or ten chocolate bars to be consumed at one time, cakes, sugary drinks, ice-cream tubs, a bag of food easily enough for a family. Our brother would occasionally join us but he lost interest, while we carried on until it became a daily habit and then an unstoppable compulsion.

At first, it was a case of following Fauzia's lead. We were creating our own sisterly bubble and part of that involved tearing away from our parents, forming our own rituals, setting ourselves apart. We talked and watched TV as we ate. It felt comforting to be doing this together. My father rarely sat with us in the living room, and whenever my mother came in we became snarky or conspiratorial and she never stayed for long. At the time, I thought she was coming in to keep an eye on us, or tidy up, but now I wonder if she was trying to become better friends with her two recoiling daughters.

We would go into the kitchen to appraise what she had left for us on the stove – because of our various tastes she made

more than one dish, so a vegetarian meal for me, pasta for Fauzia, a curry for my brother. We would sometimes eat what she had cooked but more often not. Maybe it was teenage rebellion, or a way to assert our autonomy, that played itself out in the contest between feeding ourselves and being fed these homemade dishes. We pitted ourselves against their moderation, turning away from their wholesome sustenance in place of our trashy alternative and its extravagantly empty calories. We had stopped eating together as a family years ago because of my father's shifts – he had constantly changing work patterns, which prevented us from coming around the dinner table together, so we took to eating whenever we felt like it, and less and less with our mother.

Although I had followed my sister's lead, the bingeing became its own thing over time, removed from that initial act of sister-hood and tapping into the confluence of my own deeper emotional upsets: perhaps a delayed response to childhood poverty as well as the trauma of migration. It began to fill a void I didn't realise I had, and then created new holes as fast as filling the old ones. Within two years, we were both eating recreationally, addictively, for hours at a time most nights. While Fauzia began putting herself on fad diets and speaking of her body with self-recrimination and loathing, I zoned out of mine, feeling dissociated from its sudden largeness and even a little relieved by it.

Then, aged nineteen, I went to Edinburgh University and when I returned home after the first term, I had lost all the extra weight. I had stopped overeating without noticing at first. There were so many new excitements in being away from home, and when I saw the weight-loss, I felt pleased. I was not the sloth of those troubled years any more, I thought, but the bingeing set an exhausting emotional pattern, though I never fell in as deeply as Fauzia. I simply over-ate, and then under-ate, spending most of my twenties in cycles of deprivation and

excess, which left me vacillating between a healthy weight and a hollow look that might have passed for normal. To eat in this way required effort: first to binge, then to suffer the physical effects, and finally to summon the energy to undo the damage before looping back to the beginning. It left my body in pain: ankles swollen and a racing heart from the sugar highs and swooping sedative lows. It took up inner resource and head space to go hungry too, while still functioning in the world.

At times, it threatened to take over, and I saw how I could give in to it entirely. When I was in its grip, it was what I preferred above the company of people. Sometimes friends commented on my weight-loss, and while I never hid my compulsive eating, I didn't explain it either, so I simply looked like someone who enjoyed food. There were friends who didn't notice or comment, but some expressed shock, as if the sight of a woman with a large, unrepentant appetite outraged their sense of decency.

It brought its own neat divisions too: the days of control and self-denial were a respite from the internal chaos of the binges. Everything felt calm and orderly. I counted those days, hoping they would extend to at least seven or eight, maybe even two weeks, before the cycle of order ended. The compulsive eating that followed was like a shadow life, carried on late into the night, unreal and set apart from my 'real' orderly existence. It was a constant reminder of my failure, but also, ironically, a warm, welcome blanket of numbness, which felt like exhaling before I held my breath again. In my mind, I was two people: the fleshy and the lean, the bad and the good, and both those states held their value.

But I guarded against my greatest fear: that I would one day be in the hold of a permanent, and terrifying, loss of control. I went to great lengths to manage it over the decades so that it co-existed in its own parallel world, stubborn and unremitting but also much smaller than Fauzia's. If I began binge-eating out of low-level teenage depression, Fauzia ate compulsively out of

a far graver hurt. Her disorder grew bigger and became all-consuming, manifesting as full-blown bulimia and anorexia.

I have tried to pinpoint exactly when it began to engulf her. In the letter she sent to our aunt Nilofar in 1987, after our maternal grandmother died, she described her life plans in excited tones. She was just about to begin her A levels: 'School will start again in September. I have great plans for the future.' It is meagre evidence that, at sixteen or seventeen, hope in the future was intact. But by then she was already in the early throes of her battle with bulimia. It collided with depression and culminated in an attempted overdose at the age of twenty when my brother found her in her bedroom, realised she had taken boxes of painkillers, and my mother called an ambulance. She returned home, pale and in pain after having her stomach pumped, but she carried on bingeing, purging and falling into ever more dangerous lows.

She never hid her compulsive eating, so everyone in the family became aware of it but seemed not to know how to fix it. She no longer waited for the evenings to get her sugary bag of food. She would start eating early and fall into a black hole. Then she was ready to begin again by evening. She went from binge-eating most nights as a teenager to diet pills in her twenties and then, later on, ever more extreme eating and fasting, along with dramatic changes of shape, from almost twenty stones to under seven. As the years went by, there was a re-sculpting of her face too: she got her lips injected with Botox and shaved her eyebrows off to tattoo arching black lines across her forehead. It seemed she was remodelling herself, with every last detail being overhauled.

Fauzia had been restricting her intake in the weeks leading up to her death and I learned afterwards that tuberculosis gave its sufferers a suffused radiance – the consumptive glow that men but especially women of the nineteenth century cultivated in an era that fetishized the illness. The TB look was pale and gaunt

but emanated a shine, and increasingly it was elevated into high culture and fashion. In *Consumptive Chic: A History of Beauty, Fashion and Disease*, Carolyn A. Day describes how the disease, characterised by coughing, emaciation, diarrhoea, fever, phlegm and blood, and connected to urban poverty and filth, came to represent a sinister new paradigm of feminine beauty and fashion in the late eighteenth and early nineteenth centuries. Visible signs of TB – pale skin, dilated pupils, stooped shoulders and pronounced clavicles – took on a creepy desirability that the healthy and robust tried to emulate. It was believed to confer beauty on the sufferer, alongside greater sensitivity, spirituality and intelligence – in its middle- and upper-class incarnation, at least. These misconceptions prevailed even in nursing circles, Day points out, citing an entry from Florence Nightingale's *Notes on Nursing* (1859) in which she writes: 'Patients who die of consumption very frequently die in a state of seraphic joy and peace; the countenance almost expresses rapture.'

An illness that beautifies as it destroys seems to me like the height of misogynistic conspiracy, yet I can see why it became so morbidly romanticised. In grave illness, Fauzia's weight was recorded every morning in her medical records and I saw the digits on her file decreasing day by day, from 55 kilos to 54, 53, 52, 51. But if her cheekbones were sharp and her bones jutted, her skin shone. Her eyelashes looked dewy as she lay unconscious. Every day, the nurses brushed her hair. It gleamed on her pillow. It was a strangely unsettling sight, to see her looking so beautiful in the medical tranquillity of her life-support machine and cannulas. It disturbed me more to think that her lifetime's quest of seeking perfection in thinness had ended in this illness, with its unsavoury backstory of desirable, flesh-eaten emaciation.

The hollow cheeks and bony bodies that women aspired to in the nineteenth century are not altogether unlike the eaten-away flesh of 'heroin chic' made popular in the 1990s, or the

waifs in some fashion magazines and on catwalks now. The myth that ties the cult of thinness to the epitome of feminine beauty still feeds us, and it fed Fauzia. When she became thin, she seemed far less angry, as if she had managed to silence her rage and was relieved at last to be the successful version of quiet femininity that the world valorises above the failed 'fat' woman. But for Fauzia to manifest this ideal required a severe punishment of the flesh, a starvation that left her pacified and weak.

I have wondered if her eating disorder, in part, was driven by a continued angry disobedience. Maybe her bigger body was not, as she saw it, a sign of failure, but a symbol of defiance. She binged openly, and it seemed at times a flagrant rejection of the kind of woman the world found perfect. Her furious, open and uninhibited overeating had an exhibitionist quality: she wanted everyone to see it. Maybe on some level that larger version of Fauzia was an avenging fury, refusing to shrink to smallness and silence ever again.

I am on the first floor of a hotel terrace, looking out to Margate Sands. Neat rows of waves frill beneath a huge white sky. It is a calming view that from this distance has a painterly stillness. In the far right-hand corner is Turner Contemporary, the steel-and-glass gallery exhibiting this year's Turner Prize shortlisted artworks, which I have come to see. Past it are beach-huts selling organic ice-cream, vintage clothes and oysters. They stand on a long, narrow tip of rock that juts past the shoreline and looks like a boutique pier in the water. The amusement arcades and tower blocks just outside the railway station are familiar from my family day trips here in the 1980s, but the upmarket scrum around the art gallery is nothing like the Margate I remember. The seaside resort was one of our favourite places to visit as children, partly because it didn't have Brighton's stony beach and took longer to get to, which gave us more time to dig into the mountain of sandwiches we'd make for the journey. In the

early days we came by train because British Rail offered employees' families free travel, but later the five of us would squeeze into the Ford Fiesta and become boisterous with anticipation on the way.

There were lengthy preparations for these days out, but as we got older, our excitement dimmed and we spoke of *another* trip to Margate with eyeball-rolling teenage ennui. We knew we were following a very British tradition, but we weren't quite a part of it: all our neighbours went to Brighton or Bognor Regis for their summer holidays, but our trips didn't resemble theirs. We didn't run into the sea in our swimming costumes or spend the day sunbathing. Sometimes we skimmed stones. Occasionally we took off our shoes and splashed around in the shallows. We'd see towels lying snugly beside each other on the main drag of the beach, but we'd invariably walk around the edges of the town and find a bench on a deserted spot, far away from the sand and its sardine-packed sunbathers, before we began to relax and enjoy ourselves.

Our family photos from Margate are peopled by no one but us. There is one set, all taken on the same outing, when Fauzia and I are in our early teens. We are wearing matching pink 1980s padded jackets that we had bought at Walthamstow market. She has her hair pinned up and mine is short and boyish. My father and mother still have thick black hair and my brother is a small, skinny boy in a baseball cap. We all look swept awake by sea air. We are holding plastic fishing nets we'd bought from a beach-side shop, but we hadn't known what to do with them so brought them back to London unused. We had been in Britain for almost a decade and were still learning how to be English. Where my parents tried to embrace the traditions around them, Fauzia and I were less sure about who to count ourselves among: our neighbours, who had days out like this one, or the wealthier girls at school, who spent their holidays in rural France.

I have looked at these photos many times, but when I flick

through them after Fauzia's death, I am struck by how happy we look – far happier than I remember feeling that day when we had minded leaving London to come to this outpost again. Were we a happy family? We were certainly not a harmonious one. My parents remained in a permanent state of battle, with only occasional ententes. On a day like this, there would be bickering in the car, followed by a bust-up and thorny silence, but in between, there was also some ribbing and laughter. It was a version of happiness.

Standing in front of this gentrified view of Margate, I feel far removed from that family, spilling out of the hot Ford Fiesta. My plan is to see the Turner Prize show, then get an evening train back to London. I stop at the gallery's café first, sitting at a window table. The view outside looks like a Turner seascape in motion: the waves are bouncier, with the wind behind them. I sit staring at it for too long, then realise that the gallery is soon to shut, and rush to the exhibition upstairs. A lot of the entries are built around recordings and I flit from room to room, putting on headphones, listening in ten-minute snippets. I whizz through three entries and barely have energy for the final one, which is by Tai Shani. Her piece, *DC: Semiramis,* is distributed in many parts across a large white room with a back wall painted in umbilical red. When I read around the work afterwards, I discover it was inspired by Christine de Pizan's *The Book of the City of Ladies*, an early fifteenth-century Renaissance text in which the notable women of history are situated inside a 'walled city, sturdy and impregnable' as protection from the prevailing misogyny of the time. Shani has taken that text and blended it with ancient mythology and science fiction to create her own allegorical city of women.

There are two central sculptures, red and stringy, that look vaguely visceral, like large pieces of human intestines, hanging from the ceiling. Or they could be long broken arms. A dismembered hand rests on the floor at one end of the room, its fingers

and palm turned up, and a circular mobile that looks like a single Cyclops eye dangles at the other. Below the mobiles, on the floor, there is a model of a city that resembles a museum miniature showing how a mighty bygone dynasty once lived.

I try to connect the scattered parts. They could be dislocated pieces of human anatomy: gouged eyeball, severed hand, boneless arms and curling innards. But there are other bits – foamy, circular and futuristic – that seem like an interstellar landscape of unidentifiable particles. A gallery attendant near a screen hands me headphones and I decide to listen, for a few minutes at least, to get my bearings. The screen has the floating face of a woman, part-human, part-android, who is speaking in a soothing stream of words. The tone of her voice is ambient and accompanied by synthesised music. I close my eyes as she begins a story about a woman who is kidnapped, I am not sure by whom, and I find myself forgetting details seconds after hearing them. The woman is mourned by female companions, who have been unable to save her and are so overcome by sorrow that they martyr themselves, or that is how I remember it. My ears prick up at their sacrifice. I think of Fauzia, partly because I wonder what she would have made of this room, but the picture of absolute selfless sorority that the story has sparked prods at me too. I feel a bloom of discomfort and realise, slowly, that it is guilt.

I tune back into the story but it has moved on. The monologue is undulating, one thought swallowed by another, its ebb and flow repeating, like the waves outside. I wait for the sorrowful women to return and be rewarded for their sacrificial loyalty, but they do not reappear. The recording ends as the gallery announces its closure. I am disappointed. I would like to stay and listen to it again, pressing pause or rewind so I can resist its hypnotic flow and make sense of the women's actions. The story and its effects don't leave me for months afterwards but the details blur. Was the voice speaking of a goddess or a

mortal being? Was the central woman kidnapped or killed by her enemy? And were the other women her servants, performing a voluntary sacrifice out of love or submitting to the servile obedience required of them, like the human cargo of Ancient Egyptian slaves packed into the tombs of dead pharaohs to die with them?

No, they weren't slaves. They had sounded like a fierce band of warrior women, total in their devotion, and this was what had made me feel ashamed. I had loved Fauzia and tried to save her but I couldn't. I had lived, and thrived, as she remained stuck in sorrow. I was not the sacrificing sister. Even now, when the catastrophe of her death had happened, I carried on living, and thriving.

But that wasn't quite right either because something *had* shifted. As the shock ebbed away in the months following Fauzia's death, an insidious kind of darkness began to rise and threatened to envelop me. There was no conscious desire for self-destruction but, slowly, I started to feel that, in her dying, she had left me less like myself and more like her.

We had grown increasingly distant over the decades and we barely knew anything about each other's lives towards the end of Fauzia's, beyond the information my mother relayed between us. But a strange thing happened when we began clearing her Warren Street flat: I saw myself in all her things. Her books were the books on *my* bookshelves; her furniture and jewellery looked so much like mine. After years of defining myself as her opposite – she was unstable, histrionic; I was sensible, undramatic – those categories conflated and collapsed.

When I looked at myself in the mirror, I saw Fauzia's anxious eyes staring back. I recognised the set of her grimace around my mouth. I remembered her nails when I looked at my hands and thought of her feet, bigger versions of my own. It was a trick of the eye, I told myself, or a trick of the mind brought on by the anguish of her death. Then, I sent my mother a picture

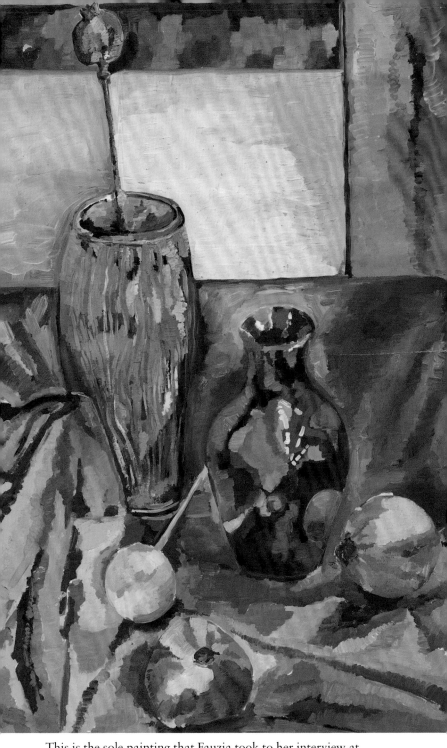

This is the sole painting that Fauzia took to her interview at
St Martin's (now Central Saint Martins College of Art) in 1989,
which she later gave to me at the age of 19.

These lovers are painted in watercolour and the work is layered with sequins and thread. This was part of her coursework at Camberwell College of Arts and made in the last few years of her life.

Fauzia embroidered this ornamental cushion for me years before she became ill. It was only after she had died that Fauzia's art tutor at Camberwell, Kelly Chorpening, noticed that Adam and Eve's faces are blotted out with black thread.

This series emerged from Fauzia's portfolio after she died and it is filled with humour and joy. Each woman has a cat nearby as well as a mirror and seems to be enjoying the act of gazing at herself or being gazed at by the viewer.

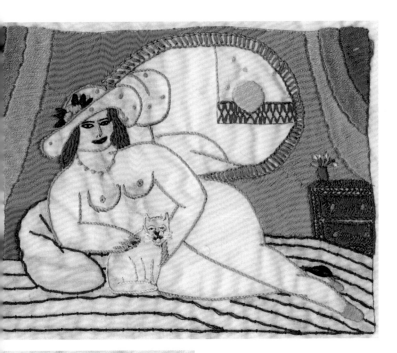

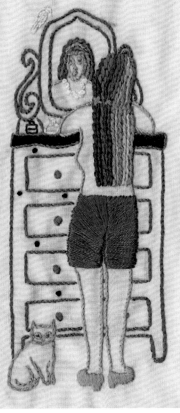

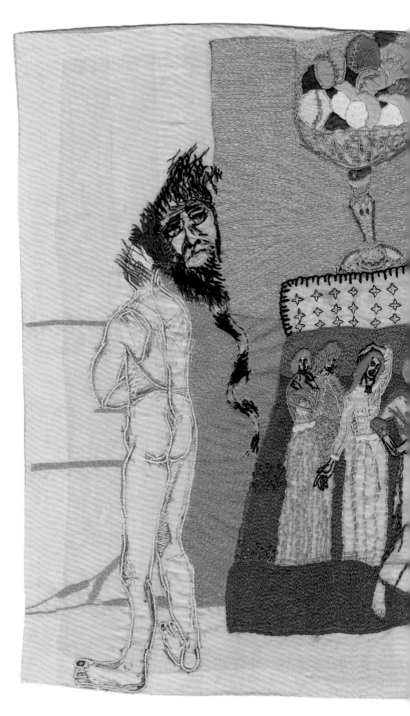

This dense and complicated embroidery resembles a painting in many ways, with what appear to be figures in various emotional states, mixed with still li[f]

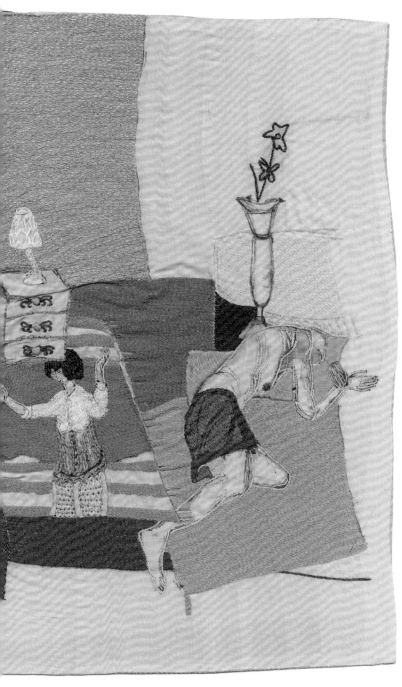

'auzia showed it to me a few weeks before she died, along with the rest of her
ortfolio, which I hadn't seen before, and I found it so beautiful that I asked if I
ould have it.

This self-portrait collage of torn pieces of paper was
made in the last years of Fauzia's life.

of myself in a new pair of glasses and she messaged back to say that I looked just like Fauzia. Until that point, she had only defined us by our differences, and it made me wonder whether our childhood positioning had been disrupted by her death and shifted my place in the world. My mother said, more and more, how I resembled Fauzia in this moment or that, as if she had begun to see both her daughters in one.

About a year after her death, I felt a physical depression descending, which was paralysing in its effects. I became foggy-headed and drained. I moved slowly and became badly coordinated, fumbling and tripping. Ordinary sounds hurt my ears. Speaking hurt my chest. I fell into miles of black, dreamless sleep at night, which felt exhausting to wake up from, even after ten, eleven, twelve hours. Everyday tasks – brushing teeth, washing plates, climbing stairs – became overwhelming. It might have been a result of grief but it felt more like recognition of something in myself that I had beaten down into non-recognition a long time ago, and never dared name for fear of becoming stuck in its depths. It reared up now, dangerous but distantly familiar, out from the dark place where it had lain while Fauzia was alive to show itself as a thing inside me, too.

And then my compulsive eating came back with an almost vengeful power. I wasn't concerned at first and even felt comforted by its return. I had carried on binge-eating until something had shifted in my late thirties. The cycle of eating compulsively, then going hungry, had become exhausting and I had got less good at restoring order after chaos. The restrictions felt impossible and the bingeing hurt too much.

Until then, I had only ever bought ready-made food or warmed things up at home; I cooked nothing because I didn't know how. Now I began making the simplest dishes. My mother gave me small bags of ground coriander, turmeric, chilli and cumin, and I would phone her for lessons. She was willing enough at first but the cooking lessons came to feel like a tug of war: she was

unable to remember proportions and ingredients, even for dishes she had been making for decades. She said it was because she had never written down recipes and that Pakistani food always had to be tasted along the way, not measured out. I couldn't accept this reasoning and felt her refusals to be the same unwillingness to pass on her domestic wisdom she had shown when Fauzia and I had asked her to teach us to cook as teenagers.

We battled on until I gained a grasp of the combinations of spices for much of the Pakistani food she had made in our childhoods. At first, my food tasted nothing like hers, but gradually I began to recognise the flavours, and as I gained in confidence, I adjusted the measurements to suit my tastes. She had always cooked with painstaking diligence, chopping onions with meticulous symmetry and watching over her stove for hours, but my food was slapdash and messy: vegetables were wonkily cut and left in the pan to cook while I got on with other things. Sometimes I would find them burned, their chars embossed on the pan. Other times, when I served my mum a new dish, she would tell me it had too much cumin or that I hadn't let the onions fry long enough before adding the other ingredients. I was quietly surprised by how thoroughly she understood taste and flavour, and wondered why she had guarded me from all this precious knowledge before now.

The cooking became an excitement and my mother became wrapped up in it too, urging me to broaden my range of recipes, enjoying the bold, brash contrasts between her cooking and mine, and occasionally, to my surprise, asking how I had made a curry she had taught me but that tasted so different from hers. I pushed on, learning recipes beyond my mother's. I crammed too many friends into my home and made double the amount of food that could possibly be eaten. I felt the joy of eating too much of the food I had spent hours making, and it began to feel like a more ordinary act of over-indulgence. Cooking became the more wholesome part of eating and I

made simpler, less showy dishes that felt soothing to prepare for myself. Finally, eating became less an addiction, more a pleasure.

But now in my forties, the urge to fill myself with high-fat, high-sugar food was back, and no amount was enough. For a while, I let it happen because it felt like an empathetic gesture; it was what I had to remember Fauzia by and what we had done together when we were at our closest. It was one side to our lost sisterhood. I thought it would fade after the first year of its return but it began to feel more necessary and aggressive. It had never felt secret or sordid before, but it did now, at this age, and scarier too, engulfing me with its endless famish, damaging my insides. I was not only eating but being eaten, and I feared this monstrous compulsion would finally drag me down and destroy me, as it had done Fauzia.

5

Rome, 1990

Fauzia's first big depression came in 1990, though none of us recognised it as such at the time. She had dropped out of her fine-art foundation course at Saint Martin's, the art school in London that has since been renamed Central Saint Martins, even though the course had meant everything to her. She was nineteen and already talking about the mess of her life. She was doing less and less, in a bathrobe most days and dragged down by paralysing lows. The depression seemed unknowable and monstrous, lurking in corners and ambushing her just when she seemed on firmer ground. While my brother and I were studying, she was buried in its sludge.

Over Easter in 1990, some friends invited her on a trip to Rome. It must have struck a chord because she got excited and my mother scrabbled to find the money for the plane ticket in the hope that it would take Fauzia out of her fug. She came back to London with her spirits lifted, at least for a while, and spoke as if the irrepressible, joyous beauty of Rome had burrowed beneath her skin and entered her bloodstream. The art she had seen had healed her, it seemed. She described the magnificence of the city and the indelible marks emblazoned on it by its Renaissance masters. I had long forgotten that trip until we cleared out her flat and gathered up her artwork. She had returned to art school, at the age of forty-three, after decades of being ill, and she was midway through a fine-art degree at Camberwell College, at which she was excelling, when she died.

Fauzia's love of fine art separated us as sisters, even at our closest. She had found so much of the world in it in a way I

never understood. In the summer of 1989, she finished her
A levels and went for a late interview at Saint Martin's. She
came home jubilant because they had offered her a place on
the strength of a single oil painting, which was highly unusual,
and for a while she felt validated. But it didn't last. She was
surrounded by entitled, confident eighteen-year-olds. She was
neither of those things and over that year all her self-belief
leaked away.

The blanket of depression that came after she dropped out
of her foundation course lasted decades and sabotaged so much
of her creative life. The art never stopped mattering, though,
and she talked of a return to it. But she was scared, I think, to
embark on that journey in case she failed. And then, one day,
when she was in her late thirties, my mother convinced her to
go to a sewing class at the Asian Women's Centre, in Kilburn,
although my sister had never before shown an interest.

'Why did you think it would help?' I ask my mother.

'She was so lonely and lost,' she tells me. 'The sewing classes
had helped me when I had felt at my lowest and I thought maybe
they could help her too.'

Fauzia sat in a corner of the class, listening to the murmuring
conversations around her and tried out her first basic stitches.
Most of the women there were of retirement age and talked in
Gujarati, Hindi or Urdu. The embroidery was something they
did alongside the chatter. They accepted my sister among them,
but while they talked, she stitched with a fast-growing profi-
ciency and an imagination that surprised everyone. Soon the
older women were waiting to see what she had worked on at
home that week and copying her designs.

Slowly, the embroidery brought her back to life, first becoming
a habit and then a passion. When we gathered her art together
after her death, I began to look for clues to her inner world
and an odd thing happened: Rome peeped at me from her
embroideries, sketchbooks and oil paintings, and I remembered

her trip there as a nineteen-year-old. She had gone with a group of teenagers from Opus Dei, a personal prelature within the Catholic Church. These girls had taken her under their wing in London, possibly with a view to converting her – I can't remember how or where she met them. She came back from Rome unconverted to Catholicism but in love with its religious imagery. She told me about seeing the Pope's Easter appearance but in the anthropological tone of a cultural observer. She spoke very differently about the Sistine Chapel. She blazed with feeling as she described it. She had bought poster-sized reproductions of Michelangelo's *The Creation of Adam* and *The Fall and Expulsion from Paradise*, which are emblazoned on the chapel's central ceiling vault. I was seventeen, still living at home, and I remember her unfurling those posters again and again in the months following her trip to Rome, as if she were trying to relive seeing them for the first time.

But looking at her work after her death, I was puzzled by how much of it was filled with images of the Madonna and the Crucifixion. This was a distinctly Western artistic tradition to which I knew she was not in thrall and I wondered why such stained-glass art would matter to a person who hated conventional orthodoxies. Then I opened a sketchbook with religious images on one side of the page, and our family on the other. The positioning was repeated throughout the book – images of my mother, my eldest niece, my sister-in-law and me – and it seemed as if the sketches were working out parallels between the biblical family and her own, with all the suffering and darkness in both. Other embroidered compositions tied Eastern and Western traditions together, with Christian imagery set against classical Indian, devotional, 'Bharatanatyam' dance scenes.

I began to see how much of her sewing was about identity and the complications of who she was in the world. I also saw a part of her I hadn't often seen in life. She was always sad,

always regretful, but here I saw a joyousness that seemed at odds with her pain. There was an embroidery of delicately stitched angels, cherubs and animals, set against graffiti. She had sewn on sequins and tiny pearls with pastel threads. One phrase stitched in cursive so tiny it seemed to want to disappear said 'little sewing girl', which brought sudden tears to my eyes. Another was stitched in dainty pink-and-purple thread and jumped out at me: 'I didn't know how to be assertive so I just raised my voice and said the same thing.' It pained me to realise how fear and timidity lay behind behaviour that the world might misunderstand as aggressive.

There was so much of it too. I was astonished by the volume. There must have been a maelstrom of productivity in her two years at Camberwell, I thought, and I felt grateful for it. In the weeks after she died, I was chilled by how quickly a life disappears from view: how a body is reduced to a box or urn and how a dead person's legal status is shrunk to a single certificate and filed away. The housing association told us we had thirty days to clear her flat, and there seemed to be less and less of her as we emptied it, packing only the few things that my mother, brother and I could fit into our own homes to remember her by.

Except for her art, which seemed to expand and gain surprising life. It emerged from drawers, cupboards, and the sides of the wardrobe. This was recovered treasure to me, and a defiant counterpoint to the way Fauzia was being 'disappeared' in the physical world. We carried it all out in suitcases, plastic bags and boxes. My brother took her easel for his two daughters – Fauzia had gone to visit them every Friday afternoon, with paper, glitter, glue and coloured pens, to give them classes, and they had developed a love of arts and crafts.

At Fauzia's funeral, I met Kelly Chorpening, her tutor from Camberwell and the course leader of drawing on the degree course, who said she wanted to stage an exhibition of Fauzia's

work in the college gallery. She came to see the artwork in my flat a few weeks later and selected pieces to show. I had never been to the college before and travelled to South London on my own on the night of the show, arranging to meet the rest of the family there. I got on a bus for the last leg of the trip that I knew Fauzia had caught every day. Looking out of the window onto unfamiliar streets, I thought of how this would have been her daily route to the college. It must have felt like a journey out of the wilderness, away from depression and those decades of blankness – a bus journey that would place her back in the world she had worked so hard, yet so fruitlessly, to be in. I felt bitterness rising.

I got to the college early, feeling dread for the funereal evening to come. Fauzia's work was displayed in glass cabinets and hung across long white walls on two floors. I walked up and down and felt myself becoming breathless, all the rancour of the bus journey dispelled. Fauzia's work looked both familiar and unknown in this space and it was a shock to see it not in the privacy of my home, folded together in its ad hoc intimacy, but as a public-facing, coordinated whole. Kelly's arrangement had turned the diffuse parts of Fauzia's portfolio into a single body, more complete in its collective coherence. Her intricate embroideries, still-life and pencil sketches looked so confident here, smiling out at the room.

Others were arriving and the evening suddenly turned into something else – not the sombre night I had anticipated but a celebration, a gift *to* Fauzia and *from* her. How thrilled she would be for us to see it in this way; how surprised and flattered. My brother and his family bustled in, along with Fauzia's former classmates, and I became lost in the company of my friends – none had known Fauzia but so many turned up. A few hours in, I looked for my mother among the crowd – she had come with a friend from her sewing class – and I was astonished to see her so animated at the other end of the corridor, sociable

and effusive in a way I had rarely seen her since Fauzia's death. Afterwards she told me she had felt exhilarated by the sight of Fauzia's work, throbbing with life and drama for all to see.

The exhibition was a wonderful moment, but soon after, my brother, mother and I split the artwork between us, and most of it was filed away in drawers and cupboards. I knew that one day I would open the innumerable sketchbooks and portfolios and find new knowledge of Fauzia but for now I was being careful. It had to last me a lifetime and I didn't want to run out too quickly. I wanted to leave some of it for later so I could still keep knowing her, in real time, despite her death – a guarantee against regarding her as a *once* sister. But there was another reason not to look and that was the fear of seeing things that would be painful to acknowledge. I knew I would find clarification of so much about Fauzia, and I would also see the ways I had misunderstood and misjudged her.

I don't think Fauzia considered the embroidery to be art when she began sewing at the Asian Women's Centre. Maybe it was a kind of therapy to sit among older South Asian women and sew as they talked about life. But it became its own addiction and she took her embroidery frame everywhere she went: a habit in the hand on the bus, at home, in waiting rooms when she was anxious or upset. She stitched through every mood, however agitated she got, pinning down her pain in embroidered images but also, perhaps, feeling a release through the physical act of sewing. The urge to pursue art rose up again by stealth in the embroidery classes and she finally submitted an application to Camberwell.

When she was lying in hospital, enervated and unable to sit up, she talked with urgency of getting back to college. So much was at stake for her, and she was determined to finish the degree after being blocked by depression for so long. She never did, but the work she left behind contains small, beautiful, incom-

plete pieces of her. It shows the pain and struggle of her life but it is also bound up in colour and sequins and gleaming gold and silver threads. There is a celebration of beauty in it. A piece of Rome.

Ever since Fauzia had come back from the city, transformed, I had wanted to go myself to see what she had seen, but after she died, I felt differently. Rome had given her the false hope that beauty would somehow sustain her in the world, but her pursuit of it hadn't helped her recover. So when I found myself there, three and a half years after her death, I felt both nervous and mournful of all this city had promised her and not delivered.

It is 7 p.m. on an autumn evening and I am standing outside a peach-and-cream house with a plaque above its door. It is on the corner of a historic square in Rome and is dwarfed by the flashier features around it: the monumental Spanish Steps leading up to the Trinità dei Monti church; Pietro Bernini's baroque sculpted fountain in the shape of a sunken ship, which spews frothy water from its portholes. The sun is setting and the throng of tourists is walking around the square's designer shops, pizzerias and pavement restaurants in a circumambulation that will whirl late into the night. I am the only one interested in the silent house and its second-floor window. It is where John Keats came in the hope to recover from the tuberculosis that was eating into his lungs in November 1820, and where he died of the illness a few months later in February 1821. I have come to see where the poet lived in his last months but I am put off by the babble of the square so I return the following morning when it is hung over with cloud and rain.

The central sitting room of the Keats–Shelley Memorial House is filled with memorabilia from his circle of Romantics – Lord Byron's portrait, Percy Bysshe Shelley's curls of hair, busts, books – but Keats's bedroom is relatively spartan. It is a narrow corner room, a calm space with a wooden bed at one

end, a desk at the other. Along its walls are display cabinets and pictures: Keats's death-mask, paintings of his grave in Rome and the pen and ink portrait of him drawn by Severn on his deathbed that I have seen hanging in its larger version at Keats House in Hampstead.

I stand by the writing desk that overlooks the window and peer out at a slanting view of the Steps and the fountain below. Noise collects in the pit of the square and arrives in the room clear and sharp so that several conversations can be heard, and followed, in discrete threads. The gush of the fountain mixes with laughter. 'Until Keats became too ill to leave his bed, the view from his window was a constant distraction and delight,' reads the introduction of the guide booklet. Delight is surely not the only emotion he would have felt, listening to the sounds of life outside as his own drained out of him. How comforting are they in the face of terminal illness? How alienating may they seem? 'I have an habitual feeling of my real life having past [sic], and that I am leading a posthumous existence,' he writes to his friend, Charles Brown, in the last letter he is known to have written, on 30 November 1820.

He had not married his fiancée, Fanny Brawne, or established himself as the great poet he was determined to become. *Endymion* received devastating reviews in 1818 but he kept on, undeterred. In his final years he wrote in a fury of creation. My sister's fever to create as much artwork as she could, as quickly as was possible, came back to me. Was this creative fury a feature of TB or was that just part of its romanticism?

Keats knew he was dying the moment he coughed up arterial blood, and I find myself wondering when he resigned himself to his death and began readying himself for it. The palliative-care doctor, Kathryn Mannix, has written of those who know they are dying to enter preparation mode. Some even ask for their passports. Keats took this journey literally: he came to Rome hoping to survive, but he had already suffered two

lung haemorrhages by then and maybe it was a trip he knew would cast him further out of life. In the guide booklet of the Keats–Shelley Memorial House, there is a passage that details how Keats asked Severn to go to the Protestant Cemetery in Rome, to bring back a description of it, and he was glad to know that the ground was carpeted with violets because they were his favourite flower.

Yet before this, even in the certain knowledge of his deadly consumption, he still hoped to carry on living. In letters to his friends, family and Fanny Brawne, he wavered between despair and the prospect of a miracle. 'I want to compose without this fever. I hope I shall one day,' he writes to his brother and his wife, George and Georgiana Keats, on 21 September 1819. A few months earlier in July he had written to Brawne to say that he brooded over 'the hour of my death'. Yet he carries on bargaining with God in his letters – what greatness he could achieve if he were given just a few more years. 'If God should spare me . . .', he writes, in November 1819.

God didn't spare him. Keats died at the age of twenty-five in a small galley room. The streets of Rome are filled with images of benevolent divinity, but God wasn't in that room when Keats was dying, or if he was, he didn't work his miracles. I had long known that Keats died in penury, and I had felt an academic sadness about a working-class man with an extraordinary talent dying so woefully before his time, but I wouldn't have made a pilgrimage to this room, to stand at this window, before my sister had died. Now, the contemplation of his illness and death takes on new meaning. I feel a small, grudging thought: at least Keats's illness was named, and at least he had some time to contemplate the end, to prepare for departure. Isn't that a better way to die than how my sister left this world, with her illness a maddening mystery to her? And, once again, false hope. That the doctors would save her: she wouldn't die but would return to her art degree to realise her long-delayed

dream of becoming an artist. She was on the verge of achieving it, and then it slipped away.

We can make sense of a disorder or deadly disease only once we have named it. Until then, it is a series of symptoms, more irrational and dangerous as an unknown quantity. What does this not knowing do to an ill person's understanding of themselves? Fauzia's TB remained unnamed until the day after her fatal haemorrhage so she must have been in a state of psychic incoherence until the end. We have little power over something that has not been identified. Did Fauzia die powerless? I'm not sure, but if she had lived for one more day, if her haemorrhage had happened twenty-four hours later, she might have heard her disease being pinned down, even in her comatose state, and flown into the next world knowing its name, at least.

Does a person know they are dying when they are surrounded by life-support machines and ICU nurses and all the other twenty-first-century mechanisms that are there to force death away? Did Fauzia know she was dying? My mother says she did. In the last few months of her life, she moved back into our family flat where she had apparently woken up one day to see a blinding white light above her. It terrified her, my mother says, and she saw it as a sign of another world opening its jaws. My mother spoke of her insistence on being treated at the Royal Free Hospital as a sign too. Fauzia's Warren Street flat was a five-minute walk from UCLH, a large teaching hospital, but she had argued with the paramedics who had come to collect her and insisted that she wanted to be taken to the Royal Free. My mother said it was where she felt safest, but paradoxically it was also where she might have preferred to die. And in her last conscious day, my mother tells me that she turned to her and said, 'Mum, I'm dying.' I have asked her to recount this moment many times. I want to imagine it but I can't quite do so.

'What did she look like when she said it?' I have asked. 'What did she sound like?'

My mother says her voice was steady, as if she were stating a fact, and her expression calm, devoid of pain or fear. I can understand why she would need to say the words aloud: if she *did* realise that her unknown illness was leading inexorably to death, it must have felt like such surreal knowledge. Declaring it to herself might have been one way to make it feel more solid, an abstract future state now grounded in words, and perhaps this was the preparation of which Kathryn Mannix speaks.

There is more evidence of her foreknowledge, now that I have begun looking for it. In her hospital bed, as she lay gasping and out of breath, she asked my mother to bring in a piece of embroidery she had been working on. It is on a background of white cloth and is a kind of triptych with three female figures that seem as if they are from a Renaissance painting. On closer study, they are three different versions of the same woman, undergoing a process of transformation. Running vertically down the cloth are human spines sewn in thick green thread so that the figures are separated, as if in their own panels. On the far right-hand side, the woman lies agonised and naked with her arms raised in pain, and a spinal column is stitched across her body. The second shows her upright and in a state of ecstasy, as if she has been freed. In the last image she has turned into a winged angelic creature sewn in silver and yellow thread.

I see the wish for release from the carapace of a diseased body in these three images, which capture the same woman's morphing states. The physical body is gradually being cracked open, it seems, and peeled away. It is an envisaged escape from the burden of a body that had given Fauzia nothing but torment. Disembodiment as liberation. Was this what she was thinking as she sewed in hospital? Did the woman represent different states of herself? Was this a fantasy of her own transformation? Or was it a premonition in which her body was revealing to

itself the imagery of a deadly disease travelling up her spinal column? Does our body carry a visceral understanding of its mortality when it is being attacked from the inside? This last unfinished embroidery withholds more than it reveals, but also offers distant, tantalising comfort.

Standing in Keats's little room, thinking about his silence being filled with other people's noise, I remembered the quietness that Fauzia craved more and more in her Warren Street flat. At least six months before her death, when she had already begun to feel unwell, a feud had been sparked between her and her upstairs neighbours. They were a family with children and elderly grandparents all apparently living in a small flat directly above hers. She had been friends with them but something changed and Fauzia had begun to feel victimised. There were flashpoints that led to the involvement of housing-association officers who, my mother says, were bullish and aggressive in the meetings she attended. Fauzia had complained for months about the noise, and asked the housing association why they had been placed in such a small flat. The family claimed that Fauzia had shown hostility towards them and installed a CCTV camera in the communal hallway. In turn, she said they had verbally abused her, impinged on her privacy with their continuous surveillance and edited the CCTV footage to present a biased picture of events. A few weeks before she was admitted to hospital, she had received a 'final written warning' and was scared by the possibility of eviction.

When we cleared out Fauzia's flat, I found an A4 pad on which she had logged the noise through the night. 3.06 a.m.: pounding again. 3.13 a.m.: loud knocks on the floor. 3.47 a.m.: thumping footsteps. This minute-by-minute tabulation of the disturbances was awful to imagine. I knew she had suffered months of insomnia, but still it distressed me to find this log and think of her, in her illness, feeling so tortured. In the months after her death, I cursed the housing officers and the family above her.

I begin to see things differently after visiting Keats's room in Rome, looking out of his window, and understanding the bitterness he felt at his impending death. Fauzia would have had every right to feel bitter, too, about the timing of hers, which came just as she had stopped wishing for it and become inspired to live again, finally, through her art. Maybe, like Keats, she felt herself turning into an ever more passive and remote observer of the world, and perhaps she didn't want to hear the brash, unstoppable sounds of continuing life above as hers ebbed away. She needed silence to see her out, and that was what she got in my mother's home.

She spoke to me of what a relief it was to be there. It became a refuge where there was no sound to remind her of the 'posthumous existence' Keats wrote about. All the childhood torments she had suffered in our family home were forgotten in its silence. She lay in the room we had once shared and where we had been such good sisters to each other.

The twentieth-century poet Geoffrey Hill writes of death as an interruption that drags us out of the world in the middle of our life plans. 'I have not finished' is the final cry of his poem 'Funeral Music', but Keats had barely got started. He felt so cheated by life that he told Joseph Severn he wanted his grave to remain unnamed with only the words: 'Here lies one whose name was writ in water.' They are opaque, poetic, but they convey a sense of a life not solid enough to warrant naming and they look mournful on his headstone, when I visit the Protestant cemetery in Rome.

His grave is tucked away in its own remote corner, but I realise that Keats is not the only 'celebrity' in this graveyard. It is home to Goethe, Gramsci, Shelley and many other non-Catholic notables whose graves I pass. The cemetery is immaculately groomed and I see the flashing tails of the cats that have made it their home. One looks like my sister's first

cat, Blue, but it darts away when I stop to study it for its resemblance. It is raining and only a small gaggle of tourists is taking pictures at its furthest end.

I wait until they are gone and the mud is mulch by the time I tramp up to Keats's headstone. It reminds me of the rain on the day of my sister's funeral on 15 June 2016. It was heavy and unrelenting. When it fell dark that night, it was still pelting and I thought of Fauzia, lying outside, at its mercy. The wind chimes that I had taken from her flat and hung on the trellis on the roof terrace outside my bedroom sounded frantic in the wind, as if they were screaming in pain. I imagined the ground swelling and rising around her. It felt like an affront that the rain should hammer down so savagely on the night that her delicate body was planted into the earth. A friend whose older sister died a few years after Fauzia said she felt like she was burying a part of herself at the funeral. They had not always got along but she still felt a sisterly affinity that was so elemental she thought it to be genetically hardwired. It was the same for me when I looked at Fauzia's fingers and eyelids, and the shape of her limbs in their stillness. They seemed so much like mine that I felt physical parts of me were lying among her in her coffin.

Muslims bury the dead as quickly as possible, ideally within twenty-four hours, so I had barely accepted that Fauzia had died when I saw her coffin draped in a green and gold cloth inscribed with the *Shehadah* (Quranic verse) inside a hearse. It was a tiny funeral because my sister had very few friends, as is often the case with people who have a lifetime of mental-health issues: they are slowly abandoned, partly because they are difficult to be close to, but also because the world prefers happy people. My aunt and uncle from Streatham came to her *Jinazah*, or funeral prayer, at Regent's Park Mosque, along with their two daughters and another aunt from Norwood. Any worshipper in the mosque can attend a funeral prayer, so my sister's coffin

was brought in and placed at the top of the men's ground-floor prayer area. I had a clear aerial view of it from the women's mezzanine quarters above. I looked down, feeling protective of her in a room full of strangers. The imam told the congregation that the coffin was that of a woman, as he was supposed to do, but his little announcement tore through me, just as registering her death and holding her death certificate in my hands had done. The language around death, its banal, quotidian nature, felt to me so supremely inadequate and anonymous. Yes, here *was* a woman in a coffin, I thought. My sister, Fauzia, alone, brave, and the first of our tiny family to be making this journey out of the world.

I remember the ride in the hearse from Regent's Park Mosque to the Muslim section of Hendon Cemetery. I was in a high state of anxiety about who would carry her coffin to its grave. In Islamic tradition, it is carried by men only, but we had only one elderly uncle with a walking stick. There was my brother, which made two. I would have to count among the men, I thought, but we still needed more. I felt a rising panic. What would happen if we couldn't lift her coffin? Who would help us?

The rain came down heavier than ever as we got out of the car. My mother and I stood wet and huddled, both of us trying to find our own silent solution. My shoes became caked with mud as I struggled towards the coffin. I'm not sure how long we stood there, but then, out of nowhere, I saw my brother's childhood friends striding towards us. There were several: boys who had become tall, rangy men with children of their own. They had known our family for most of their lives and I will never forget how grateful I felt, how true they seemed as my brother's friends, in that moment. The heavens didn't part and it didn't even stop raining, but I felt that we had had our own small miracle when they became Fauzia's coffin bearers.

After that, other special things happened. A few of my sister's

art tutors from Camberwell turned up, including Kelly, alongside a friend Fauzia had talked about. Kelly brought a reel of embroidery thread to leave inside Fauzia's grave. The imam, a gentle, progressive man, read a Quranic surah and then the Lord's Prayer for the Christians among us. It was still raining when the bulldozers came to fill the grave, and from a distance, when I turned for a last look, it seemed nothing more than a heap of wet earth. We would have to wait a year for the ground to settle before we could raise a headstone. Until then, it would remain unmarked, with only a tiny nameplate to distinguish it from the other fresh graves. In returning years, I have seen the empty rectangles of grass fill around Fauzia and have felt anxious that she might be hemmed in or encroached upon.

It is one reason why I find Keats's grave so calming. It is away from all the others, in the serenity of its own grassy corner. If Keats had died with his passion for Fanny Brawne unspent, at least he made up for it with the love of his many friends. There was Charles Brown, his former housemate, alongside Charles Wentworth Dilke and Leigh Hunt, all from his Hampstead days. Beside Keats's grave is that of his great friend Joseph Severn, whose death came decades later in 1879 at the age of eighty-five. Severn had not only held Keats in his final hours but painted him numerously, both before and after his death. Among them is a beautiful if melancholic image of Keats in his parlour painted in 1819, just before the onset of his illness, and another large, idealised image of the poet sitting in the verdant surroundings of Hampstead Heath where he first imagined 'Ode to a Nightingale', which was painted thirty years after his dying, in 1851. When he became dangerously ill in Hampstead, it was his friends who clubbed together to raise the money for his ticket to Rome. They had loved him not only in word but also in action. Afterwards, Brown and Shelley carved their own sentiments on his headstone to add to Keats's inscription: 'This grave contains all that was Mortal of a Young English Poet

Who on his Death Bed, in the Bitterness of his Heart at the Malicious Power of his Enemies[,] Desired these Words to be engraven on his Tomb Stone.'

The following day, it is raining again but I feel robust against it. I am with a tour guide in central Rome who will take our party to the doors of Vatican City an hour before its official opening. I have come to see only the Sistine Chapel and I have a plan of action ready for when I am given my entry ticket. A colleague has told me to head for the chapel, not stopping to look left or right. Run if you have to, he has said, and explained how remarkable the painted walls look when the chapel is empty of the crowd that will inevitably fill it by mid-morning.

I feel a great fizzing excitement. I begin a running walk towards the chapel as soon as I am inside the central hall. There are cloakrooms and escalators and hallways to navigate even before I get inside the complex containing any art. I feel a surge of adrenalin and pick up my pace, and as I do I remember Fauzia's Michelangelo posters, the way she spoke of the chapel, of how its art felt like a miracle to her.

I break into a light run. I jog past a haze of religious paintings. I see flashes of gilt, floating cherubs, Madonnas and pietàs. From an open window I glimpse a view of the topiary in the Vatican's gardens. I want to slow down and take in these things but I know I have no time. I keep turning corners and wonder if I have gone down the wrong staircase and missed it, until I am suddenly standing at the mouth of the chapel. I walk in and stand at its centre, wanting to look everywhere at once. I think of Fauzia gazing at these walls and I am her eyes and my own. We are sisters here, in mutual awe. I look up and see *The Creation of Adam* above me, and I see Fauzia smiling at its glory. Sitting in this chapel, I can't begrudge Rome its beauty and, in it, a sense of the divine.

The longer I look, the brighter the paint gleams. Figures

constantly emerge from the sea of humanity on the walls. A woman in a green dress on the central altar wall that I didn't see in the first hour. A man balancing a pillar on his back. Another with his head in his hands. A serpent wound around the legs of a man. Sky, clouds, death, life, love and ecstasy. There is a collision of worlds: human and phantom. God and the devil. The seen and unseen. Now and eternity. Occasionally, a priest steps to the front of the chapel to hush the crowd and remind us that it is a place of contemplation. 'Worlds without end,' he adds quizzically, which gives me strange comfort. After two and a half hours, I wrench myself away. If I ever need to feel close to Fauzia, I will come back here.

On my final day in Rome, I return to the Spanish Steps and its noise no longer offends me. We live and we die. Life goes on, noisy and vigorous, without us. I look up to Keats's window. The sun is shining across it and the blue of the sky streaking behind. There is a shadow at his window, and I squint to get a better view of the figure looking down on this sunny autumn day, but it is gone. The sun floods warmth around the square and I smile as I think of the Sistine Chapel, and its worlds without end.

2

What Remains

6

Art

My last meeting with Fauzia outside hospital was in May 2016. It was shortly after her first admission to A&E in April, when my mother called and I rushed to be with her. Until then, there had been four years of silence between us after our last big fight. I had been the one to pick it. We had been at our mother's – Fauzia, my brother and I had gone over for dinner – and I can't remember what triggered it but I felt all my old unaired resentments rising to the surface over the course of the meal and I rounded on Fauzia over a slight so tiny I've forgotten what it was and told her I hated her, shouting the words before storming out of the home.

Afterwards, my mother told me I needed to apologise, but I couldn't because the anger, now out, was too big to put away and too irrational to explain. I was furious with her for her lifetime's depression, for not being the sister she had once been, for making me feel like her oppressor when I had never betrayed her, and I felt it was *she* who had built up a narrative against me, calling me her bully when I had been her friend.

After we met at A&E in April, it felt like we were starting over, reconciled and given a second chance, but I didn't apologise for the fight. Why not? She invited me to her flat in Warren Street anyway and I was grateful for the invitation, relieved to be friends again.

In the years of icy silence between us, I had missed her company, her careful listening, her passion for things, even if I had stayed angry. I felt a weight lift now, although a part of me remained apprehensive, waiting to land back at the same place

because, however many fresh starts Fauzia and I had had, we always seemed to circle back to grudge-bearing and mutual resentment, either assigning ourselves our old identities or blaming each other for them. Since she died, I have begun to suspect that this was more my doing than Fauzia's, in the later years at least; that it was *I* who was dragging the rankled past with me and setting it between us, like an undead creature. But it had become a defensive gesture on my part and I didn't know how to be another way.

Before our last meeting, I sent her a text to ask if there was anything I could bring with me, and she responded with a long message, asking me to come to a hospital appointment with her, or so I thought. My heart sank. She was asking for more than I had offered and I felt cornered. I wrote back to say no. After that, we had a flurry of exchanges, which ended in chiding tones, with her saying that I shouldn't offer help only to withdraw it.

Some weeks after Fauzia died, when I had already started to pick at who she had been, and who we had been as sisters, I reread the exchanges from that day and was first surprised, then dismayed, to see that I had misconstrued what she had written and ascribed my own meaning to it. She had made no demand on me at all. She had responded to my offer of shopping with an explanation and apology. She had had more painful investigations in hospital, including a lumbar puncture, she wrote, which she had previously described to me and which I imagined as a blunt knitting needle inserted into her spine to extract its fluid. She was left in such pain that it hurt to walk so, yes, could I bring some smoked salmon and bottled water?

How had I decided that she was embroiling me in her care? And why was I so terrified of that? I have reminded myself that we all misread text messages and misconstrue meanings. Even so, I am full of regret for the small shopping trip I could have made for her, had I read her message correctly. It has left me

wondering what else I might have misunderstood. How much of our embattled sisterhood came from my accumulated fear, anger and the concerned love that I found too painful to express?

Everything changed between Fauzia and me when I left for university. I remember how on the day I caught the train to Edinburgh she wouldn't talk to me. When I asked her to come to see me off at King's Cross, she refused to change out of her dressing-gown. She behaved as if I had wronged her. I thought she was being unreasonable but I felt twinges of guilt all the same for leaving, especially knowing how low she had been in the past year. My father came to see me off instead, but a few minutes before the train moved out of the station, I saw Fauzia running along the platform with a scroll of paper in her hand. She got to me in time and I rolled the paper open to find her favourite painting – a still-life of flowers in meticulous brush-strokes of oils in deep blues, purples and turquoises. It had been the only finished artwork she had taken to her admissions interview at Saint Martin's in 1989, and on its back she had written, 'To Arifa – look – my first great work of art!! Fauzia'.

I felt elated. We were still the best of friends. She had given me her most important work. I hung the picture above my desk in my first year at Edinburgh and in every other room after that, bringing it back with me to London to store in the dank family shed. Some years later, I went to look for it, but it was nowhere. I wondered how I could possibly have lost such a precious thing, and where it could have gone.

In the early days at university, I would ring home so Fauzia could give me a pep-talk for my essay deadlines. When I asked about her life, she repeated the usual phrases: that she felt overwhelmed and depressed, that nothing was working out for her, that she had been binge-eating for weeks on end. I had run out of solutions. I couldn't fully face how worried I felt for her from that distance, and I was becoming absorbed in my new

student life. Nonetheless I spoke about her endlessly, telling everyone about her troubles and that I didn't know how to rescue her. It seemed to me as if she had fallen into a pit and I had tried throwing down ropes, hoping to get her out, but every time I dragged the rope back up I'd find she wasn't at the other end. Eventually, it felt too hard to keep hauling so at some point I took myself away from the pit, perhaps also out of fear that she would one day tug the rope and drag me down to the dirt and darkness to keep her company, and that I'd remain there, in bondage, out of sisterly love.

Leaving home for university had meant leaving Fauzia when she was slowly falling apart. Had I been her only crutch? Did I abandon her? Was I, in fact, partly to blame for her depression? I felt these uneasy questions swarm wordlessly between us after I returned from Edinburgh. Maybe Fauzia planted them there. I suppose she had a right to do so: the legacy of having been my father's favourite in childhood felt toxic when set against his brutal treatment of her. During my years away, Fauzia must have decided I had shown her cruelty, too, because she became snide and jeering when I returned, reminding me mockingly of our childhood positioning: me as the spoiled sister and her as the outcast. I wondered if I had played a passive part in her oppression. Rationally, I knew I wasn't to blame, but I felt increasingly guilty when Fauzia's life kept on taking wrong turns.

The first big fracture between us came a year after university. It was 1992 and I had left home to teach English abroad. I was living in Kielce, a small satellite town just outside Kraków in Poland, and I had a disturbing dream. It felt as if I wasn't asleep and seeing Fauzia standing in a corner of my room, opposite the bed. She was speaking words I couldn't hear, but the dream was flooded with her fury. She was fiddling with her hands, and when I looked down, I saw that she was holding razor blades

and jabbing at her flesh until her fingers were bloodied and meat-like.

The vision of her tearing at her hands was so vivid that I felt afraid whenever I looked into that corner of the room, even in daylight, for the rest of my time in Poland. I have had very few other dreams as fiercely alive as that one, and I remember it felt as solid as the furniture in that room. Whether it was simply a dream or telepathy, I had picked up on the anger that Fauzia was feeling towards me. She stopped coming to the phone whenever I called home, and when I returned to London to begin a master's degree, my mother told me she had left just before my arrival to go to Edinburgh for a while, although she had no connection to the city as far as I knew.

A few days later, I went to fetch a metal box in which I kept my most treasured secret belongings. These were sentimental things, like pebbles from beach trips and stacks of teenage diaries filled with intimate outpourings, along with childhood photographs. I couldn't find the box anywhere and I wondered if Fauzia had hidden it. I asked my mother for her address in Edinburgh and wrote her a letter to ask if she had seen it. She sent me a reply of about four lines, written faintly in pencil, which gave no explanation about the box but said she hated me and didn't want to hear from me ever again. It was clear from the letter that she knew the whereabouts of the box but was not going to tell me. It was also clear that she felt I had wronged her heinously and that she would be a victim of my aggression no more.

I was stunned by the finality of her words. Had I behaved badly? I *must* have done for her to send me that note. But we hadn't had a falling-out so what had caused her to hate me so suddenly? Slowly, the shock of her letter solidified into my own anger. It was not the childish theft in itself that appalled me – Fauzia later admitted to taking the box – but how the whole incident seemed designed to cast me as the aggressor even when

this was a violation against *me*. I realised she had decided to hold me responsible for the abuse she had suffered in her early life, at least in part, and although I felt guilty for my far more charmed childhood, I also saw the unfairness of being blamed for something I could no more have controlled than she could. Looking back, I think Fauzia knew, instinctively, that I could not be held responsible but still couldn't stop resenting me for it.

The incident of the locked box was proof to me that I couldn't trust Fauzia, that she was rewriting the past and making me her oppressor sister just as I felt she was becoming mine. I must have held on to my sense of injustice over her letter because in our final falling-out, two decades later, I told her I hated her and didn't want to see her ever again. They were the words she had used in her letter and I wanted her to have them back. We had been friends up until then and she was no longer blaming me for her life, but my belated anger at being accused in the first place seemed to grow with time, not fade. I had never retaliated until then because she was ill, and because she had suffered in childhood where I had not, but my grievances, however petty in comparison to hers, had built a high wall over the years, and I couldn't see past them.

I didn't know that she would die four years later and that I would be left with an unspent apology in my mouth, and the shame of that sudden, uncontrollable tantrum. I should have explained myself but I had become so confounded by the accusations and counter-accusations of who had wronged whom. I dug my heels in further when I heard that Fauzia had begun to call me her bully again. I see the irony of that final fight now: I had behaved just like the childhood bully she had cast me to be.

When we were teenagers and shared so much with each other, Fauzia went through a phase when she couldn't stop talking about the warped sisterly relationship in the 1962 film, *What Ever Happened to Baby Jane?* It stars Bette Davis as Baby Jane

Hudson, a spoiled brat of a sister who is their father's favourite, while Joan Crawford is Blanche, the less loved daughter who is treated 'unkindly' by him and quietly protected by her mother. She is ostensibly the 'good' sister while the petulant, pouting Baby Jane is 'bad'. The film fast-forwards from childhood to middle age, when the sisters are bound together in battle.

The now faded child-star, Jane, is a monstrous bully to Blanche, who, we are told, grew up to find far greater fame than her sister in 1930s Hollywood; it is Blanche's talent that the world talks about, and remembers, decades later. The central time-frame of the film is the 1960s when the sisters are living together. Blanche is in a wheelchair after an accident that ended her Hollywood career and that – it is heavily hinted – was engineered by Jane out of jealousy for her fame.

Fauzia talked about the film with great excitement, telling me its final twist – that it was not Jane who had tried to destroy Blanche's career or caused the accident that left her paralysed, and that, in fact, Jane is Blanche's victim, but she doesn't know it until the final moments of the film. I have a vague sense that Fauzia watched it repeatedly, although this was very unlike her: it was my brother who loved watching the same favourite films as a teenager – *Trading Places*, *La Haine*, *The Rocky Horror Picture Show* – while Fauzia and I were always moving on to the next thing. This film was different. She kept telling me to watch it. For some reason I resisted doing so for a while, and when I got round to it I couldn't get to the end. I was amused by the film's horror, which verged on black comedy at times. I found Bette Davis's hammy villainy entertaining and I was intrigued by Joan Crawford's calculated, sisterly niceness, but I wasn't compelled to keep watching.

In my second, full viewing after Fauzia's death, I come to the film knowing of the off-stage rivalry between Davis and Crawford, and of the claims that the latter was jealous of the former's talents. This knowledge only makes its central psychodrama more

terrible. Almost against my will, I realise I am starting to watch the film through Fauzia's eyes. She is Blanche, and I see myself, wincingly, in the brattish vaudevillian child-star, Baby Jane, tap-dancing on stage, then being lavished with her father's praise while Blanche looks on darkly from the wings.

'You will have your day,' the mother tells Blanche, and reminds her to be kind to Jane when that time comes. I stop and start the recording, telling myself that I am too hungry or tired to keep watching before forcing myself to press 'play' again.

I get to the famous scene in which Jane serves up Blanche's pet bird to her sister on a covered silver platter. She has killed it earlier, to play her nasty trick, and just as Joan Crawford lifts the lid and sees the bird placed on top of a salad, the camera closes in on Bette Davis's face, lit up with sadistic glee as she hears her sister's screams outside her room. Its horror is schlocky but I feel only nausea at Jane's ever more baroque tortures. I realise I do not want to see these rivalrous sisters gouging holes out of each other's flesh, determined to destroy the other at any cost.

One sister is too improbably evil, the other too much the helpless victim, yet it is impossible to ignore what Fauzia must have seen. There is trauma in every scene, when viewed through her teenage gaze, and I see the warped bond between Jane and Blanche as the pained love between Fauzia and me that – much later in our lives, long after she had seen this film – felt like hate.

What neither Jane nor Blanche acknowledges is that it is their father's unequal love that pits them against each other. The shadow of 'Daddy' hangs over them yet they never round on his memory, only each other. When Blanche finally confesses that Jane was not responsible for the accident, even though Jane has convinced herself that she was, Bette Davis turns to Joan Crawford, looking childlike, and says, 'You mean all this time we could have been friends?' Fauzia and I, all that time, could

have been friends. She was never my enemy, I was never hers, but we got tangled up in circles of distrust, accusation, hurt and blame.

I eventually got back the contents of my locked box: Fauzia phoned from Edinburgh a few months later and asked for me. I told my mother I didn't want to speak to her but she carried on phoning until, almost exactly a year later, I relented.

'Where's my box?' I said.

She confessed to having taken it and was full of contrition. During my time at university we had seen each other less and less, she explained. So she had prised open the box to discover all that was unknown to her about my life and be close in the way we used to be. It came in the post a few days later and I was appalled to see it. There was no outer carapace – Fauzia must have broken the lock and thrown away the box – and the childhood knick-knacks I had treasured looked tacky. All its lustre was gone. I disposed of most of what had been inside except for a couple of my earliest diaries. I clung to my injury, refused to forgive, and even though my enduring grudge seems childish now, it was never about breaking open the box in itself, but concerned a far more fundamental violation. Fauzia had wrenched open the parts of myself that I sought to keep hidden from the world. It is why I had locked up the box, but Fauzia had pushed her way into my secrets and vulnerabilities in this act of forced exposure, and even though she had framed it as an act of sisterliness – 'I wanted to know you better' – it felt aggressive, the framing dishonest. Perhaps it wasn't, and she was speaking the truth, but I imagined her consuming the private pleasures and insecurities of my diary entries, gleefully, sneeringly. It seemed like invasion, mockery and punishment, all at once.

Maybe hate is as ardent as love with sisters. There is a scene in Louisa May Alcott's *Little Women* that has always stayed

with me, even though it is a book I find grating for its moral sermonising and its saccharine portrait of sibling love. But this scene captures something dark and real between the sisters, albeit momentarily. It comes when Jo, a budding writer, refuses to take her younger sister, Amy, to the theatre with her because she will get in the way. Amy hits back in a rage by burning the manuscript of Jo's novel while she is out. Amy apologises the next day but Jo is inconsolable. 'I'll never forgive you for as long as I live,' she says to her sister. Their mother tries to bring Jo and Amy together again. 'Forgive each other, help each other, and begin again tomorrow,' she says, but Jo stands firm in her anger, feeling 'so deeply injured that she really couldn't quite forgive yet'.

The burning of Jo's manuscript was, for me, the theft of my locked box and I felt every inch of her devastation. Jo feels hate so passionately in that moment and the narrative begins to tread on the darker complexities of sisterhood that are so rarely touched on in literature. So many stories seem to want to show happy, harmonious, supportive sisterhood, not the prickly, combative, but no less loving reality. Alcott doesn't show this darker side for long. The sisters make up through a convenient plotline that brings their relationship back to one of unquestioned devotion, with Amy's near-death the following day when she falls through winter ice into the waters beneath while she is running after Jo. After this, all is forgiven and Jo is only relieved her younger sister has survived her treacherous fall. Alcott confects this incident for forgiveness so quickly, yet the rage Jo feels towards Amy is, for me, one of the most powerful moments in *Little Women*. Their fight is over in a matter of two or three pages, their sisterly conflict submerged under the icy waters into which Amy falls, but it captures something very real: that love is tied to hate, and it can be expressed as hate.

*

On May 2016, after Fauzia was well enough to leave hospital, I arranged to meet her at a café opposite her ground-floor flat in Warren Street. I had fallen out with her before she had moved there, so this would be my first time seeing it. I had only been to her previous flat in Kilburn where she had lived for several years and been happy until a man moved in opposite her whom she felt was an oppressive presence. I didn't know the full story behind her antipathy but I knew there must be more to it than the quibbles she mentioned: that he had borrowed a drill and not returned it, that he complained about the various plants and sculptures outside her door and had even removed some. I had seen him once on the stairwell to her flat. I was busy fiddling with my phone and only raised my head when he was close by. He slowed to a creep on the landing and stared so intently at me that it seemed as if he were preparing to pounce, or for me to do so. It was such a strange, exaggerated gesture in its stealth that it unnerved me. I didn't mention it to Fauzia for fear of inflaming her anger towards him, which I sensed carried an undertow of unarticulated fear.

Until she began to speak of moving out, this first-floor council flat had been her sanctuary. It was quiet and airy, with its balcony thick and bright with plants, and broad windows that she kept open so a breeze always flowed through the rooms. There were no neighbours beside her, although my mother told me she would occasionally get anxious about the smell of frying onions or the waft of morning toast rising from the flat below. I knew this must have been particularly upsetting for her in the times when she was only drinking water, which she would do for a week at a time before eating unstoppably, as if she had finally let herself inhale and ingest the smells.

But on the whole she was content to live there with her two cats. Every time I visited, she would get up from the sofa as we chatted and lead me to a nook in the flat to show me what she had done with it. Sometimes she pointed to new gauzy curtains

and asked me about their colour or the way they folded. More often it was something she had varnished or painted after finding it in a skip. She had an eye for discarded things and I was always disbelieving when she said she had found a piece of furniture on a street corner. Sometimes it was made of mahogany or oak and I wondered how she had had the strength to drag it up her stone stairwell. Whatever lengths she had gone to, she had found a way to make every crevice of the flat beautiful so that its social-housing uniformity was all but eradicated.

She went through sudden states of renewal or reinvention with it too, and my mother would tell me worriedly that Fauzia was throwing out an expensive wardrobe or the dresser she had saved up for months to buy. The flat went from looking like an antiques shop, from whose dusty layers things kept emerging, to a bare, gallery-style space with little or no furniture. The starkest transformation came when she painted everything white, including the door handles, taps, every inch of the walls and even the furniture. When I saw it for the first time, I felt as if I was inside an empty painting, and that I – we – were the moving artworks within it. This was still at a time when she was too depressed to paint, or to make any art, and it felt as if the materials around her – her flat, her clothes, even her face and body – became proxy canvases, which she was painting over and redrawing, again and again.

She began to speak of moving from Kilburn soon after she returned to studying art in her early forties. She had just enrolled for her degree at Camberwell but, frustratingly, wherever she moved after leaving Kilburn felt wrong to her. It seemed as if she had begun a search for the perfect home that kept eluding her. First she moved in to a flat at the bottom of Kentish Town, a few minutes away from me, which was on the top floor of a period house. It had sloping ceilings and spaces of such strange dimensions that it felt like a doll's house, or the room in Lewis Carroll's Wonderland in which Alice drinks the potion to become

oversized. Fauzia felt there were too many things wrong with it so she moved again, this time into her last flat on Warren Street, which she would come to hate and which she felt was slowly killing her.

She was sitting at the back of the café when I arrived. She looked frail, with a sallowness to her skin, but smiled when she saw me. She wore a furry hat and shivered as we spoke, and I became nervous when I saw the first signs of her agitation towards the crowd around us – the sudden rise of decibels in people's laughter, their accidental invasions of space. I could see her flinching, so I was relieved when she suggested we go to her flat.

She seemed instantly invigorated when we got inside and began showing me around. It was small but it had character and spaciousness, with pale wood floorboards and original Victorian window shutters. At first I followed her around the flat as she talked about how she had renovated each room. I occasionally picked up the things I recognised: a mirror with a picture of can-can dancers at the Moulin Rouge in its foreground, a jewelled frog made of metal, and a big cut-glass butterfly I had bought her a few birthdays ago.

She asked if I wanted to see her portfolio and began darting to different corners of the flat, bringing back canvases, pieces of cloth and sketchbooks bursting with drawings. She was flushed and breathless with the excitement of showing me, and her voice trembled as she talked about each piece. It was the first time I had seen her artwork in decades – ever since Saint Martin's – and it seemed as if she wanted to show me everything she had created in that time, putting the work on the bed, the floor and the surfaces, one piece on top of another. Just as I was focusing on one canvas, trying to take in its various parts, she was presenting another. She was berating herself for not doing enough on her course, not doing better, but it was clear she had produced prodigious amounts in a short space of time, and was exhilarated by it all.

So this was what Fauzia had been bottling up over the years, I thought, as I looked at the welter of works with gouache, charcoal, stencil, batik and thread. Some of the pieces were teeming – almost angry – with ideas, while others flashed with glitz and decoration. There was a portrait of lovers in yellows and oranges that combined embroidery with pastels and I was taken aback by how romantic it was, and at how much she had improved. I stopped her taking it away too soon. Then another piece was brought out, a Renaissance-style painting, I thought, but when I looked closer, I saw it was a large, embroidered cloth held between framed glass, with an intricate silver-threaded central panel. There were figures sewn around the panel – the back of a naked body outlined in gold thread, which looked like one of Michelangelo's perfectly proportioned men. A face sewn in thick black stitches resembling an ancient Greek god with a tumbling beard and grave black-and-gold eyes. Further in, a quartet of Grecians wearing togas, and a prone body at the far end of the embroidery. This figure lying down had her face buried in the crook of an arm. Her limbs were listless, her feet bare.

In between the people, there were pieces of still-life embroidered in tiny, tight stitches: an ornate bowl of fruit, a vase, a wooden bedside table. Its various parts seemed *non sequitur*, as if they had been copied from more than one Old Master painting, yet the more I looked, the more the images seemed to choreograph into visions of beauty placed alongside pain – or pain itself made beatific. The naked and prone figures on either side of the cloth emanated distress, while the Grecians at the centre stood in classical poses, impervious to the anguish at the cloth's outer edge. I was stunned. I knew our mother had encouraged Fauzia to go to her community centre sewing classes and that she had taken to needlework, but I had no idea she had incorporated it into her degree. This seemed like painting on cloth to me, yet it followed the formal rigour and rules of needlework, which created a strange, attractive tension.

'You embroidered this?' I kept saying, but even as I enthused about the tactile painterliness of the stitches, she seemed dubious of her accomplishment. Her course tutors were pushing her towards embroidery, she said, and she worried that she ought to be focusing on the classic art school traditions of drawing and painting instead. Much later, I spoke to her embroidery teacher from the Asian Women's Centre, Millie Jaffe, about the way in which needlework was so often seen. She had learned embroidery at Goldsmith's College in 1957 under the tutelage of Constance Howard, a leading light in British textile art at the time. Millie told me that Howard was doing astonishing things with needlework and appliqué, along with artists in the Glasgow School of Art, but these figures were outliers, and embroidery was still not seen as 'real' art in London's male-dominated scene. So much has changed in recent decades, with artists like Tracey Emin using embroidery techniques in her early, seminal pieces, and activist movements like the Craftivists. Embroidery no longer carries the stigma of being a purely feminine art – or, worse, not an art at all but a craft – but I am not sure it is regarded on the same footing as painting either.

I wonder if this was what Fauzia worried about, as well as associations with traditional Indian embroidery and, by extension, traditional subcontinental identity. These might have been all the ways in which her tutors' focus on embroidery had worried her about being pigeon-holed. 'Embroidery returned her to painting, and painting took her back to embroidery,' says my mother, but I think a tension between the two remained, and Fauzia was intent on proving herself in the field of painting, even if her new-found talent lay in applying the rules of fine art to cloth, not canvas.

I told Fauzia I loved this embroidery above any of the other works she had shown me and thought it was the most accomplished thing she had ever made. More than just admiring it, I coveted it, and asked her outright if I could have it. She put it

away, laughing nervously, as if she didn't want to refuse the request, but it was clear that the embroidery was too important to give away. Perhaps it was the work of which she was secretly most proud; I'm not sure if that is something she said. Either way, just over a month later she died and it became mine.

In the middle of showing me everything, she stopped and said, 'Ah, I haven't seen any of your work.' I shrugged and carried on looking. The acknowledgement was significant, though: at some point she had withdrawn her interest in my world, creatively and in every other way. She had had good reason for disengaging, I knew. The day she showed me her art was a memory I might have treasured, but the trauma that came with her readmission to hospital and shockingly quick death pushed it to the back of my mind.

It has taken me several years to think back to that afternoon and turn over its importance in my mind. I am cutting an apple in the kitchen in the spring of 2020 after opening her art portfolio for the first time since her death and, just for a moment, I feel an overwhelming sense of Fauzia's presence. It asserts itself in an electric snap, as instant as a Polaroid image flashing across my vision. It feels as though she has been conjured back from that afternoon. Maybe it is the opening of her art that has brought her to me.

She ran out of puff very suddenly that day in her flat. She stopped pulling out canvases and sketchbooks and coiled up on her bed. She lay there with grave eyes, prone body, a reflection of the figures in her Renaissance-style embroidery. In the stillness, we tuned into the thumps and footfalls from the flat above and she began speaking of the noises that had become such an obsession for her over the past year. She said she felt tormented and bullied by the family and neglected by housing-association officers. I asked her about moving but she said it wasn't easy to exchange such a tiny flat on the council housing system, and

also that she had worked so hard to make this space beautiful that it felt like a wrench to leave it. 'It's not that bad,' I said to her, about the noise, but really I was alarmed by how weak and sad she looked. 'Get out of here,' I wanted to say. 'Just save yourself.'

After Fauzia died, we decided that her artwork should be divided between the three of us: myself, my mother and my brother. But when it came to divvying it up, my mother said she didn't want any of it. As someone who has always been unerringly unsentimental – there are no family photos displayed on her walls and she is happy to give away all mementos from the past – this wasn't surprising. Still, I found it inexplicable that she shouldn't want any of Fauzia's art around her at a time like this. She had been so invested in her progress at Camberwell, discussing ideas with her in detail, sometimes sitting for portraits and telling me how accomplished Fauzia had become in embroidery.

I kept asking why she didn't want anything until she finally said it made her sad to see it. She had watched Fauzia's depression suck away her creativity over the decades and had been immeasurably proud when she had decided to go back to art school. She told me afterwards that she had longed for the day when Fauzia was awarded her fine-art degree. Maybe these works-in-progress were a painful reminder not only of Fauzia's thwarted ambition but of my mother's own unrealised dream for her.

When the art was first hauled into my home, it was so much and so unwieldy that I wasn't sure where I'd store it all. Bulging bags, canvases and stacks of sketchbooks lay, like tightly packed body parts, all over my attic flat. Fauzia's tutor, Kelly, came to see it in the summer of 2016, along with a colleague, Annette Robinson, from Camberwell. It had been only a few weeks since she had dropped the reel of embroidery thread into Fauzia's grave at Hendon Cemetery and I was still

in a paralysed state, unable to smile or sustain a conversation. I steeled myself for meeting them. But they were quiet, intuitive, and after a cup of coffee, they suggested they open Fauzia's artworks in another room. I heard them murmuring in conversation but couldn't make out their words. After about an hour, I drifted past the room and saw they had laid some pieces side by side. Certain pages of sketchbooks were open and embroideries unravelled to their full size. As they arranged the works, they talked in low tones, pointing to things as if this were a jigsaw whose adjoining parts were slowly becoming clear to them.

I eventually went in and asked questions. The more they talked, the more I felt they were seeing Fauzia in a way I had never done: through the work spread out in front of them. There is a repeated engagement with Western canonical art in Fauzia's work, Kelly felt, and particularly Renaissance-era artists, but also subversions and challenges to its orthodoxies.

'Look,' she said, pointing to an embroidered biblical scene featuring a naked Adam and Eve in the Garden of Eden. Fauzia had given me the image some years ago. 'Look at their faces. She has erased their features with black thread.'

I was surprised I hadn't noticed this detail until now, even though I had it framed on my wall. It was a curious thing to have done in a work that looked so traditional in every other respect, and it made me wonder if Fauzia had been thinking of the supposed *shame* of their original sin as she rubbed out their expressions, or if she had been masking the X-rated *pleasure* in them.

I felt intrigued by what they had found, and how Fauzia's work could yield new knowledge of her. After they had left, I decided I would look through it all, too, while it was still in one piece and try to make my own discoveries. But my grief felt too much an open wound and the images, so energetic and alive, were too painful to look at. I could see why my mother

didn't want to be reminded of the aborted potential in them, however dazzling they were, so I packed everything away.

Around a month later, my brother came to my flat so the work could be shared between us. My mother came too, to oversee proceedings. We unzipped the biggest portfolios first and laid out the work on every surface we could find, tiptoeing in the tiny spaces in between. As new or unseen pieces emerged, we gave them up to the other or made bids for them – 'You have that one' or 'I didn't want it anyway.'

But the tone tightened and then turned to hard bartering – 'I'll give you those two for that one.' The atmosphere changed, the further we went. There was a large collage I hadn't seen until Kelly unearthed it from a portfolio: it was a self-portrait made out of pieces of paper – a kind of papier mâché collage. My sister's eyes were large and melancholy and she had cut shapes around her face – neat geometric designs under her eyes and nose – that looked almost decorative. I loved it at once, and was amazed at how Fauzia had managed to capture the sadness around her eyes but also make it so beautiful, setting mosaic pinks against patches of black. My brother was just as struck by it, saying he'd swap it for two or even three others, and because I was so desperate to have the big embroidery Fauzia had shown at her flat, I agreed to the sacrifice, but the mood darkened between us with each hard-won bargain.

There had been some tensions already from when we had shared out the most cherished things from Fauzia's flat, and I hadn't said it but I felt upset at how few things I'd got. Now that grievance came back to be voiced, though I recognised the petulance in it. Maybe this is what tears families apart after a loss. The things that the dead leave behind can seem totemic. We clasp them close in lieu of our loss, as if the objects them-selves have taken on the value of our love. Or maybe we are making up for the love we didn't show them, by cherishing the things they cherished. I remember Rosalind's words at her

hospice: 'Don't hold on too tightly. She will come back to you.' Perhaps they were an instruction for just this moment, although I didn't think of them as I clasped my sister's art. It took almost the whole day to agree on who was having what, and even then we left it at an exhausted impasse with the last bag of artwork still to share between us another time.

My eldest niece, Martha-Bela, who was five then, had come to see Fauzia's art with my brother and she sat doodling in a corner of the room as we divided it. Just as my brother was leaving, she gave me the drawing she had been working on. In it, two figures stood at either side of the page. She had coloured in their clothes and faces, adding trees, butterflies and a sun. At first glance it looked like any one of her happy pictures, but in a thought-bubble rising above the two figures were the words: 'Stop fighting.'

I put my half of Fauzia's artwork away and it has lain, asleep, for almost four years. As I begin opening it, piece by piece, I wonder what I am looking for. I leave paintings propped up against the furniture, and they watch me beadily as I walk past them every morning. Her smaller work covers the rug in the living room and there are sketchbooks on tables and stacked underneath them. The task of looking, and finding, seems so big and bewildering that I feel like packing everything away again. Will I really know Fauzia better once I have gone through every artwork? Can she be exhumed from these piles? And isn't there something cowardly about searching for her innermost feelings now? Aren't I trying to get close to her only when it is safe to do so, when I don't have to negotiate the loud, difficult and messy realities of a sister contending with seriously bad mental health?

The idea of searching for her 'hidden self' fills me with a discomforting voyeurism too. It is clear in some pieces of work that Fauzia is capturing ideas and feelings as they occur, and

maybe their intimacies are for her eyes alone. What, for instance, would she have felt about the choice of works shown in the exhibition at Camberwell College? Would she have approved of the pieces that had been picked out as the most defining ones? Did they best sum her up or create a version of her that she would have contested? And what would she think of my leafing through it all? Is this the same raiding of her inner world as her prising open my locked box so many years ago? Maybe there are secrets that the dead want to keep, and they should be entitled to their privacy. Perhaps we should have buried her art with her so she could take it into the next world.

Then again, Fauzia was never the one with a locked box. She had shared secrets with me as a teenager – or, at least, she hadn't been as furtive as I was with her feelings. I begin to see that last meeting at her flat as her parting words on the matter: in showing me her art, she was showing me all she had become, her thoughts captured in the pictures whose pages she was holding open for me to read. 'Here is what I was feeling when I was in the depths of my despair,' she was declaring. 'Here is the person I am now with my still suppurating wounds and my undimmed delight in all that is beautiful in the world.' Maybe that was why she had called me over to her flat that day – to give me permission to look – and was showing her work to me as quickly as she could, in an almost fevered state, while she had the time and energy.

Years ago, I had met the Portuguese artist Paula Rego in her Camden Town studio, which looked like a cross between a junk-shop and an art gallery. It had reminded me a little of my sister's over-filled flat in Kilburn. I was an arts correspondent at the *Independent* and Rego had wanted to encourage the public to take up drawing, so she had offered to give me a lesson. 'Looking,' she had said, was what drawing taught above all else. 'When you learn to draw, you learn to see. When you learn to see, you begin to see things you did not realise were

there. You discover all kinds of things when you really look.' I had felt inspired after the lesson and Rego had given me an empty drawing pad to encourage me to carry on at home. I prized it, like a trophy, taking pleasure in feeling its thick blank pages, though I quickly became too busy for sitting and looking, so it stayed empty. But her words remained with me and came back now as I saw how carefully and keenly Fauzia had looked at ordinary objects, as all artists do, I suppose, seeing blues and yellows in apples and multi-coloured swirls in the grain of a wooden table.

So, I try to be the artist and begin to look. I leaf through the large, unmounted paintings that are packed in a black leather portfolio and I am dazzled by the brushwork in them and their minute, ornamental industry. A painting among this work looks familiar. It is a composition of vases and acorns set on a piece of cloth, and Fauzia has used the colours that recur in so many of her paintings: shades of blues and greens with autumnal yellows and browns. It must be one of the paintings she had shown me in our last meeting, I think initially, or something I saw hanging in her flat. It is only weeks later when I pull it out again and turn it over that I see her writing on the right corner of the paper. The words are faint, in pencil: 'To Arifa – Look – my first great piece of art!!'

I look at the front of the painting and I am surprised at how I could have forgotten it. It is – surely it *must* be – the painting that Fauzia gave me on the train to Edinburgh in 1991, just before I left the family, and her, for university. I squint in an effort to remember the painting I had stuck up on my wall with Blu-tack as a student. I would tell anyone who asked that my sister was studying art and wasn't she talented? They would nod and I'd be sure their admiration was genuine. Was this the same work? I recognised the vase in the foreground. But I also remembered the tactile brush-strokes of that painting, congealed thickly to make the paint shine, like ruffled velvet. The strokes

here seemed longer and looser. And at the front of *that* painting there had been a small object – I forget what – that looked out of perspective, perhaps too small compared to the objects around it. My eye had been drawn to it every time I looked because the rest of the composition was so rigorous in its proportions that it jumped out at me, like a small, single flaw on a beautiful face. But there was no imperfection in this one: all the proportions cohered. Was this really *my* painting and, if so, how had it landed back with Fauzia? After graduating, I had brought it home, I remembered again. Then, somewhere along the line, it had disappeared and I had blamed myself for losing it, although I had often wondered how it could have gone missing when I hadn't unpacked anything. Had Fauzia taken it or might I have given it back to her and somehow forgotten?

As I studied it, I wondered if this wasn't a more mature version of that original painting. The colours weren't as vivid, its strokes were more harmonious, and there was something not quite right about the inscription on the back: only half of her signature was on it. It was as if the edge of the paper had been cut. Then I noticed that the painting was made up of two layers of paper, with the back of the original work stuck to the front of another painting of the same likeness, perhaps. Why had she done that? Was this the improved or perfected version of the picture she had given me? But if she wanted to obliterate the original, why keep the inscription at the back?

I felt frustrated by the not-knowing. The two paintings, stuck together so firmly that I dared not peel them apart for fear of ripping both, represented the impossible process of under-standing Fauzia now and the impossibility of extricating the many sticky layers. She had become *more* unknowable through small discoveries like this one, and I was left in the equivocal territory of interpretation. I wondered if this was a good sign, that she had wanted to remember the moment she'd given me her most precious artwork, with all the hope it contained in its

inscription ('My *first* great piece of art') and also be reminded of our closeness through the inscription. Or if, in fact, as I suspected, it contained a rubbing out, a literal redrawing, of that moment. Maybe this was the 'better' painting she wished she had presented – a more perfect version of it.

Having it back in my hands, I felt ashamed for losing track of it. It might have been proof for Fauzia that I was careless with my love of her art, and of her. The painting had disappeared shortly after I returned from teaching English in Poland and maybe, finding it mouldering in our parents' shed, where I remembered leaving it, she decided I wasn't a worthy owner of it. Of course I could be wrong with all of these half-formed theories. The slipperiness of seeing my sister through her artwork was all too apparent; the act of looking wasn't a neutral activity and I would forever be projecting my own stories onto these images.

Perhaps the 'truth' of Fauzia was not here to find or see. But then I pick up a sketchbook and there is a picture of a human spine that Fauzia has drawn with soft pencil in all its anatomical intricacy, and it puzzles me. Here is a spine again. She has written a note above it that is faint but discernible: 'I sometimes draw with my fingertips rather than my eyes.' Yes, I think, Fauzia *did* use her fingertips to draw, through her embroidery. It was what Kelly had suggested too. Sentences and scribblings-out are stitched into her largest embroideries, protest and outrage sewn alongside pretty sequins and stitches. Some words look scrawled and wobbly, like sprayed graffiti, but as Kelly had said, 'There is a tension between their apparent spontaneity and the slow process of rendering them with needle and thread.' If Fauzia saw the world through these needles and threads and felt its shape in her fingertips, this was where I would begin to see her more clearly.

*

The women on my mother's side of the family are all trained in something or other. My grandmother, Shireen Rasheed, trained as a teacher in pre-Partition India; my grandfather's sister was the gynaecologist who partly oversaw my mother's first pregnancy, with Fauzia. The expectation to become a professional working woman has streamed down further. One aunt is the head of a law school; others are artists and teachers. One is a single mother and radiographer. So many of their daughters, in turn, are academics and medics.

My mother wasn't one of those working women. Her father – my grandfather – was an anomaly in the family for not wanting his daughters to take up professions. He was a wealthy businessman who thought they shouldn't work. Shireen didn't agree but he wanted them to become pampered wives whose husbands would provide for them. My mother has two sisters and each was named after a flower. His endeavour seems so ironic, given that none of their marriages brought the life of luxury for which their delicate names were chosen. My mother has spoken of her frustration at being denied an education. It must have been doubly frustrating with so many older women in the family as models of highly educated, multi-tasking motherhood. Her brother, Awais, became a nuclear physicist. She conspired to push her youngest sister, my aunt Nilofar, through a fine-art degree in secret, which she completed with the help of my grandmother.

In 1937, Shireen was sent from Lahore to the Punjabi city of Hoshiarpur for her teacher-training course. Embroidery was a formal part of it, and she returned home as a maths teacher with a love of stitching. She began decorating the edges of everything in the house, from pillowcases to handkerchiefs and bedspreads, my mother tells me. A single piece of Shireen's work remains – a rectangular dressing-table doily with a border of geometric shapes that look like art-deco-style snowflakes. They are stitched so meticulously in frosty blue thread that they might have been machine sewn.

When my mother was growing up, most women in Lahore made their own clothes – professional tailors catered only for men – for her, sewing was an integral part of everyday life. But what she loved most was the embroidery her mother had passed down, so she adorned her trousseau of bedspreads and table-cloths in 1968 with pieces of cut-glass sewn into them and neat columns of green and blue flowers, which I remember being used in my childhood. When we came to London, she started learning tapestry alongside embroidery at local community centres. Our Primrose Hill flat was gradually covered with layers of stitched cloth, just as her childhood home had been.

But the sewing my mother took up in my childhood, could not be called a mere hobby because it was more necessary than a carefree act of creativity. She speaks of feeling numb and mute for years after arriving in London. Silence filled her life and left her at a distance from others, and from herself. Sewing was the one thing that connected her to some form of self-expression. Embroidery is intricate and exacting work, and perhaps she found some comfort in the precision it demanded: order in her new state of chaos. She has spoken of the drudge of full-time motherhood and said her inner life narrowed to such a degree that she would spend hours cleaning the house when we were at school, and the remaining time staring out of the window, thinking of nothing, observing nothing, until we came home.

Even when we were there she was a remote presence, often quiet or cleaning compulsively. She says she didn't realise it at the time but she must have been deeply depressed, cut off from her family and stuck in a bad marriage. Her response was to retreat into herself. She carried on with the sewing, though, also knitting hats, scarves and jumpers one after another in an endless circuit of productivity, and following cross-stitch patterns to create pictures of pretty houses, boats, birds and trees. I have asked her why she didn't design her own patterns and only

followed the ones she was given in class, and she says it was because she wasn't good enough at drawing.

I remember her stitching for hours at a time in the evenings and never understood its appeal, but I can see now how such steady activity might bring physical calm, slowing the heart rate and occupying the mind while not demanding everything of it. Still, I wish I had looked closer at what my mother was sewing. When I met Paula Rego, I asked how much of her work contained autobiographical elements. She said that although artistic creation took her outside herself, the end result almost always presented back to her aspects of her life, or states of feeling. She described this as an unconscious and almost accidental process of creative self-discovery. 'In the end, what you find is something about how you feel.' But my mother's tapestries only ever replicated an existing pattern, presenting an alternative world that perhaps she craved to build for herself, which had an idealised, unpeopled, chocolate-box quality and no hint of darkness.

'Embroidery can be very therapeutic if it involves counting threads and following a pattern,' says Millie Jaffe, but even within this soothing repetition there are opportunities for creativity and imagination. She remembers an Asian Women's Centre in Camden Town where she taught decades ago. A lot of women there had come to England at a very young age to get married and were not confident in the wider world. They had needed a certain degree of courage even to venture into the building, she says. 'I started them off with very simple designs and got them to embellish them. They did some lovely things, yet when someone from the local Adult Education Institute came to observe the class, they thought it could all be more creative. They didn't see the gradual evolutions of the designs and the imagination these women were putting into their work.'

Maybe that's a lesson for me, too, in ways of looking. Perhaps, if I go back and look at the nuances within my mother's tapestry

and embroidery, I'll find some parts of her quietly lodged between the formal patterns.

Either way, it makes perfect sense that when my mother saw Fauzia in the grip of another debilitating depression in her late thirties, she urged her to embroider. By then, my sister was deep in a viciously repeating cycle of compulsive eating and purging that seemed to crush her spirit and leave her physically ill. She had been seeing an eating-disorders specialist at the Royal Free Hospital for around a decade; she said they only made her feel more hopeless. My mother thought embroidery might bring her some respite from her struggles and lift her mood, just as it had done for her. Incredibly it did, although her depression still hovered close by. Fauzia began learning the basic stitches from Millie, who had been running the class for many years, and instantly took to her.

I had heard my mother and Fauzia talk endlessly about Millie but I only met her after Fauzia's death, at the exhibition in Camberwell. She was eighty-one then and had put off plans to visit family in Scotland so she could come to Fauzia's show. I had imagined her to be a frail woman, but she was sturdy and vital. Fauzia had her own approach to sewing right from the start, she said. 'She didn't tell me about her art background or about the difficulties she had had. She just did things. She didn't seem to have a plan at the start of an embroidery and she took a path that was quite off-the-wall sometimes. She was obviously talented but, more importantly, she had things to say.'

A black leather suitcase that my mother brought to her marriage in 1969 with her dowry now contains all my sister's first pieces of embroidery. The case is thick with stitched work at different stages of development. The early pieces are made up of large, childlike blanket stitches, but as I peel through the pile they become more complicated until they are dizzying in their adornment: a palimpsest of beads, sequins, coloured netting and satin, all layered

on top of each other. I wonder how long it took Fauzia to make all of this. There are thousands of hours of slow, solitary sewing inside this suitcase, her thoughts made solid and woven into fabric. At least there is this left of her in the world, I think. These are the imperishable parts of her that remain, but a memory of my neighbour Rosalind Hibbins prickles in the back of my mind and undermines my certainty.

On the day she emailed about her terminal diagnosis, I went to see her with a neighbour. She opened the door and seemed as stunned as we were by the news. She wobbled as she walked and her voice was thin and shaky. I hadn't seen her for a few weeks and I was startled by how transformed she looked, her skin ashy, her hair grown back after chemotherapy in short tufts. There were a few others already around her – a carer, a friend, the vicar's wife from the church next door – and a wordless separation seemed to take place in the room. We were the living, come to comfort – but also to stare at – the soon-to-be-dead, or so it felt to me, and I felt uneasy at this unintended hint of voyeurism. I should have come on my own, I thought, when there was none of this spectacle. Rosalind might have felt that divide, too, because she looked lonely and lost. No one knew what to say and I felt tears welling. My sister had died a few weeks earlier and everything that had happened surged back in this moment of imminent loss.

The others looked shocked at my outbreak of tears and Rosalind tried to reassure them, saying that my sister had recently died. After that we sat together in her living room even more awkwardly, looking at our feet until Rosalind started scanning everything in the room, her books, photographs, the stone carvings by her fireplace that she had made over the decades. 'What will happen to all my things?' she said, and no one knew what to say. These were her lifetime's treasures but I could already guess what would become of them after she died, when the flat was emptied. She clearly thought the same thing

because she kept asking the question, then reassured herself by pointing to an object to say that she had left it to this or that friend, and her sadness was made easier to bear.

A few months later, I was on my roof terrace, which over-looked Rosalind's back terrace, and I looked down into it. By then, the flat had been bought by an art historian who was in the process of putting in soundproofing. The roof terrace was jam-packed with bulging black bags and bits of broken furniture. I tried not to recognise the dining-room chairs with legs missing and the old radio clock from Rosalind's kitchen, which now lay with all its wiry innards exposed. This was what had become of her possessions. I have no doubt that the things she had cherished most and lovingly preserved had gone to good homes, but so much else had become debris, to be taken to the dump by workmen.

I had gone back inside and thought of Rosalind, then looked around my own living room, its endless bric-a-brac whose senti-mental value no one else could know. I imagined all this domestic treasure one day being broken up and made into a pile of rubbish. There is only so much you can leave as parting gifts to the living, and even then, it has to be of some value to them if it is to survive beyond you. Fauzia's artwork would be part of the precious hoard I'd leave and it felt like a responsibility. How would I ensure its survival? It was too beautiful to destroy or to remain unseen. But if I gave pieces away, I would be parting with the only physical bits of Fauzia I had left to hold on to.

I turn back to the embroideries in front of me. There are so many, I think again, and each is so intricately composed. Every leaf and petal is coloured meticulously. There is a bird whose plumage is stitched in shades of yellow, blue, grey and brown. A fruit bowl has the same complexity of shading. Nothing looks flat. Images of foxes, fish, butterflies and cats are stitched and repeated in other media: stencilled, drawn, etched. She seemed not to get bored by repetition and in this

I see the dangerous perfectionism that fuelled her eating disorder and her punishing exercise routines: sometimes six hours in the gym at a time, and days without eating solid food. This is perfectionism made manifest; exacting, supremely controlled, not a stitch out of place.

It is not the most complicated or accomplished pieces that hold my attention, though. There is almost too much to look at in them – a relentless need to keep doing more that overwhelms me. I put them to one side and return to the early embroideries. I find what looks like a deliberately naive image of a picture-perfect house, the kind my mother replicated in her tapestries. A couple looks out of it. The man smiles from a window, the woman from the door. Outside the house, two mermaids stand in bikinis. It is clear that they are from another world and that they have brought their watery universe with them; Jurassic-sized butterflies fly around them, a shoal of fish rides on waves, a comical crab has eyes on stalks. There are cute, coloured umbrellas overhead and two suns in the sky, one for each world. The mermaids watch the home, smiling. The couple inside smiles back. It is a sunny stand-off between the two parallel worlds.

I think I know what Fauzia is saying. That the couple's dream home – the kind that children learn to draw, and desire, at an early age – is as much make-believe as the Atlanta from which the mermaids have risen. Both are mythological. The embroidery takes me by surprise. Her life wasn't all pain: there was wit and liberation in it, and here the tail-finned water women were looking on at the model of the life we are often taught to wish for, and chuckling at it. 'Needlework has duality: the ability to show one thing and tell of another,' writes Clare Hunter in her history of embroidery, *Threads of Life,* and I think Fauzia is showing and telling two things in this piece. We had both grown up with the same disregard for traditional femininity, despite Fauzia's love of dressing up, and neither of us had bought the

manufactured dreams around the ideal of nuclear family life. Even now, in unmarried middle age, it still seems to me a far better prospect to end up swimming in Atlanta's strange underworld than become the glassy-eyed couple with the picket fence.

I see why Fauzia's tutors at Camberwell nudged her towards embroidery. Cloth seemed to be a far more inventive canvas for her, and she could also give in to the urge to make things pretty as she emerged from the depression that had swallowed her for so long. Did it feel like Jonah being vomited back into the light? Did colour and shape seem sharper after she'd lived in the murk for so long? As with my mother's tapestries, what I find in this suitcase is the absence of pain, but the happiness is so blinding and shiny that it begins to feel hallucinatory and unreal.

7

Pain

Life brought Fauzia pain. There were endless Sisyphean cycles. Just as she pushed back one agony, another careered towards her. After my brother and I left home, she was still there, her life grounded while ours took flight. In her early twenties, she would intermittently leave without getting in touch for months at a time; she would tell our parents that she had lived in another city or European country when she came back but give them no more detail beyond that. There were constant stops and starts, when she would enrol on a university degree course, then drop out, not because she wasn't succeeding but because the depression had ambushed her again. That depression, which was later diagnosed as bipolar disorder, along with a possible borderline personality disorder, fed her eating disorder, but she made painstaking attempts to get better, with visits to eating-disorders specialists, psychiatrists, social workers. Always the crashing disappointment when nothing worked.

There was anger as well, which escalated in her twenties and turned not just on herself but outwards at the family. She became more disruptive and disturbed. 'I have been quiet for so long,' she said to me once, as an explanation for her explosions. There was something volcanic in the unburdening of her pain now. She screamed out her suffering, reminding the family of the injustices in her childhood. She wished our parents dead, herself too. She shouted on streets and in supermarkets. People stared, but she was unashamed. She smashed plates against the kitchen walls while my mother watched in horror, then threw them out of the window, onto the street. She began confronting our

parents about her past, with anger burning in her voice – our father for his acts of cruelty, and our mother for failing to protect her against them.

'You've made me like this,' she'd say to our father, who shook his head with shock and denied it. She would shout louder until he became scared, and shrank away from her. She stopped going out for weeks at a time and skittered between severe lows and erratic or hyperactive behaviour. Our parents returned home one day to find that she had opened the albums and cut out her image from every family photograph to leave a hole where she had been. It seemed like a symbolic withdrawal from a family that had made an innocent victim of her as a child. She had used a Stanley knife to excise her image and its blade-like scars looked like an aggressive gesture towards the family too, as if there was a will to mutilate it. She didn't throw away the cut-out figures of herself, and some months later, when she had come to regret the act, she stuck some back onto the original photos. There were too many to mend so most of her images remained disconnected and were put away in an envelope for safekeeping.

I come across these cut-out images of Fauzia some years after her death, and gathered together in this way, they form a magnified portrait of her in various stages of childhood. Among the defaced photos, I find a picture of myself. I am about three years old, sitting beside Fauzia, who has our baby brother in her arms. In this photo it is *my* face, not hers, that is missing. It is not cut out cleanly with the knife but gouged through messily, and it is a shock to see Fauzia's anger at my three-year-old self. I stare at my defacement and contemplate the collision of old feelings: the horrifying possibility of my own culpability in Fauzia's pain as a child, the outrage that I should be hated at the age of three, the realisation that this is not hate but hurt, and a recognition of my own pain over Fauzia's ruined childhood.

I realise that I was aware of this cycle, even as Fauzia was blaming me, but I couldn't help being angry back. Her rage seemed designed to push us all away. After I had left home, and was out of Fauzia's line of vision, the brunt of her aggression became focused back on our father. I was working as a journalist in Newcastle when our mother went to visit her sisters in Lahore, in the spring of 2000, and I got a scared phone-call from him. He was living in the family flat with only Fauzia, who was behaving in threatening ways, he said, prowling around after him, glaring and shouting. He asked if he could come to stay with me for a few nights to give her time to calm down. He came up on the train later that day, bringing nothing with him but his wallet. The sight of him was pitiful but I felt something of her anger too. 'Isn't this all your own doing?' I wanted to say.

After Fauzia died, I asked my mother if our father had ever apologised to her. She had walked in on a moment between them in which he acknowledged what he had done, she told me. It was when Fauzia was in her thirties, and living in Kilburn. She had paid a visit and was upstairs with our father. My mother says she was surprised to hear their murmuring conversation from downstairs. Fauzia rarely talked to him beyond cursory greetings or angry accusations, but this conversation sounded protracted and calm. My mother went upstairs to see my father sitting in his usual corner and Fauzia standing at a distance, listening to him.

'*Mujah maaf kurday*,' he said. 'Please forgive me.'

He went on to admit he had done her wrong and that this was why she was so angry and ill. Fauzia remained silent, neither accepting his apology nor rejecting it, my mother says.

'Did you discuss it with him afterwards?' I ask.

'No,' she says, but she adds that she was surprised to hear him apologise, and see him look so ashamed. I ask her about Fauzia's reaction again, and she remembers that the lack of a

reaction was marked. Fauzia just stood silently listening, then walked away.

I wonder what relief, if any, she might have felt. Maybe the apology came too late. Maybe it was inadequate in relation to the weight of her suffering. Or perhaps what was really required was an explanation – *why* had she been targeted in the first place? – which our father didn't give her, as far as I know. Her psychological upset seemed undiminished by it, either way. More and more, the precarious state of her mental health commanded our attention. The air changed when she was in the room – we were on tenterhooks, waiting for something to happen – and when she *wasn't* in the room, the conversation always returned to her: what she had done, what she might do, what danger she was in and who was to blame for it. Her anger was the enactment of a retributive kind of justice on the family, but it carried its own tyranny. She stayed enraged long after she had silenced our father. Even after she moved out of the family home, she carried on bursting into flames.

It grew difficult to be with her, and to express my sympathy, even in the times we weren't arguing, because everything came back to her bigger pain. Her suffering was insurmountable, it seemed, and I was fed up with being implicated. After years of feeling apologetic, I began to see her differently – her selfishness, because her illness left no room for others, her self-pity, which seemed boundless, and her eating disorder, which made her self-obsessed.

There were some years when Fauzia and I would be friends again. I went to visit her in Edinburgh where she lived in a pretty flat with large bay windows for much of her twenties. When she moved back to London, I went to see her in Kilburn, sometimes to borrow a skirt or top for a party, and we'd spend the evening drinking tea and trying on clothes, with her telling me what suited me and what didn't, then finding jewellery to set against the outfit.

There were years when the mutual suspicion and bitterness would be put aside until something sparked up again: often it was Fauzia's relapse into depression, but later it was my grudges and suspicions. I don't think either of us orchestrated the space that grew wider and wider between us, but I could see that much of it arose from her illness. That was what I grew to resent most. Her depression and eating disorder had hijacked her life and our friendship. She had spent years numbed on Prozac, and some months in a locked psychiatric ward at the Royal Free. She became increasingly distant in her thirties. Her depression sucked away the intimacy between us and made her more and more unknown to me. It was a returning riptide that dragged her out, further every time, to black waters. It turned so many years – decades – into voids filled with medication, psychiatry and estrangement from life. I could see that it was *barely* an existence for Fauzia, a slow drowning. At times when we got together she looked too sad, too resigned, even to speak. By the time she died, she felt miles away from me, a dot of a sister on my horizon, painful to love, but no less loved.

It is hard to see the whole of someone when they're still alive, however intimately you know them. They are a moving subject, resisting a conclusive pinning down, and it is only when they stop that a definitive shape and form presents itself in the stillness. That's how it seems to me now, or maybe Fauzia's absence is just an opportunity for me to create a false version of her. I hope not. When I look for her in the stillness, I see that her never-ending anger came from her never-ending suffering. And I see her suffering in others now, unravelling on the street, shouting at strangers, demanding justice for themselves. These are profoundly upset people who may not be easy to know, but life has left them destabilised, destitute, ill, desperate or embittered. Shouting might be their last remaining iota of power. It may offer *some* level of resistance, of protest, to the condition of suffering. I think back to the embroidered graffiti I came

across in Fauzia's portfolio: 'I didn't know how to be assertive so I just raised my voice and said the same thing.' There was as much fear as anger in her apparent acts of aggression. In a text message she sent me from hospital in May 2016, she had written: *I try and give up making a fuss about things. THEN something always crops up and makes me disturbed and bitter.*

Fauzia's pain, right from the start, was the opposite of the genteel fantasies of suffering that Susan Sontag and others talk about. It was obnoxious and 'unfeminine', spiky and real. It wasn't a means of Delphic illumination, as Virginia Woolf suggests of illness in 'On Being Ill', in which she equates suffering with a higher sensibility or state of mind. For Fauzia it was a negation of the self. It deadened her creativity and numbed her senses. She told me she came off the Prozac, and several other antidepressants, simply to *feel* things again.

Sontag also reflects on the way in which TB (and cancer) has been pathologised in the past and connected to the sufferer's predispositions, as if to suggest they have brought it upon themselves. I think mental illness has been stigmatised but also sentimentalised in a similar way. It is still not seen for the savage malady it really is, with all its cruel paradoxes, and too often, the sufferer is either not believed or blamed. Fauzia was desperately lonely yet she seemed to push away those closest to her. She was dangerously vulnerable, right up to the end of her life, yet she was seen as a difficult woman – or an aggressor – by people around her.

I am glad now that Fauzia didn't bear her suffering graciously. She wasn't the quietly ailing person that the world requires the ill – and especially ill women – to be. A week before she died, a doctor who was partly overseeing her case took us into a side room and told us her condition looked precarious. 'Is there anything she could be hiding?'

'No,' I said. If she had been taking drugs, or doing anything illicit – as the doctor seemed to suspect – she would have told

us about it. Fauzia never hid her self-destructive urges. She declared them openly, accusingly, to the world.

The central expression of Fauzia's pain was through her eating disorder: the perennial oscillations between bingeing, purging, fasting and bingeing again, that left such brutal effects on her body. Her sudden weight-losses filled me with fear and wonder, the sudden and dramatic gains made her body look like it had been stuffed. Loose skin hung like old lace around her limbs after she had expanded to more than nineteen stones, then shrank too quickly from taking diet pills. There was so much of it in her mid-thirties that she had an operation – a kind of skinning – to slice it all off. Then, in her late thirties, a more extreme shrinking so that she looked stretched out, her limbs and features elongated, now barely seven stones. She seemed calmed by this new physical state, but the lack of food left her in a daze, and in 2006, she stepped out into the road and was hit by a bus. She was taken to St Mary's Hospital in Paddington, and when I went to visit, I was frightened by what I saw. The nurses had tucked her up so only her face was visible. She had a black and bloodied eye socket and a gash above her upper lip. Her body was such a tiny bump beneath the blanket that the bed looked oversized. Her back had been mangled and, as a result, she suffered from almost constant and acute pain for the rest of her life. After the accident, she began eating compulsively again and speaking of the small scars on her lip and eyelid as giant deformities. She went to the doctors to ask for their reconstruction and was enlisted in a pain clinic for her back, living on painkillers and antidepressants. There was pain in the body, and pain in the mind.

When Fauzia was in her early teens and still living downstairs in the box-room of the family flat, I remember her telling me, in conspiratorial tones, that when the rest of us went to bed, she crept back into the living room downstairs to watch TV

late into the night. This was when she saw the frightening things that we were banned from seeing and described her viewings to me: the terrifying twists in *Tales of the Unexpected* and the *Hammer House of Horror* series.

Among them was a television adaptation of Fay Weldon's pitch-black satire, *The Life and Loves of a She-Devil*, in which a hulking, clumsy and apparently ugly wife, Ruth, enacts an inconceivably elaborate but exquisite revenge on her husband, Bobbo, after he leaves her for his mistress. Fauzia explained its plot to me, episode by episode, and I listened wide-eyed. I had seen the trailer for the drama, which showed Ruth glaring out at us, with flames lapping around her. I only ever received the story through Fauzia's narration and she seemed to thrill in the baroque turns of the plot.

But when I read the novel after her death, I see certain parallels in Bobbo's positioning of an unwanted wife at one end of his life, and an adored mistress-turned-second-wife, Mary Fisher, at the other. Ruth is a sort of modern-day Medea: she sacrifices her children by deserting them, so she can be free to orchestrate her revenge and is guided principally by an over-whelming envy for Mary Fisher, but also anger towards Bobbo. 'Hate obsesses and transforms me: it is my singular attribution . . . Better to hate than to grieve. I sing in praise of hate and all its attendant energy . . .' she tells herself.

Her revenge not only destroys Mary Fisher but leaves Ruth's own body mangled and in constant pain after she enlists plastic surgeons to transform her physically in ever more queasy acts of cosmetic surgery, which amount to elective butchery. They truss or slice skin and chop through bone so she can become as petite and pretty as Mary Fisher. It is anger turned outwards but inwards too: '. . . loose skin from beneath her arms would be tucked, and fat removed from her shoulders, back, buttocks, hips and belly. If she insisted on leg shortening, the shoulders would be braced back to keep the arms in better proportion to the rest.'

This intricate embroidery of fauna and flora emerged out of a suitcase of needlework that Fauzia left behind after she died. It was part of a body of embroidery work that glitters with colour and sequins, even though much of it was created when she was suffering from acute depression.

Graffiti is combined with images of crows and the crucifixion, which emerged repeatedly as a motif in Fauzia's artwork, and demonstrates her engagement with Western canonical art history.

They made art, I just moaned...

am ous Girl
endences in art
IT REALLY SEEMS LIKE THAT
They were scared to death of me, being close
to the edges of a crazy despair
They told me to live with it
40 stone man he has no limbs
She'll confuse it all
GONE WRONG
Space is for us
ARM BANDIT
ection was words seconds
ges. lips
lumpy words
aniels
paint me up
when the rejects became the mainstream
I had nowhere to go
Eradicate Me—
DID YOU DO THIS?

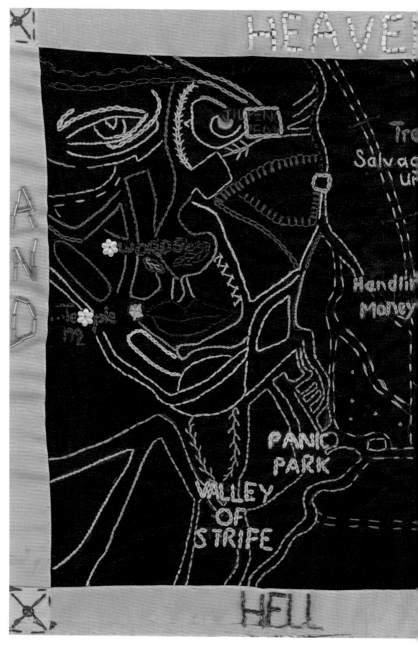

Heaven and hell are imagined in words and mapped out as roads, but also in the shape of a face, which gives this work a double meaning. It was clearly a subject that fascinated Fauzia as she filled several notebooks with similar grids in different media.

en Sanctuary

EXPLORATION

Unity & Love
Institute

Adventure
Amusement

Learning to Draw

KEY of understanding

SYSTEMS OF CONTROL

AVENUES TO SUCCESS

PERCEPTIONS
OF
SUCCESS

BREAKDOWN HOUSES

AND

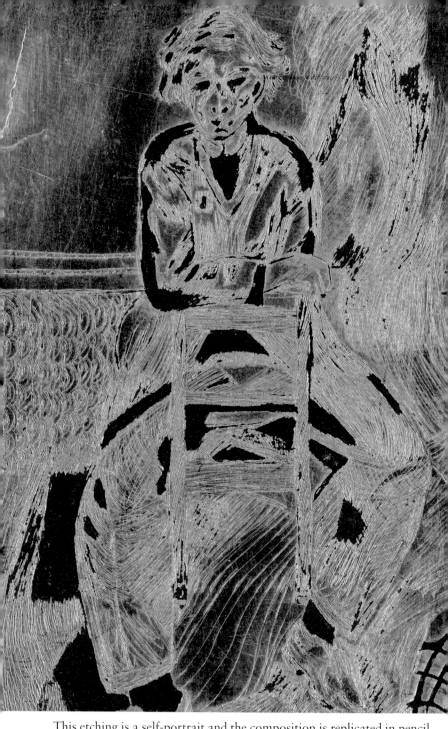

This etching is a self-portrait and the composition is replicated in pencil sketches and stencils. It has no date but there are hints that she made it when she was feeling unwell or upset. It seems to be a portrait of her emotional state, carrying sadness in its downcast eyes and lugubrious shadows.

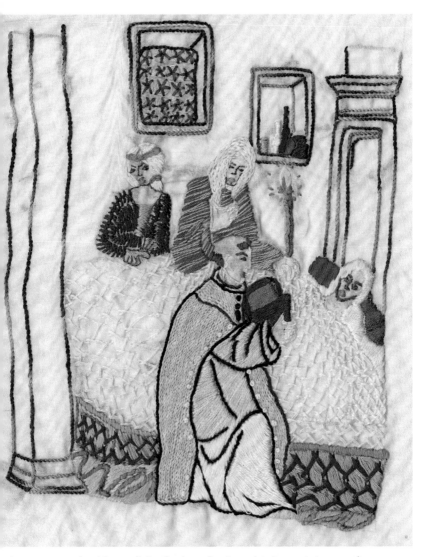

An ornate embroidery of the final confession, this is reminiscent of a scene from an old painting though the exact inspiration for it remains elusive. Fauzia often replicated Old Masters and added her own twists. Here, there is drama, colour and intrigue to the final confession.

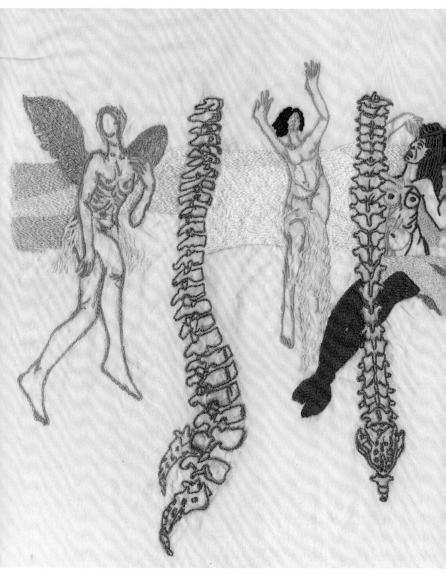

This was Fauzia's last embroidery, composed in 2016. She was working on it in her final days, breathless but determined to finish it. Its spinal columns, and ailing women seem to foreshadow her own death from undiagnosed tuberculosis which travelled fatally up her spine.

Ruth doesn't listen to the doctor who tells her, at a certain point in her physical metamorphosis, that she doesn't need to look any prettier, or to have three inches of bone cut from her femur. And that if she does, it will leave her feeling as if knives are digging into her flesh every time she walks. 'I'm remaking myself,' Ruth thinks, impervious to this prospect of never-ending pain, and keeps on honing and perfecting, enacting her vengeance on herself, it seems, as much as on her enemies. It seems far-fetched but I see something of Fauzia in this: her all-consuming anger left her combusting and seemed to generate an existential anger towards the world, but she also seemed intent on tearing into her body in another kind of pained anger, turned inward, to 'correct' its apparent faults, and make it ever more perfect.

Living through continuous pain is one thing. Observing it is another, especially at close quarters. That, too, is its own onslaught. Susan Sontag writes about it in *Regarding the Pain of Others*, focusing on representations of suffering in wartime. Her book is mainly a reflection on photographs from the front-line and how we demand 'authenticity' from them: they can't be staged or symbolic, they must be literal and real. Sontag goes on to say that these photographs position us either as spectators who can't stop gawping or as cowards who look away.

The rules are different for fine art, she argues, and defined by the iconography of biblical suffering through the centuries. There are a thousand and one canonical images of saints in states of spectacular pain to prove her point, and of Jesus nailed to the cross. Christianity shows pain in all its glorified detail but none of this undercuts its 'truth' in Western art. Towards the end of her argument, Sontag talks about pain on a more singular scale: how watching others suffer can leave us powerless, impotent, fearing that nothing can be done. And so we look away.

There is a dimension to Sontag's definition of turning away that disturbs me as I read: in looking away from those in need

of help, we are in fact turning away from examining the privilege of our safety because 'our privileges', says Sontag, 'are located on the same map as their suffering, and may – in ways we might prefer not to imagine – be linked to their suffering'. So I am returned to the childhood positioning of Fauzia and me as sisters. Was Fauzia's depression linked to my wellbeing? Was her pain a condition of my – relatively – pain-free early life?

But I am not convinced by Sontag's theory of how this separation leads to a desensitised state, or perhaps I just don't want to accept it because it implicates me. Looking away from Fauzia's cycles of pain was more a result of too much pained empathy. I couldn't stand to keep observing it because it felt too traumatic to do so and I could never have desensitised myself to it either. I didn't doubt its reality but I couldn't keep bearing witness to it without taking on the unachievable duty of finding a solution for it. When I didn't, or couldn't, I became disenchanted, both by my failure and by Fauzia's continued suffering.

Perhaps I also stopped treating her pain as mine to resolve. Bit by bit, over years and decades, her complicated mental health and continuing state of sadness made her the unknowable sister. At one time I had thought of us as so similar. Now the pain of observing someone who was both like me, and not, was confusing. I began to convince myself that I would surely have heaved myself out from whatever depths I found myself in, and it distressed me to see that she wasn't doing that. I mistook her for myself and at the same time I became frustrated with her for *not* being more like me. In the end, there was too much pain in being the observing sister. There has to be *some* hope when you're observing the pain of a loved one or it becomes unbearable. I didn't want to keep looking because, in truth, I lost all hope she would ever feel better. Her life seemed like a ceaseless battle in which she was being assailed from all corners.

*

When we were clearing Fauzia's flat after her death, I found an old diary from 2003. I read a few pages, and it was so excruciating that I couldn't carry on. The most hopeful entry I read was on New Year's Day:

Wandered about Kilburn High Road by myself after watching the fireworks from my house yesterday. Ate chocolate at midnight . . . After returning home, I ate other food, which I vomited a few hours later. Then I slept for some hours before another binge. It all left me bloated and in a state of emotional turmoil. My only consolation is that it's New Year's Day and everyone is celebrating. Hoping that this sort of behaviour will not be carried into the year for too long. Despite my panic eating, I think I had an alright time.

As the year progressed, each entry became shorter and more factual – a dead-eyed catalogue of daily suffering:

I was in a lot of pain today because I ate so much food.

Didn't do much today as I was exhausted from the last two days of eating.

My stomach hurts, my mouth hurts.

At the bottom of each page there is a log of what food, if any, has been eaten, and the number of hours it took to consume, set against hours of exercise in the gym. It is a ledger of losses and gains, pain and more pain. All the pages are filled with black, looping writing with the same grinding repetitions of weight-loss, weight-gain, exercise, no exercise, and spirals of bingeing and fasting. Sometimes the writing is big, angry and jagged; at others it is a crushed line of words that becomes smaller and smaller, like ants disappearing into a hole. Much of the sadness in the diary lies in its emotionally clipped tone, as if there is a deliberate deadening of the senses. Only occasionally are there chinks of feeling:

My life has been unbearable for months on end.

Even now when I open it, a bat-like darkness flies out of it and I am not able to read more than a few sentences without closing it again. It still hurts to observe her pain and I am not sure what to do with it, posthumously, other than hope that there was at least some space for other, happier, states. A few people who learned of Fauzia's depression after she died said, 'At least she's out of her suffering,' and these words wounded me, even if they were meant to console. It is for no one to weigh up the obliteration of death against the pain of living, even if it is lifelong, and decide that death is the better solution for someone else. Maybe between Fauzia's maelstrom of torments there was relief. Maybe there were moments of happiness.

And as I open her artwork, I *do* see unmistakable joy in it. There are the most exquisite birds and butterflies, still-life and figure work that revel in an extravagant beauty. There is humour, with embroideries of naked women who stare at themselves in mirrors, wearing just hats or thigh-high boots. They look like solitary versions of Beryl Cook's comically disrobed women. Everything beams with colour. There is exploration and learning too: sketchbooks labelled 'Cartography', 'Photography', 'Composition and Layout'. Two intricately copied sketches by Paula Rego, surreal and disconcerting, one of geese with human faces and the other of a rabbit shooting a woman. A variation on Degas's dancers is drawn in pastels and layered with embroidery. Other compositions by Cézanne, Miró, Velázquez, Chardin and Courbet have been copied or modified in some way.

The everyday misery of her diary is nowhere to be seen in these works. In her painting and drawing, Fauzia seems far more engaged with ideals of beauty and art history than personal suffering. There *are* more generalised images of pain, with recurring sketches of the Madonna and the Crucifixion, but they are copied from works by the Old Masters, again and

again, as if they are being memorised for their technical skill. Violence is copied too: a meticulously rendered sketch of Caravaggio's *David with the Head of Goliath,* in which he is holding a sword in one hand and Goliath's disembodied head in the other. Over the page, another biblical beheading by Caravaggio, though this time it shows the figure of Judith, a widow who is believed to have seduced and killed the Assyrian general Holofernes; her sword is bloodied at his neck, his chest is bare and his mouth is open in a frozen scream. As Sontag reflects, these canonical images contain metaphorical pain, vividly transfigured and beautiful to observe.

There is the inside of the body, too, in a ring-bound pad: internal organs have been sketched in intricate detail. There are lungs that look like an amorphous mass of flesh, a heart, small, holed, dark, and a hand with all its insides visible, alongside a line describing it: 'Human hand preserved in a jar'. Lots of sketches of body parts follow, from intestines to ribs, legs, and, on the final page, a skull with its eyes still in the sockets. Fauzia showed me some of this anatomy work when we met in her Warren Street flat in May 2016. We leafed through her sketchbook and she described her classes with medical students, as part of her course. She was fascinated by the body parts she was drawing – the people they had once belonged to – and I felt like her smaller sister again. When I spoke to Kelly Chorpening about this part of her degree at Camberwell, she said that Fauzia had been unafraid, but not every student could overcome their fear and shock of seeing the body in this piecemeal way. It was, she said, a 'confrontation with mortality', and it wasn't easy to pick up a pencil and draw it.

But anatomical art does not seem like a depiction of suffering, neither in Fauzia's sketchbooks nor from what Kelly tells me. The body is being observed not as it would be in a life-drawing class but in a way that turns it into still-life – a hand, a heart, the body turned inside out, post-life and post-pain. I speak

about this sketchbook to my mother, who remembers how Fauzia told her about these classes and specifically about a man, or parts of a man, she had drawn. He had died of TB, she says, and we both sit in silence, pondering Fauzia's unwitting encounter with her own mortality on the table before her, waiting to be sketched. Some time later, Kelly emails to tell me a statue of John Keats is close to Gordon Museum at Guy's Hospital, where Fauzia's anatomy classes took place. I ponder proximities: my sister's to the parts of the man with TB, and his short distance from Keats. In the email, Kelly attaches her sketch of the statue, which sits on a bench near the hospital, where Keats trained as a doctor before turning to poetry. On the day she sketched it, one side of the statue had been partially, mysteriously, wrapped in plastic sheeting and red-and-white hazard tape. 'I made a little drawing that attempted to expand on this puzzling encounter,' she writes. 'It somehow seems to express the way so many questions can never be answered. The questions exist as facts.'

The prone figure from Fauzia's large embroidery comes closest to an outright portrait of pain. It is of a woman, half clothed, lying face down. As I look through her portfolio, I come across the same image, replicated in sketches and prints, and I wonder what made it so fascinating to her. There are also self-portraits that exude a certain darkness. She is never smiling in them. I find one on a Flickr account she created while she was on her degree. I imagine she set it up because she was preparing to make her way into the industry. Among the still-life sketches, I discover a pencil drawing of her face in which there is a wince around her eyes, a grimace around her mouth. The face is lopsided and ageing and I feel my heart squeezed by its honesty. But there is something else that I can't quite name. Fauzia doesn't seem consciously to be drawing the viewer's eye to her sadness. It is as if this isn't her main concern and the task at

hand is simply to capture herself with as much transparency and technical skill as she can muster. The wince and grimace are conscientious lines, drawn to capture shape and shade.

I find another self-portrait. It is an etching of her sitting on a chair, and again I see mournfulness in her sloping shoulders, her downcast eyes and the lugubrious shadows around her, but it has an observer's distance. She is not pouring her pain onto the page. It is almost as if she is looking at herself objectively, like a stranger might.

Later, I discover an almost blank page with words in the middle of it: 'It's so real and gritty. I'm such an artist.' The sarcasm in them is clear to me. I can almost hear her saying it, rolling her eyes, smiling wryly. It makes me think that she wanted to avoid making her pain a part of her work, or at least that she was alert to the murky ground in which this left her. Even though I heard Fauzia speak with admiration about artists who integrated their sufferings into their work, here she is balking at the expectation of etching her autobiography into her art to give it the 'gritty' reality that supposedly authenticates it.

If I look for it in her art, Fauzia's suffering is almost always written in words, not drawn in images. Sontag talks about the lesser 'weight of words' compared to the far more graphic and visceral 'shock of photos', but in Fauzia's artwork it is the words that seem to carry the greater shocks. One big embroidery is entirely made up of graffitied words in different-coloured threads. In magenta: 'He kept stomping so I cut his feet off.' In lilac: 'My relatives killed me.' Other discomforting sentences: 'They told me to live with it'; 'Gone wrong'; 'She'll confuse it all'; and in gold thread: 'Eradicate me.'

One sentence stands out: 'When I couldn't get what I wanted I went overboard.' So she knew she could be difficult, I think, and it seems obvious now. Then I see a sentence with a word missing: 'They were scared to death [. . .] me, being so close to the edge of a crazy despair.' I wonder why she has left it out – it

must have been deliberate because she would surely have spotted the omission, slowly sewing every letter. I wonder whether the missing word is 'for' ('they were scared to death *for* me') to reflect a caring world, or 'of' ('they were scared to death *of* me'), which would give the sentence the opposite meaning: that despair and despairing people represent a serious threat to others.

It is a strange piece of work from which more and more sentences emerge. But as I look I also realise it is not in fact made up of words alone. There are four crows squatting among the graffiti. How did I miss those? It takes me even longer to see that, in the middle of the cloth, a couple sits next to each other. They are just an outline, so it is easy not to see them. She is topless, he is wearing a toga. They are, again, Renaissance-style figures who hold each other as if in the grip of sorrow. More camouflaged images emerge, most of them outlined in cream or gold thread and not coloured in. One is of a naked, kneeling woman, another is an elephant with a man's torso, and there is Christ on a crucifix. I am surprised it has taken me so long to distinguish them all. It is as if they have emerged from invisible ink.

There is only one other artwork made up of words. Again, it is an embroidery, but this time it is in the shape of a map you might find in a tourist's guidebook with landmarks on a grid. At the top, Fauzia has embroidered the word 'Heaven' in white beading, and at the bottom is a blue-beaded 'Hell'. 'Kitten Sanctuary' is sewn close to the top, along with 'Trees' and 'Learning to Draw'. These were clearly the things that brought her most comfort, and there is something childlike in seeing them stitched as they are.

Near the bottom, there are far bleaker destinations: 'Valley of Strife', 'Panic Park' and 'Breakdown House'. This dual roadmap to Heaven and Hell is replicated again and again, with different destinations in each version. I find a sketchbook filled with maps and realise this must have been planning work for the big embroidery. I flick through the pages and see

imagined places of comfort: 'Beautification Centre', 'Make-U Better Park (An Institute)', 'Gender Freedom Centre' and 'Ice Cream Shop'. Then, the places of pain: 'Killing Dad Building (to be free)', 'Violent Interrogation Playground', with stick figures drawn around the words, and 'Mutilating Mums Building (Punishment Centre for Fun)'. A barrage of other words summarising Hell on earth: 'Infuriating and Ceaseless Anger', 'Uglification Shop', 'Despair', 'Salvaging Attempts', 'End of Life Payment Centre'. Humour bristles against it all. There is 'Clever Clogs College' and 'If Your Face Gets Creased Centre' in one map of Hell, and a 'Numskull Parenting Centre' in another watercolour iteration.

As I go through the sketchbook, words turn into images. Suddenly the Renaissance artists are back: a pencil sketch of Leonardo da Vinci's *Virgin and Child with Saint Anne* and another of *Virgin of the Rocks*. Each is beautifully replicated, but as I turn the pages, I see the spaces in between becoming tracks, roads and destinations. I go back to the Heaven and Hell embroidery and there, to my surprise, is a face sewn into the map. Two eyes, a nose, lips and eyebrows jump out at me, then melt back into the network of stitches to become tarmac and tracking again. It is like the 'point of view' pictures that children marvel at – an old man with a long chin turns into a young woman wearing a hat in the blink of an eye. As Paula Rego had told me, it was all a matter of looking: the more you look, the more you see. I'm not sure what Fauzia is saying but the embroidery has a duality that feels significant, and reassuring. If pain was a feature in her life, its opposite was there too. I just hadn't seen it, or had misread it, like her last text message to me. Pain was the only thing I saw and, wincing, I looked away, but there had been another side to Fauzia – her droll humour, an almost spiritual love of beauty, an intelligent self-awareness and blunt honesty. I had failed to see it but here it was. Here *she* was.

*

To my surprise – and, at first, my excitement – I find myself in Fauzia's art too. There is a sketchbook called 'Artist's Research' and its first page has a pencil drawing of my mother with Fauzia's cat on her lap. The date is written on the right-hand corner: March 2014, with 'Collecting random ideas for my final major project'. On the next page, there is an image of me. I am smiling and hugging my niece, Martha. My eyes are open, my niece's are squeezed shut with laughter. I recognise the image: it has been copied from a photograph taken in our mother's home at a family get-together, though Fauzia wasn't there. I assume our mother had given her the photograph.

I am flattered to see myself, partly because there are so few drawings of the family in Fauzia's art, but I am more taken aback when I read the words she has written underneath: 'This is drawn from a photograph of my sister Arifa. She lives in her house alone, she is social and organised. She's a journalist, works really hard, is literary, creative and assertive. She looks after dad and has a stressful life, has a lot of warmth and love to give. She gives a lot of her precious time to our niece.'

It becomes apparent that it is part of a project whose themes revolve around mythologies. There are seven more portraits of me, almost all in close-up, and most are on a double page, set against a classical painting featuring cherubs, biblical figures and saints drawn on the opposite side. I recognise each picture of myself from photographs that have been taken by the family. These images startle me for their likeness, but also the sense of being airbrushed in slight but significant ways. She has made my face more harmonious than it is – my nose is smaller, the gap in my top teeth is gone. I look like a more symmetrical version of myself and I realise, with some apprehension, that it is deliberate.

There is something sad about her intentional smoothing away of my imperfections, but the idealised tone of the words accompanying the portraits saddens me more: 'She's funny and honest!' is written under one. Another, in which I am hugging my niece:

'She's travelled all over the world, been to film and book festivals and goes to London Fashion Week get-togethers for her work. Those are the little delights in her life. The child she holds is stable and secure.'

I turn the page. Another smiling image of me with writing beneath it: 'She is multifaceted, like all well-directed, hard-working human beings and her individuality is remarkable.' I look at my image and the saints on the opposite side of the sketchbook and it is clear I am being set beside the canonised, mythologised and the Ideal. It goes on for several pages and the almost fantastical tone of the words is excruciating. I see in this the pain of being the 'other' sister, the one who was deemed not as 'remarkable' or as 'hard-working'. She is showing the power and drama of such mythologising within art history and within her own family. Here is my elevated status in the family as the perfect daughter, and in its absence, the position she was given as my opposite.

There are two final images of me that bring a stop to the whole project. Again I recognise the photographs from which she has copied the portraits, except here I am alone, in even more magnified close-up, and I am not idealised now. For a moment, I am relieved that the airbrushing has stopped, that I am back to the gawky, less glamorous sister I was in life. But I do not look like myself here either. I look *almost* like myself but, just as she has made me prettier in the previous sketches, here other sleights of hand have the opposite effect. Small oddities have been inserted that make my face look Gothic and ever so slightly grotesque: my features bent, my nose long and bony, my chin witch-like. Below the images, she has cut out a single printed word, in capital letters, from a magazine. I stare at it, surprised at first, then reminded of all the ways in which we distrusted each other: 'DEMON'.

The word instantly casts the previous pictures in a new light, or perhaps makes a mockery of them. Here is what she was

building to: my fall, from angel to devil. These last pictures remind me that, just as she was my demon sister for a time, destructive and dangerous in her anger, I was hers. The picture marks an end to the project. There are no more images of me. It seems like a conclusion, somehow, but it was not the end of us, as sisters. I was not her demon sister at the end of her life, and she was not mine. We were reunited, two months before she died. I had gone to her hospital bed with a racing heart, hoping to see her alive, showing her I was still there for her. We might have remained friends, had she lived. I wonder how she might have sketched me, three years her elder now, not through photographic facsimiles but if I had sat for her myself. I hope I would not be the angel sister any more, or the demon, but wavering somewhere between, and that she would see me for the person I had become, with all the love and fear and flesh wounds of our sisterhood.

8

The Beautiful Death

When Fauzia turned eighteen, I gave her two tickets to the Royal Opera House to see *La bohème*. Neither of us had ever seen live opera before. I don't remember having a conversation with her about Puccini, and after this one show, she never went back to see another opera as far as I know. A lot of Fauzia's interests became mine, and even when they didn't – The Smiths, fashion, Renaissance art – I knew what she loved. Opera didn't feature among them, or that was how I had remembered it until her eighteenth birthday finally came back to me.

For years – until three years after her death – I had forgotten about this gift completely. The buried memory presented itself one morning, as I was talking about her last days in hospital. I was telling someone about the doctor who came into Fauzia's room, sat beside her bed, a few hours after her brain haemorrhage, and talked about tubercular women in nineteenth-century operas. I was recounting the details slowly. His blank expression and shrug, as my mother and I asked him about Fauzia's too-late diagnosis. His inability to convey even perfunctory sympathy felt shocking, and this emotional disengagement carried its own self-righteousness: he wanted us to know he was just the duty doctor, that he bore no responsibility and knew nothing of what had happened or why. But he didn't go after he had made his detachment known, but stayed and started talking about Puccini and Verdi.

Perhaps this was the sign of an emotionally overburdened doctor whose responses had gone awry. Maybe he was tired of explaining a hospital death in which he had had no involvement,

or maybe he felt awkward in the face of other people's grief. Either way, he came across as odious and insensitive, I told my friend. But he is not the buried memory. It is remembering his facile treatise on contagion-filled women in opera that sparks the trail back to 3 September 1990. It is a slow kindling that surprises me when it returns, and leaves me questioning how I could have forgotten something that seems significant now.

Had Fauzia gone through an opera phase? It seems so unlikely. Had she expressed a special love of Puccini? She might have done. At that age, she would come home with suddenly reared passions for things she had read or seen. I *am* surprised, though, because in 1990 we were still short of money. We had after-school jobs and took turns to revise for exams on the kitchen table, but here is a memory that doesn't cohere in its extravagance. I had saved up my pocket money for tickets that cost £75 each, which would have felt like a fortune then. Was it an aspirational gift, a way of coming closer to the middle-class girls at school, who had enormous family homes in Highgate and sometimes celebrity, North London parents? Fauzia and I talked about them with scorn, but also a hint of envy.

I remember her gasp when she saw the tickets. I also recall my confusion when she didn't take me with her. I had bought two tickets and assumed I would be part of her special evening. Who did she say she was taking? I'm not sure she did. Why didn't I ask? Maybe I felt it wasn't my place and that, at eighteen, she was entitled not to tell me. I had also bought her a dress from a shop in Hampstead. It was wine-coloured with a scoop collar and a jagged hem, made of fine, diaphanous fabric. I had envisaged her wearing it that night but she said she would need to go to the West End and find something a little more fitting for the opera, so the run-up to the evening was filled with this last-minute shopping spree.

She came back with a flamboyant floor-length black velvet dress and asked me what I thought. I nodded and smiled, but

privately I preferred my safer, more understated choice. She had bought black, arm-length velvet gloves to wear with it, along with diamanté-studded costume jewellery. I wonder now how my sister appeared to the audience that night, dressed to the nines in her attention-seeking outfit, and I am still impressed by her boldness but also pointlessly protective of any sideways glances she might have received from the doubtless older, wealthier, conservative crowd at the Royal Opera House. The drama of the dress left me quietly smarting: it had become its own adventure. Maybe I felt it deflected from my present to her and I now remember her saying she had arrived late at the opera house because she had spent so long shopping, but that they had let her in, or something to that effect.

As I strain to remember more, I find myself wondering if she really did see *La bohème* or whether she missed the show altogether. Why should I doubt her going? She was breathless with excitement when she came home that night, full of the air of having had a wonderful experience, but I don't remember her saying anything about the opera. She didn't describe its plot or tell me the names of the characters, as she normally would have done. I can find reasons why: it is likely that what happened on stage would have been an exotic blur to her, all the more so if she hadn't bought a programme. She might have been over excited to be in the audience and too distracted to focus on the story. But still I toy with the idea that something left her apologetic that evening. The more I try to remember, the more it feels like I am filling in the blanks.

'Do you remember I bought Fauzia those tickets to the opera?' I ask my mother.

'Yes,' she says, 'I do.'

'Did she enjoy it?' I ask, and she looks vague. I ask again if Fauzia definitely went to the opera, and what she said about it afterwards. My mother answers uncertainly, and I am reminded that she was a distant figure in our lives at that time. Fauzia and

I shared things with each other but our mother remained on the outside. So that evening is an unstable memory, dotted with lacunae, but it leaves me questioning how much I knew about Fauzia's life outside our sisterly relationship, not only because I gave her opera tickets, of all things, but because she didn't take me with her. Just for a minute, Amy's tantrum from *Little Women* comes back into my mind, after she is told she can't tag along with her big sister, Jo, and the boy from next door, Laurie, on their trip to the theatre. It is what causes the explosion between the sisters for those few pages when Alcott shows us the spiky side of sibling relationships. At least I wasn't like spoiled little Amy, whose demanding sisterliness revealed the distance between her and Jo. Fauzia and I were undoubtedly close at the time but maybe we instinctively understood that intimacy contained space within it and some things needed to remain your own. Fauzia had her own adventure that evening and I suppose that became my present to her, whether she got to see *La bohème* or not.

I am still left wondering why I bought her the tickets, though. I have never been drawn to opera – I find it overlong with clumsy plot-lines and screeching finales. I have had plenty of chances to watch *La bohème* but I have never felt compelled to do so. Now I am intrigued, so I find a 2008 German-Austrian film version, directed by Robert Dornhelm, and I watch it on my laptop. The arias hold me in moments of intensity but the story bores me and makes me uneasy. Giacomo Puccini's fourth opera was first performed in Turin in February 1896 and it features Mimì, who has TB. She is already pale and weak when she meets and falls in love with the impoverished poet, Rodolfo, in a Parisian garret. The opera is a slow process of her dying and ends melodramatically as she sings to the death. I think back to the surprise present as I watch the beautiful, doomed Mimì, a kept woman and seamstress, who embroiders linen and silk and whose tubercular decline gives her love affair with Rodolfo its desperate, tragic momentum. The final moments in the film show Mimì in a

panoramic aerial shot. The camera draws upwards as she takes her last breath, and we are shown her lying in repose, hands in a winter muff, dark hair spread on the chaise-longue, as if her corpse is a thing of beauty. It is a majestic scene and it sends me spiralling into superstitious thinking. Was my gift prophetic – a piece of foreknowledge and a sign of the end that awaited Fauzia?

I decide I need to watch it live to clarify its meanings, and to see what Fauzia might have seen at the Royal Opera House. I search for upcoming summer-time shows in London but find none. I look further afield, across Britain, then Europe, and find an annual opera festival in Puccini's hometown on the Tuscan coast of Torre del Lago. *La bohème* is due to be staged over two weekends in a 3,400-seater open-air amphitheatre. The first weekend is booked up already but there are tickets for 4 August 2019, my forty-sixth birthday. So here is a sign, I think, and I buy a single ticket, feeling nervous for having been so rash. But it is done. I have paid so I will have to go.

Just as on Fauzia's birthday visit to the opera, the preparations become the focus, and the performance an afterthought. I fly to Pisa, then get a train to my hotel in Viareggio. Its owner is a woman who speaks no English but sucks in her breath when I mention *La bohème*.

'Angela Gheorghiu!' she exclaims.

I nod vigorously, though I hadn't known when I booked my ticket that the renowned Romanian soprano was giving three performances as Mimì, including mine. I arrive at the gates of the Gran Teatro Puccini several hours before the evening performance and wander into a square that looks onto the shimmering silver waters of Lake Massaciuccoli. Puccini's villa is on the opposite side. I inch closer and queue for a tour of the house, deciding that I can always sneak away if it gets dreary.

I am waiting in line when two Italian women come up behind me. We smile and begin to chat. They have come from Milan to visit their friend Stefano Fava, and also to dance at a club in

nearby Lucca, they say. Annamaria works in an acute hospital ward and Marianna in a bank.

'What kind of dance?' I ask.

'Argentine tango,' they say, and tell me that Stefano is a professional tango dancer as well as a writer.

'And why are *you* here?' they ask me.

'For Puccini,' I say, and point to the amphitheatre, which crouches like a hulking concrete-and-steel spider on one side of the square. They tell me they have grown up with opera in their lives and go to see shows at La Scala. Before I know it, they have introduced me to Stefano and are buying tickets for that evening's performance of *La bohème*, making arrangements to pick me up beforehand.

This isn't what I had planned when I booked the trip. I had been looking forward to getting away from the chatter of my London life, and giving my undivided attention to the performance. But I find their company easy, without any of the awkwardness of new friendships. They are staying in Stefano's childhood home, they tell me, and they seem energetic and unconventional, with a natural warmth to their three-way friendship. It puts me at such ease that I find myself telling them about Fauzia's death and the opera tickets I gave her when she was eighteen.

They look unnervingly glamorous when they come to pick me up that evening, like revellers from *La Dolce Vita*, Annamaria in tango heels and Marianna in Dolce & Gabbana, with long, feline up-strokes of eyeliner. They order champagne and tell me about life in Milan, while Stefano speaks of growing up in a town dominated by opera, listening to performances from outside the amphitheatre as a teenager or sneaking in without paying. When he can't hear us, I ask the women about any romance with Stefano but they laugh and say they're all just good friends. They invite me to a tango night the following evening, but I will be travelling back to London. We decide we will meet again in

Milan or reunite in Torre del Lago. For my new Italian friends, life is not about death but about living – and dancing – and their presence turns my birthday into an unexpected adventure, just as Fauzia's had been on her eighteenth.

Inside, the theatre is filling up with well-dressed families and hums with their chatter. The sky around us is an impressive sight – a cobalt blue dome that turns to black in the time it takes the orchestra to warm up. Nature looks large and strange against the stadium rigging. Birds career away from the strobe lights and tumble into darkness. The backdrop to the set in the opening scene is a cityscape of 1830s Paris, which looks as if it has been drawn onto the sky. Gheorghiu's Mimì is a knowing woman, not the wide-eyed seamstress from the film on my laptop but a flirtatious kept woman who knows how to work her wiles, and I like the character better for it. Her strong, clear voice cuts against the wind and is choked with melancholy, then with romance, and then a raunchiness that verges on the winkingly vulgar.

The opera speeds along, and at every interval I turn to Annamaria, Marianna and Stefano to discuss what we have just seen. I am surprised to be enjoying it so much, I say to them, given my past reaction to the work. There is something spellbinding in seeing it in the open air and with the festive warmth of the audience. But the mood drops in the final scene, when Mimì's final aria is sung as she slowly expires. I try to focus on the music but my attention snags on a small single bed on the right side of the stage and it holds my attention because it is so much like a regulation hospital bed. Where have they got it from? I wonder. Suddenly, in its dying moments, this doesn't feel like Mimì's story and I am pulled back to my sister's bedside.

When we gathered around Fauzia's hospital bed a few hours after her haemorrhage, there was no pain in her expression, or any other sign of death. She looked as if she was in a deep, nutritional sleep that was feeding her health. I am not surprised

that TB became so mythologised in the nineteenth century: her death looked like a transfiguration. How could tubercular contagion not leave any visible marks? I watched her carefully in her last days on the ventilator. This is not what the dead look like, I thought, waiting for an arm or leg to twitch, and I wondered if it was some kind of biological trickery, and that, if we kept her on the ventilator for long enough, one day she might rise again. Or what if we kept her on the life-support machine even if she were never to stir? She could live a quiet sub-existence, hovering around the room, watching the nurses rub cream on her face and smooth her hair, in her new peacefully removed state. The desire for Fauzia to keep existing in the world, however little she lived, felt less illogical than it might have done because she looked so alive.

The following day, when her ventilator was switched off, I felt a strange forgetfulness sweep over me as I walked out of the hospital. It was as if I had left a vital possession behind and needed to run back to retrieve it, but couldn't quite remember what it was. A friend, years ago, had spoken to me of her mother's unexpected death: she had been taken to hospital after a heart attack and my friend, still only in her twenties, had gone to visit her. She had kept a mental snapshot of the visit, speaking of the moment she had turned to wave goodbye from the door, fully expecting to see her again. When she was given the news that her mother had died later that day, she said she felt as if an express train had been driven through her, and pointed to her middle. She still felt the same emptiness in her abdomen more than a decade later, she told me. The image of the express train and its psychic disembowelment had been so graphic that it had stayed with me, and as I walked out of the Royal Free after Fauzia had officially been declared dead, I thought of the express train, tearing through my friend, and its permanent hollow.

I try to bring myself back into the auditorium, but the lights go out just after Gheorghiu gasps the lines that mark Mimì's last

breath, and the pitch-black silence in the amphitheatre contains that June morning in 2016 of Fauzia's clinically managed last moments: I think of the antiseptic, glass-fronted room designed for medical teams to keep watch on living patients over granting them privacy in death, and the suddenly silenced machinery by her bed. I am hyper-aware of my surroundings in the darkness: the balmy air, its colder undercurrent, the swish of wings overhead and the audience's frozen inhalation in this thundering black silence. When the lights are raised again, Gheorghiu is out of the bed, still in a long white nightdress and dishevelled from the death scene, but all smiles and bows now. The audience is clapping and I try to join in. My Italian friends sense my sadness and long after the audience has begun moving and chatting, we sit in our seats before rustling up and walking away.

After that I begin a more empirical investigation. I speak to opera-lovers, read books, listen to librettos. I go down a rabbit-hole into the world of nineteenth-century opera in the hope that it will give me another, more meaningful, explanation of Fauzia's death than the perplexing one her doctors offered, and answer the questions that still hang around it. TB is not one part of the love story in *La bohème* but a central component, I realise. The story couldn't work without it. It sucks the life out of Mimì, making her frail, pale, barely able to stand, but it also renders her irresistible to Rodolfo. The disease fuels the drama with its apparently mystical powers to seduce and enchant. We are repeatedly reminded that she is doomed to die, and he seems to love her more ardently for it. His passion and her imminent death are intertwined.

'Mimì is dying and Rodolfo calls her beautiful as the dawn,' Leslie Jamison points out in her essay 'Grand Unified Theory of Female Pain'. The suffering of women is so often transfigured by 'an old mythos that turns female trauma into celestial constellations worthy of worship,' she argues, drawing a line from Anna

Karenina's suicide and Mimì's consumption to contemporary narratives around women and self-harm.

Mimì's is 'the beautiful death' that recurred in operas of the era, romanticising women in the latter stages of fatal illness. I follow the trail of tubercular women in nineteenth-century opera from *La bohème* to *La traviata*, Giuseppe Verdi's three-act opera, which opened in Venice almost half a decade earlier, in 1853. It has many of the same features: its central character, Violetta, another kept woman – though wealthier than Mimì – also has a deadly dose of TB. She is wooed by Alfredo Germont, for whom she gives up her independent earnings as a courtesan. They separate after Alfredo's father, Giorgio, urges her to sacrifice her love for Alfredo's honour – his association with a courtesan is a black mark on his family's social standing. She does as he asks, rejecting Alfredo, returning to her kept life in Paris and dying alone, in the depths of poverty.

In my sumptuous 1967 screen version, Violetta is played by the incandescently beautiful Anna Moffo, and the scene in which Giorgio talks her into leaving his son ends in an ecstatic fantasy of impending death in which they both sing 'The very last breath of life will be for him alone' in a state of exhilaration. What morbid romanticism, I think, but I am mesmerised by the aesthetics of this production, in spite of myself. There is a voluptuousness to its filming and the camera seems almost to kiss Moffo's face in close-up and linger on her open-mouthed smile, as a rapt lover might. These tight, sensuous shots recur in the latter stages of her illness, as if to underline the fact that, although Violetta is ravaged by TB, she never stops looking ravishing. The camera strokes her face in its death throes and ogles her last moments. If Mimì is alluring in illness, Violetta's deathly eroticism reaches necrophiliac heights.

Both operas are unsubtle in their underpinning message of sin and expiation. Violetta and Mimì are fallen women whose TB is a necessary punishment for their wrongdoings, it seems.

A disease of the lungs is, metaphorically, regarded as a disease of the soul, says Susan Sontag, in *Illness as Metaphor*, and here it resembles a Christian plague that purges these women's soiled souls of their vices through death, although this spiritual cleansing is – perversely – eroticised. Flora Willson, a lecturer in music at King's College, London, who has a special research interest in nineteenth-century opera culture, says that women's psychological and emotional states were increasingly being medicalised and defined as hysteria, while their bodies were seen to be harbouring infection. 'Opera is an HD version of life so, of course, these women are all terminally ill and have to die in the most dramatic ways.' The formal artfulness of the music becomes a mirror to the illness. 'The hectic hot flushes and the sense of time speeding up are all reflected in the tempo of the music,' adds Willson. Violetta's first coughing fit is accompanied by a fast waltz and her last aria is fragmented, her energy ebbing and her voice breaking down.

Ultimately, both *La bohème* and *La traviata* reflect 'the fad for dead women' in the operas of this time, she reflects. The singers themselves were seen as transgressive simply for engaging in the physical act of singing publicly, and the inevitable death of the female protagonist doubled up as a kind of proxy, dramatised punishment for these singers too. 'Even though their dying becomes incredibly erotic and seductive, it is a reinforcement of bourgeois morality not just for the character in the opera but also for the woman on stage who holds the opera house in her grasp. She has to be taught a lesson.'

A real-life 'wayward woman' with tuberculosis was the inspiration for the story in *La traviata*. Violetta was based on Marie Duplessis, a nineteenth-century Frenchwoman who became Paris's most celebrated courtesan. Her early life in Normandy had the markings of an abusive childhood, and she fled to Paris where she ended up on the streets until she was picked up by men of means

who, in effect, rented her body in exchange for shelter. The grittier details of her life are often glossed over, but much has been written about her beauty, her lovers (the composer Liszt among them), her death at the age of twenty-three from TB, and her funeral, which became a calendar date for Parisian high society.

There was an almost ecstatic public response to Duplessis's death; the biographer, Julie Kavanagh, quotes Charles Dickens on the media clamour and what he suggests as the sheer 'romance' of it all, in her book, *The Girl Who Loved Camellias*: 'For several days all questions political, artistic, commercial have been abandoned by the papers. Everything is erased in the face of an incident which is far more important, the romantic death of one of the glories of the demi-monde, the beautiful, the famous Marie Duplessis.' He also famously turned up to an auction that sold off her possessions to square the debts she had left behind, and to which the good and the great flocked in hope to claim their own trophies of high-class prostitution. Everyone wanted a piece of Duplessis in death, but there seemed to be a nasty misogynistic edge to it as well, as if her death had to be celebrated to remind all 'good' women of what happens if they deviate.

To add to the cashing in, Alexandre Dumas fils (the son of the novelist Alexandre Dumas) wrote a novelised account of the brief affair he had had with her. *The Lady of the Camellias* (*La dame aux camélias*) was completed in just three or four weeks, and it was this that inspired Verdi's opera. Dumas was not high on Duplessis's list of lovers, according to René Weis, who, in *The Real Traviata*, writes, 'She let him [Dumas] into her bed probably because his father ranked as the most celebrated, if not necessarily the best, writer in the city, vastly influential on both the literary and theatrical scenes.' She died in February 1847 and Dumas published *The Lady of the Camellias* as a novel the following year, and later as a stage play, calling his lovers Marguerite and Armand. Dumas's fictionalising of Duplessis's life and death

seems nakedly self-serving: he was desperate to come out from under the immense literary shadow of his father and this book was written in what sounds like a red-hot fever of opportunism.

Like Duplessis, Marguerite is a society prostitute. There is no mention of Duplessis's son in the book, Weis points out, although Dumas knew of her child's existence. 'A baby would have opened up a Pandora's box about motherhood and related issues that would inevitably have detracted from the novel's drive and its interests in the secret world of Parisian underground sex.' Dumas's affair with Duplessis, however minor, had been an open secret and many saw this fiction as thinly disguised fact, which gave it an even grimier sensationalism of life turned into art, and another prurient reason for some to buy the book.

I am disgusted by Dumas's novel when I read it. It is written in terrible, titillated, high-pitch prose that pretends to be compassionate towards the plight of prostitutes but is adolescent in its hormonal excitements about Marguerite's sex trade. 'To be loved by a virgin is one thing but to conquer the heart of a prostitute, to be truly loved by a courtesan, that is a much harder victory,' Armand thinks, leering at Marguerite's lips, eyes and 'supple waist' with the gaze of a pornographer.

The associations between sex, love and death are repeated and sinister, and the sexual imagery around death in Verdi's opera can be seen in this original source at full glare. Armand watches Marguerite from afar before he meets her, and when his friend, Gaston, tells him that Marguerite is a consumptive and that 'she's dying' he is perversely pleased by the news. 'The heart is strange; I was almost happy about this illness,' he thinks. Dumas puts lines into *her* mouth, too, to suggest that the prospect of death is making her life sweeter and brighter. When Armand first proposes an affair between them, her heart begins to beat violently, and she explains the palpitation 'come[s] from the fact that, knowing I will live a shorter time than others, I have sworn to myself to live with greater speed'. When Marguerite finally dies,

we are told, emphatically, that she died 'young and beautiful', though in reality Duplessis died impoverished, abandoned by her rich patrons, yet unrepentantly quaffing champagne for as long as she could. Seeing the apparently beautiful tubercular death in book form, stripped of the operatic finery of its music, I am sickened by its almost sadistic pleasure in orchestrating the lingering death of a disobedient or 'deviant' woman.

I crawl back up from this rabbit-hole feeling grubby. None of it has brought me closer to Fauzia, though it has chimed in another uncomfortable way. There is something appalling about the way that strong-willed women like Violetta are broken by the men who tell their stories. However indomitable their spirit seems at the start, they end up as waifish victims, consigned to certain death. Again, this doesn't describe Fauzia. She was not a romantic. She pushed against meek, obedient, retrograde versions of femininity. She was difficult in illness. I was embarrassed when she spoke too loudly and became agitated in hospital, but I see it differently now, after Verdi, Puccini and Dumas. She was not going to play the part of the pale, prone, passive woman in her sickness. Neither did her death give a man's love greater meaning.

Yet, there *was* a kind of destitution to it: she had a fatal brain haemorrhage in the early hours of the morning, alone and with nothing but whirring machinery around her. There was no one to hold her hand or comfort her on her outbound journey from life. Even if we were there when she was declared dead, she had her haemorrhage alone, in the early hours of a June morning. It was a stark, sorry, medical death, however much the doctor by my sister's bedside at the Royal Free Hospital had tried to attach a beautiful romance to it.

9
Doctors

Before he began his eulogy on tubercular women in opera, we asked the duty doctor why Fauzia hadn't been diagnosed earlier, when she might still have had a chance of survival, and why they hadn't suspected TB in all her time in hospital.

'Because no one thought of it,' he said expressionlessly.

Soon after he left, another doctor walked in with an assistant. He was warmer, expressing his sympathies and saying he had been the one to discover Fauzia's TB, after retesting her spinal fluid from a lumbar puncture. He explained the unusual nature of miliary TB and the difficulties around diagnosing it. We found out afterwards that this infectious-diseases consultant had seen Fauzia during her first admission to the Royal Free and, after seeking a second opinion, dismissed infectious disease as a possibility. He told us so himself, a few weeks later.

But hearing him talk by her bedside, not yet knowing the history, I thought he had swooped in at the eleventh hour to make an inspired diagnosis, so I thanked him for it. He remained, watching Fauzia lying in her bed, and watching us too, it seemed. My mother and I were in a state of strangulated disbelief and had stood in virtual silence for hours beside Fauzia's bedside. I could barely form words, but this doctor seemed not to want to go, and in an effort to make conversation, I repeated how shocked I was by the cause of her death, how out of place the illness seemed in this day and age. No, he said, TB was back. We, the family, should be screened in case we had been infected, although there was no great chance of that as miliary TB was generally less contagious. I saw the sense in this precaution:

Fauzia was clearly lying in quarantine – we could only enter her room through an antechamber wearing PPE aprons – so who was to say we hadn't been infected at an earlier, more contagious, phase of her illness?

The reality of her death as a result of infectious disease only sank in over the next few days. TB is an airborne contagion, which can be transmitted through coughing; my mother had been in close contact with Fauzia in the months leading up to her death. Fauzia had been living with her in Primrose Hill on and off; they had eaten together, hugged, shared the same air, and my sister had had a strong cough for some of this time. Now my mother was worried. My sister-in-law, Mary, became increasingly anxious too. She had gone to see Fauzia in hospital most days and occasionally taken her two daughters along, albeit leaving them in the waiting room. Although we had been told that there was no likely risk of infection, Fauzia had died of an apparently rare TB, which not even the doctors had suspected until too late. What was the likelihood of *that*?

Over the next few days, we waited on tenterhooks to be contacted for our TB screenings. We also waited for the offer of a fuller explanation, beyond the passing words we had received at my sister's deathbed, when we had been in a mental haze, barely speaking, barely listening. Surely the hospital had a process of pastoral care, especially in a case with so much mystery around it, and that had clearly left so many doctors flummoxed. A week after meeting the infectious-diseases consultant, we had not heard from him, and he had given us no contact details, so Mary wrote to him through the hospital's liaison service: 'I hope you can understand that we, as a family, need to speak to you or your team of TB nurses about our risks [of infection] in a more formal way than an impromptu conversation over Fauzia's bedside on the day of her death . . . We feel vulnerable about the state of our health after watching our family member die a quick and horrific death.' She also asked

for a meeting so we could learn more about why Fauzia's illness had not been detected in time. 'We all appreciate that you and a large team of others did your best to find a name for this illness, but failed to do so despite every effort, but we feel abandoned at the moment, in the light of this too-late discovery of her infectious disease . . .'

We heard back three days later and a meeting was agreed. The infectious-diseases consultant, with a second doctor, met Mary, my mother and me, and expressed sadness on behalf of the hospital. He said lessons had been learned, which was not only cold comfort less than two weeks after Fauzia's dying, but I wondered what, exactly, those lessons could be. Again, he explained how difficult miliary TB was to detect, so much so that they had been focusing on the lower part of Fauzia's lungs, where the problem was thought to be, so missed the signs at the top where TB typically leaves its marks. When, some years later, I asked the hospital why a medical team would not look at a patient's whole lung as part of an investigation relating to inflammation, I was told that 'Consultants would review the entirety of the lung [and that] in this case the pattern was not presenting in a way typical of tuberculosis.'

The consultant also told us he had seen Fauzia when she had been admitted to the Royal Free the first time but had not seen signs consistent with infectious disease. I kept firing questions at him and I could see, even in my grief-soaked outrage, he wasn't ducking out of answering them. None of it had been my sister's fault, he reassured us, when I mentioned that she hadn't turned up for a follow-up appointment after leaving the hospital the first time, in May. We spoke for well over an hour and he said her case had been reviewed by the clinical team alongside hospital management and clinical governance. Would it help if he sent us a summary of the review? Yes, we replied, shook hands, and left.

Afterwards, I learned that TB screenings were usually performed

six weeks after exposure, which explained why we hadn't been contacted straight away, and all our tests came back clear. I felt as if we were making some progress and waited for the review to land. A month later, it hadn't arrived, and when Mary emailed, she was told that the consultant was summarising the clinical review meeting, in layman's language, so we could understand it. Almost another month on, it still hadn't been sent to us. We emailed in between, asking for the unedited version of the review, saying that we preferred to have the original. No answer. We asked *when* the review might arrive and we were given no answer to that either but were told that the consultant was away, then away again, and that another specialist would send it. Still nothing. Almost two months on from our meeting, we remained in the dark about the medical details around Fauzia's diagnosis and death. I sent an email on 15 August 2016: 'I have been waiting for a report regarding my sister Fauzia Akbar's death ever since a meeting on 24 June. It has been nearly two months. To restate the obvious, we are a bereaved family hoping to find some understanding and closure.'

A three-and-a-half-page summary arrived the following afternoon. I saw, in it, that her case had been raised with the hospital's Serious Incident Review Panel (SIRP), which listed it as 'Urgent Care: TB: Delayed Diagnosis', and pointed to the gravity of the case. In this summary document, 'opportunities missed', 'potential issues' and 'learning points' included everything from Fauzia's South Asian ethnicity – 'The patient was from an ethnic group at an increased risk of TB . . . tuberculosis might have been more actively pursued as a possible diagnosis' – to an acknowledgement that, in hindsight, 'the imaging from her second admission was consistent with a number of conditions including tuberculosis', which meant there *had* been some signs of the disease on her lung X-rays, had they looked for it.

There were nine points in all, some harder to swallow than others: the 'large number of specialists involved in the patient's

care' meant there was great input 'but also the potential for difficulties with communication and coordination'. Fauzia's many unexplained symptoms might have been better dealt with on a high-dependency unit. CT brain scans were performed but an MRI, which is more sensitive to changes in the brain, was not, despite numerous calls for one – I saw this later in her full medical records. More generally, a family should be actively consulted for medical history, mycobacterial cultures routinely performed in cases where diagnosis is unclear and tuberculosis may be a possibility, and alert systems put in place for a patient, such as my sister, who does not attend follow-up appointments.

In the summary I saw her death unfurl in the gaps between symptoms and treatments. Here was TB invisible to a hospital team that *must* have been aware of its return in recent times. The infectious-diseases consultant himself had told us of its comeback. The summary pointed out that my sister suffered from depression, anxiety and body-image issues. 'Anorexia', 'eating disorder' and 'body dysmorphia' were cited in her medical records. TB is often connected with malnutrition or a lack of nourishment, which coheres with the effects of a serious eating disorder, and her long-term psychiatrist worked in the very same building as these doctors. Even the hospital leaflet on TB that we were handed, following our X-rays, flagged up this sign in its bullet points on who is most at risk of infection. But none of it had been enough for her doctors to join the dots, as hard as they had tried.

The ground shifted beneath our feet after we read the summary. We asked for another meeting and this time my brother and I talked to a doctor involved in her care. My tone was combative: why wasn't TB explored as a possibility, given her ethnicity and the signs on her scans? Why had they thought, at one point, that she might be being poisoned by an excessive use of aromatherapy oils and asked me to fetch them from her

bathroom? If death by miliary TB was rare, wasn't death by bath oils even more so? Wasn't that harebrained? I said, aghast, but the doctor defended the reasons for it. My brother left the meeting early, and the doctor's tone changed after that, becoming increasingly tetchy. I asked him if he would be more alert to TB among patients of South Asian heritage – a high-risk group – and he said he would remain alert towards everyone, despite the summary's point on ethnicity. Again, years later, the hospital trust said that the review of Fauzia's case had led them to identify areas of learning, and this included 'testing patients who come from high-risk groups for tuberculosis, if diagnosis is unclear'.

'You can't bring her back,' he said and sighed, as if my questions were a chore. I didn't know what to say. This was only a second meeting, and a long-delayed one at that. Was he suggesting that in seeking a full explanation for Fauzia's death I was asking for the impossible? I was tempted to tell him that a grieving family member should not be batted away with a tired cliché. Far from hoping for the miracle of Fauzia's return, the process of asking questions, however interrogatively, was eminently rational: an endeavour to understand the complexities of an illness that had confounded a large medical team with decades of experience, and at a leading London hospital.

We carried on until, out of the blue, he said that my sister's unreliability hadn't helped. His words left me astounded. I was holding a medical report listing the opportunities her doctors had missed. We had already been told that Fauzia was not responsible for any part of the medical delay around identifying her illness, and when I formally asked the hospital about it years later, they confirmed there 'was no evidence that Fauzia's mental-health issues impeded diagnosis'.

'Surely doctors here had dealt with patients with mental-health issues before now?' I said. '*Surely* my sister could not have been the first?'

I'm not sure how he answered that, or if he said anything at all, but after that I pulled away from the conversation. I was disgusted by him and needed to leave. It was the last meeting I had with Fauzia's doctors and it made me think about how the world had received my sister's mental illness and, more widely, how those with similar conditions might be rendered unreliable witnesses of their own pain, even in medical environments. Marginalised communities are most likely to be affected by TB in Britain – immigrants, prisoners, the poor and homeless – all of whom often tend to have underlying mental-health conditions. Fauzia had spent her life being judged by the world for her mental health – often harshly – and it felt like she was still being judged in death.

Joanna Cannon, a former doctor turned bestselling author, writes of the unwitting injuries contained within words in her medical memoir, *Breaking & Mending: A junior doctor's stories of compassion and burnout*. She considers how much she learned about language as she travelled through junior medicine, 'how some words are so heavy that, whether you mean to or not, handing them over to someone else can change a person for ever. How – medic or non-medic – we should all choose our words with more care because we never know the scales with which they will be measured.'

As a doctor, one of the most important things to realise is that patients will always remember how you treated them, she reflects further on. 'Even decades later, they can immediately recall the way a doctor spoke to them or looked at them, and how those words and looks made them feel. I know this because I have been a patient myself, and I too remember very clearly how it made me feel.'

She is right. The families of patients remember too, and are similarly scorched or soothed. My sister died over four years ago, but almost every conversation I had with a doctor, nurse, friend or colleague, in the months around her dying, remains

persistent in its clarity. Some words were a balm with their accompanying nods and sensitive pauses. Others cut me to the quick. I can remember many verbatim, with all their subtle inflections of genuine sympathy, empathic pain, or arrogance. Some still carry me now with their extraordinary insights, their wisdom and kindnesses. Others continue to sting, however unwittingly the pain may have been inflicted.

After reading Fauzia's medical review summary, I resolved to lodge a complaint with the hospital. Then I had a dream. Fauzia was lying on the sofa of the Primrose Hill flat. I felt a surging relief that she was alive, but when I went to hug her, her body was rigid with cold – colder than it had been when her ventilator was switched off. I kept drawing her closer to me and that was when she whispered in my ear. Her voice was a gentle moan, full of exhaustion: 'Leave me alone,' she said. But if she resented me in death, if she felt I was unsettling her in her freshly dug grave, I resented her back. She hadn't valued her life enough when she was alive, not nearly enough, and here she was accepting her death as black fate, just as she had done with all the badness that had come to her.

Questions around Fauzia's death lingered long after my last, unpleasant meeting with her doctor. When had Fauzia's spinal fluid been retested for the too-late diagnosis of TB? Before or after her haemorrhage? Why was she given a pregnancy test a few days before her death? I still needed to understand the medical trajectory that had ended in her dying, so I asked the hospital for full medical records of her case. They arrived in the post a few weeks later and I was shocked by the sight of them. They stood three inches thick – a hefty paper brick, the weight of my sister's last illness. The medical review summary, which we had already received, lay on top, but underneath, reams of observations, graphs, symptoms and medications, voluminous and granular in their details. I closed the file,

alarmed by the scrawly doctors' notes and their medical esotericism, storing the wad of paper out of sight.

Years later, I drag it out and dust it down. I have come fresh from the posthumous discoveries I have made of Fauzia from her artwork and now I feel curious about what I may find of her here. Is there a possibility that the file holds some surprising new knowledge, or do these pages represent only an *unknowing* – a final investigation into her physical being that led not to enlightenment and discovery but a fog of medical confusion to arrive at her death? Even if they contain all that she was not – and all the ways in which she was misunderstood at the most cellular level – it seems important to see what the doctors saw, what they looked for and what they didn't. This was, after all, *their* investigation of Fauzia and I feel ready to know all that eluded them.

For a while, I simply stare at the pile. Just as I had been fearful of opening Fauzia's artwork for what I might find there, I feel the same about this breeze block. Gingerly, I begin reading, and at first it is an impenetrable spew of medical jargon. There are so many administrative records and so much ritualised form filling: sheaves of emergency assessments, admission forms, nursing notes, antibiotic policies, social history and lifestyle records, intensive-care charts and ECGs. I stop to look at the ECG grids that chart the abnormal beating of my sister's heart and I feel strangely close to her, just for a minute.

The notes have been sent to me in a non-chronological muddle. They begin in June 2016, when Fauzia is close to death, but snap back to May, just as she has recovered in her first admission to hospital and is, triumphantly, discharged. There is no clear beginning, middle or end, only repeating loops and jumping timelines that throw me off course. But a narrative begins to form as I submit to the disorder and simply absorb the lists and graphs. However impersonal they may be, they build a picture of Fauzia's last days. I see the names of the drugs

she was administered in the week of her death. There are hourly nursing updates, so I know when she ate yoghurt, when she was confused, and when she was on 65 per cent oxygen. I see the repeated mentions of a future MRI scan from various doctors, which never came, and feel a flush of distress as I remember the points listed in the review summary.

But I am interested in these notes beyond that review alone. I begin to see the sum of Fauzia measured out in milligrams of electrolytes, metabolites, arterial samples, and organ analysis. 'Degenerative bone joint changes', reads one entry. 'Scattered osteophytosis'; 'The spleen appears normal in size'; 'The pancreas and the aorta appear normal.' I am seeing her in a way I haven't done before, from the inside, and it is intriguing. It is as if she is slowly being resuscitated through anatomical detail and physical fact.

Then, a pen portrait in two sentences that could serve as the briefest of obituaries or a headstone epitaph: 'Born and spent almost entire life in UK. Lived alone with two cats, full time student (fine art).' A narrative around her mental health builds too, charting her body dysmorphia, depression, anxiety, anorexia, over and over, with suspicions that she is taking 'toxins' as part of her eating disorder. The notes mention how she is at high risk of absconding, and at times I see the ways in which she is difficult to manage; a nursing entry on 2 June observes: 'Patient was shouting, complaining of pain.' Another on 3 June: 'Patient very restless since start of the shift screaming/shouting trying to remove her femoral line and catheter.'

The doctors hover around the mystery of her illness, full of enquiries and requests for further tests, with red herrings and dead ends along the way. One entry refers to the investigation into the possible toxic effects from essential and aromatherapy oils after Fauzia said she had been using a lot of them in baths. Did *she* plant this idea in their heads? A hypothesis of 'Pneumonitis [inflammation of lung tissue] due to oils and

essences' is posed, and a few pages later I see an appointment card for a health spa where Fauzia went to get a back massage because she was in so much pain. The card has the image of a woman lying flat on her stomach under a towel, her calm smile just visible, and it has been expanded to A4 size, as if it were the magnified face of a suspect in a police investigation, or evidence found at a crime scene: 'Exhibit A'. It makes me laugh. If the file is an anatomical work of detection, this feels like the most comical of false leads.

Then, seven days before Fauzia's haemorrhage, on 3 June, a note by an infectious-diseases consultant – a different doctor from the one I have met – ruling out 'an infectious aetiology' in her unknown illness: 'Overall unlikely to be a recurrence of an infection – more likely to be a repeat exacerbation of a multi-system disorder . . .'

'No!' I say out loud. 'You idiot.'

Certain words light up from amid this forensic catalogue and classic TB symptoms jump out, so pronounced now that it is painful to see them listed with such regular frequency: stiffness in the neck, nausea, shortness of breath, shivers, fatigue, dizziness, malaise, nail clubbing. Again and again the notes say Fauzia is febrile. I could open a nineteenth-century novel about a dying consumptive and find these descriptive words there.

I am saddened, transfixed, and then I am exhausted. The stack of notes is never ending. However many of its pages I read, it stays undiminished, reminding me of the fictional, paper-bound bureaucracy of *Bleak House*.

Just when I feel like giving up, a piece of important information turns up. I find my answer for why she was given a pregnancy test in a note on 3 July: 'Pregnant in view of possible gynae malignancy?' and I am later told by the hospital that 'This was a routine test carried out in order to avoid harming an unborn child from medication.'

And then I find a doctor's note in ebullient handwriting, on

10 June, with underscored words: 'This lady has <u>miliary TB</u> and <u>tuberculosis meningitis</u>. I think this explains <u>all</u> of her illness over the past four months . . .' It is written by the infectious diseases consultant we met by Fauzia's bedside, and he goes on to list new drugs to administer, old ones to stop. His excited findings cover more than one side of A4 and zing with the relief of his 'lightbulb' moment. The tone is so upbeat that I realise he cannot have known that Fauzia had had a fatal haemorrhage the day before, on 9 June, and that his discovery had come too late. He mentions the 'positive' result of her spinal-fluid samples in the note, and I remember him later explaining to us that it had been retested for TB earlier that week, though this is confusing in the light of a hospital statement, years later, which says that the test for TB using Fauzia's spinal fluid was carried out *'following* the bleed on Fauzia's brain'. I waver over this inconsistency, then brush it away, returning to the naked optimism in this report.

But beneath it another doctor's note immediately robs it of all hope: 'The CT looks [catastrophic?] . . . Unfortunately the TB results have come through following this event and she looks to be dying.' So here is the formal logging of Fauzia's outrageous misfortune – the hope of life bound up in a last-minute diagnosis and a virtual pronouncement of death almost simultaneously, written in two consecutive paragraphs. I do not know how many hours came between them, but I can only assume it was the difference of a few.

Some pages later the report winds back to 9 June 2016, in a summary of the moment we were taken to the hospital side room and told that Fauzia had had a massive bleed on the brain from which she would not be recovering. It is written by the sensitive doctor who broke the news to us, and it reports: 'Many questions answered in turn surrounding the lack of diagnosis, HLH [a severe inflammatory syndrome that can send the immune system into fatal overdrive], uncertainty of one unifying

diagnosis and that there may not be one forthcoming.' I am struck by timing again: the onset of death, an admission of no clear diagnosis, and then sudden too-late certainty, all within twenty-four hours. I am not surprised that this day left me so bewildered, or that I expressed a fundamental confusion around its timing to Fauzia's doctor, who became so irate at my repeated disbelief.

It takes me nearly a day to read the full notes, and after I have finished, I put them away carefully. This record is not the fearful black hole I had imagined at the start. It is a log of my sister's living, breathing body, however besieged it may have been. Its pages contain carefully tabulated life, and it tells me that the medical team was trying hard. Fauzia's TB was evidently difficult to detect and these doctors just didn't have a suspicion of the illness, however hidden in plain sight it may seem in hindsight. A suspicion is what they would have needed for the TB to become visible, I am told afterwards by Professor Francis Drobniewski, at Imperial College London, an expert in global health and tuberculosis. Only that was missing.

What the opera-loving doctor at the Royal Free hadn't mentioned was the 'doctors' of nineteenth-century opera. There are physicians in *La traviata* and *La bohème*, as well as in Dumas's novel, some more shadowy presences than others. These medics are variously kind, ineffectual and impotent in the face of tubercular infection. I find a quirky online thread called 'Physicians in Opera' on the *British Medical Journal*'s website, in which doctors from across Europe discuss the changing figure of the medical expert over the course of the nineteenth century.

The thread posits lots of opinions: one says that Violetta's physician, Dr Grenvil, in *La traviata,* is a benign but useless figure. Perhaps this is unsurprising, given that the illness was shrouded in medical mystery when the opera premiered in 1853. By the time of *La bohème's* first staging in 1896, it was still

greatly feared but its contagious nature had now been established, and no longer regarded as hereditary. Another opinion notes that Mimì's doctor in the opera is an often unreachable off-stage figure, whose treatment she cannot afford, but her TB is alluded to by Rodolfo in tremulous tones, and at times his fear of its infectiousness overshadows his ardour for her: '*Amo Mimì, ma ho paura*' ('I love Mimì, but I am afraid').

It is not mentioned in the thread but there is a very different kind of doctor in Jacques Offenbach's French opera, *The Tales of Hoffmann,* which premiered in 1881, who is not half as benign. The work is comprised of three parts, each based on a supernatural story by the German writer, E. T. A. Hoffmann, and brought together in an *opéra fantastique*. The tales revolve around a poet called Hoffmann and his encounters with three alluring women, each of whom is controlled by a demonic man. One of these is the physician, Dr Miracle, who entrances a young soprano, Antonia. He knows that she has an unnamed illness, a form of cardiac arrhythmia, which renders it fatal for her to sing, and he goads her into song, and to her death.

In 1951, Michael Powell and Emeric Pressburger adapted the opera into a 'composed film'. Shot on a stage with a spectacular sense of scale, its design was both dazzling in its opulence and macabre in its effects, with decapitated heads rolling off bodies and a barefoot dancer walking over a field of corpses. Dr Miracle is a Nosferatu-like creation, charismatic, fantastically evil, and cadaverously white with black hollows for eyes; he uses nefarious and hypnotic powers to entrance Antonia. The legendary American horror director George A. Romero called him 'the greatest Dracula that has ever been on screen' and he is the most dreadful, but also the most compelling, character in the story – both a demon figure from the ancient world and a post-Enlightenment man of medicine, who represents the negative capability of new science. As Antonia's father, Crespel, sings: 'He never cures but he destroys. He'll kill my child as he killed my wife.'

Fauzia's doctors were obviously not demons. No doubt they were – are – heroes for people whose lives they save. To us, they were many and faceless, mostly brisk but well-meaning. Some – especially the doctor who took us into the side room to tell us of Fauzia's brain haemorrhage – seemed earnest and compassionate. But far from revealing the dark side of scientific advance that seems to be made so fearsomely manifest in the figure of Dr Miracle, Fauzia's doctors reminded me of the limits of modern medicine butting up against an ancient infection, which, for all its twenty-first-century demystification, was evidently still tricking some doctors with its mysteries, and with fatal outcomes.

Fauzia's medical record left me in little doubt of their all-too-human efforts. Amid the charts and graphs, I saw the gyrations of hope and concern. During her first stay in hospital, her illness was reviewed by specialists in infectious diseases, rheumatology, respiratory medicine and intensive care. Her shape-shifting disease was evidently taking doctors on a wild-goose chase from one damaged organ to another: she was variously suspected of having lupus, acute stress cardiomyopathy [heart muscle disease], encephalitis [inflammation of brain substance], and bacterial meningitis, and given medicines accordingly. What the notes showed, ultimately, was not even so much the limits of medicine as the humanness of it. Doctors were combining hypotheses, making breakthroughs, hitting brick walls, trying new routes, failing, failing again, right until the final, spidery entry: 'Brain stem dead. Immam [*sic*] to come tomorrow morning' and then 'RIP – 11/06/16'.

For all the gains of medical science, TB remains the unknowable, or at least not *fully* known, contagion that had been so susceptible to myth-building in previous centuries. I think about nineteenth-century theories around temperament and predisposition, and then of my sister's disturbed emotional state and

her heightened anxiety in the final few months of her life. The rift between Fauzia and her neighbours had grown into a war in the year leading up to her death, and she was feeling the trauma of it.

They had been intimidating her, she said, but when she met with housing officers, she felt doubted. After she died, I found piles of letters, and among them was a copy of an official complaint made to the housing association's management; in it she said the family upstairs had not only harassed her but used the stigma of her mental health to paint her as an anti-social character, and that she did not feel her accounts had been believed by housing officers. Among the stash, I found a final letter from a housing-association manager, sent three months before Fauzia died, which apologised, accepted they could have done more to support her, and pledged to warn the family not to act aggressively. But this letter came just weeks before Fauzia's first hospitalisation, by which time she must have felt desperate. She had been saying for so long that she felt ambushed and trapped in her home, and that the endless battle with neighbours and housing officers was killing her. Could all of this emotional burden have tripped a switch and, if so, might the nineteenth-century doctors have been right?

'No,' says Francis Drobniewski, Professor of Global Health and Tuberculosis at Imperial College London, and former director of the World Health Organization (WHO) Supranational Reference Laboratory, but 'depression, sadness or stress *could* manifest in physical ways and impair the body's defences, leaving it more liable to illness, particularly in those with compromised immune systems.' It must have done so with Fauzia, who was contending with the prospect of eviction and unable to sleep most nights. She was working feverishly on her art during the day, anxious not to fall behind on her degree course, and still going through starvation and binge cycles. It is dizzying to think of it all. It seems like a twenty-first-century form of 'hectic fever'.

But beyond Fauzia, and beyond her death, there was her disease. My eyes had been opened to the knowledge that it was not an illness in faraway or ancient lands alone, but one that was squatting surreptitiously inside the bodies of undiagnosed Londoners. And also that, despite a vaccine and a cure, it was often elusive in character and could evade detection.

A major medical breakthrough came in 1882 when the German microbiologist Robert Koch discovered the pathogenic bacteria, *Mycobacterium tuberculosis*. An effective vaccine was formulated in 1921 and an antibiotic cure – streptomycin – in 1943 (the first patient received it soon after). Several more antibiotics since then (including isoniazid, rifampicin, pyrazinamide, ethambutol) are used to produce the standard multi-drug therapy that cures TB now. New experimental vaccines have been developed, while gene technology has fully sequenced the DNA of the bacteria's chromosome, leading to better diagnostics, earlier identification of drug resistance and greater research.

So why does TB still seem sly and elusive, and why does it resist eradication? There are several reasons, says Professor Drobniewski. Some are scientific and others have to do with money and global politics. Scientifically, we still do not have the perfect diagnostic test, he says. There is 'sputum' analysis, which studies the patient's phlegm under the microscope, but this usually only comes back positive when the TB bacteria are plentiful and a sufferer is at their most infectious. Another way of testing is by growing cultures – recommended in my sister's medical review – but that takes up to four to six weeks. The spinal fluid can also be tested (ideally with molecular DNA-based tests), which was how Fauzia's illness was finally detected, but there are sometimes very few bacteria here too.

Transmitted mostly through coughing, the disease can be harmless or deadly. It can shape-shift and hide, wreaking havoc on the body while evading detection. 'It's a great pretender and mimic so there are a lot of diseases that people think it could

be first, and it is often picked up incidentally,' reflects Professor Drobniewski. 'Once you start getting a suspicion [of TB] it all starts to fall into place. The difficulty is *getting* that suspicion.'

Around a quarter to a third of the world's population is dormantly infected, but only about 5 to 10 per cent go on to develop the disease, mostly within two years of infection; a greater proportion of the disease occurs in those with HIV, and it is also triggered by HIV, diabetes or anything else that causes the immune system to weaken enough for the bacteria to take hold. Disconcertingly, it can lie latent in the body for decades, then suddenly erupt. Once active, it nestles in the lungs in ball-like cavities, clings to lymph nodes or circulates around the body, infiltrating cells and undermining the immune systems. It has a kind of creeping approach too, dividing every twenty-four hours while other bacteria typically divide every twenty minutes. But it grows remorselessly, wearing down an unknowing sufferer in centimetres and inches, and with a slow, steady insidiousness that can eat through organs and bone.

Cures are just as uncertain as detection in some cases: the BCG vaccine is largely for children with non-pulmonary TB and it runs its course after about ten years. Fauzia had a shot at school but it clearly did her no good by the time she was in her mid-forties. If you have one strain of TB, you could still be affected by another, and even when the disease is beaten off with drugs, there is a chance of future relapse. There are growing strains of drug-resistant TB, which account for 10 per cent of new cases, says Bill Bryson, in *The Body: A Guide for Occupants*, and these have such growing virulence 'it is entirely possible that we could one day in the not-too-distant future be facing an epidemic of TB that medicine cannot treat'.

As far as containment goes, the National Health Service in Britain has developed an effective contact tracing system over the past seventy years, long before the government's privatised parallel system was devised for coronavirus in 2020, says

Professor Drobniewski. Just as in the case of Covid-19 patients, those with TB are put into isolation – no longer in sanatoria but in separate rooms within hospitals – for fourteen days, or for more complicated, multi-drug-resistant TB, there are negative-pressure isolation rooms in which clean air is sucked in and out with a HEPA filter, rather like on an aeroplane, for months, not weeks.

The infectious-diseases consultant at the Royal Free had said the illness was back but I hadn't quite realised how close to home it had been for Fauzia until I began looking at the demographics of the illness. It is concentrated in cities like Birmingham, Bradford and London, and of all the cases in the UK, three-quarters are among people born outside the country – those of Indian and Pakistani heritage are at the greatest risk. Around four hundred people die every year of TB in England, Professor Drobniewski says, and these are usually a result of delayed diagnosis. The disease is most rife among migrants or those living invisible, impoverished lives. 'These groups are easier to forget,' he reflects. 'They're not going to vote or appear on *Question Time*. They want to stay away from interacting with the state because they feel the state is not good for them.'

A Public Health England (PHE) review paints a vivid picture of the rate of infection in London in the year my sister died, when there were 2,210 cases. The highest rates were in north-west London, where TB exceeded what the WHO classes as the high-incidence threshold (40 cases per 100,000) in four boroughs. Worst among these hotspots was Brent (as well as Newham, Hounslow and Redbridge), along whose boundary Fauzia had lived, in Kilburn, for over a decade before moving to Warren Street.

But TB rates in the previous year were even higher, surpassing those in Rwanda, Eritrea and Iraq, according to a report issued by the London Assembly and presented to Boris Johnson, when he was the city's mayor in 2015. A third of London boroughs

exceeded the WHO's high-incidence threshold and, once again, Brent was among them. But there has been a downward trend since the disease's most recent high point in 2011, when PHE recorded 8,280 cases across England. In 2018 that figure had almost halved to 4,655.

Isn't this drop a success story in the battle against TB? I ask Professor Drobniewski. It represents a certain achievement, he says dubiously. Although rates have dropped in Britain, we may just have pushed them out of our line of vision. TB is still raging further afield. He points me to a 'tuberculosis strategy' for England, devised by PHE and NHS England, which outlines a compulsory pre-entry screening for anyone wishing to enter the United Kingdom: 'All individuals from high-incidence countries applying for a UK visa longer than six months are now required to provide evidence that they do not have active pulmonary TB.' Part of the reasoning is that incidences of the disease in England are higher than in most other Western European countries and more than four times as high as they are in America. If figures have been recently reduced on our shores, has this come at the cost of an aggressive immigration policy, which ensures that the disease remains another nation's problem?

Globally the outlook is far more worrying. Again, rates of infection have declined in recent times, but TB remains the top infectious killer worldwide, with 10 million infected and 1.5 million dying from it in 2018, according to the WHO. In 2019, a year before Covid-19 swept across the world, a *Lancet* commission gathered together almost eighty of the world's most eminent TB experts and epidemiologists. They included Jeremy Farrar, the director of the Wellcome Trust, and also part of SAGE (the Scientific Advisory Group for Emergencies), and Anthony S. Fauci, director of the National Institute of Allergy and Infectious Diseases, and a lead member of the White House Coronavirus Task Force. This panel described

tuberculosis as a pandemic, however far removed the Western world *felt* from it, and questioned why it had not been eradicated by now: 'Tuberculosis can be treated, prevented, and cured. Rapid, sustained declines in tuberculosis deaths in many countries during the past 50 years provide compelling evidence that ending the pandemic is feasible. Yet this disease – which is the greatest infectious killer in history – remains a relentless scourge.'

TB has never stopped being a threat in the developing world but rates have risen and fallen and risen again in industrialised countries over the past century. After a drop in the 1950s, they slowly climbed again. In New York, they tripled between 1978 and 1992, mostly due to poverty, homelessness, the HIV epidemic and the rise of drug-resistant TB. In *Tuberculosis: The Greatest Story Never Told,* Frank Ryan tells us that in June 1992,

> the WHO issued a press release listing a dramatic rise in ten industrialised countries: Britain, Switzerland, Denmark, Netherlands, Sweden, Norway, Austria, Ireland, Finland and Italy. Globally, there were an estimated two to three million deaths from the disease. A year later the WHO declared a public health emergency and called on all governments across the world to make its control an immediate priority.

Then in 2014, it set a goal to eliminate the disease in countries with low levels of TB by 2035 and on a total global scale by 2050. In 2018 a UN High Level Meeting (UNHLM) on tuberculosis also resolved to build a 'tuberculosis-free world'. The *Lancet* commission, too, stated that 'The world can no longer ignore the enormous pall cast by the illness.'

So many clarion calls, yet the disease resists eradication. Bill Bryson reflects on why: 'If TB is off the radar for most of us, that's because 95 per cent of its million and a half-plus annual deaths are in low- or middle-income countries.' So it continues

to ravage populations in India, Nigeria, Indonesia, South Africa, Bangladesh and Pakistan, while the West shores up its borders and looks away.

However anomalous Fauzia's death, however rare her strain of TB in Britain and aberrational her hospital dying, a distant part of me felt bound by sisterly rules to follow suit. I was forty-three when Fauzia had her haemorrhage, so felt I had just two more years. For that time, life hurtling forward. I had my own kind of 'hectic fever' of overworking, hardly sleeping and thinking of tying up loose ends. My life could be put away fairly quickly and without fuss, I realised, with some disappointment. Then, as I crept towards my forty-sixth birthday, I began to take stock. Fauzia's death had defied the laws of our sisterly relationship. How could she start being my younger sister? How could I be her elder? I was soon to be a year older than she would always remain. What did that mean?

3

How To Be Sisters Now

10

Sacrifice

In 1890, Vincent van Gogh died from a self-inflicted gunshot wound. His death was quickly followed by his younger brother Theo's, in 1891. It is Vincent van Gogh we remember for his tragic life but Theo's life story is its own tragedy, which seems eclipsed by his older brother's. A respected art dealer in Paris, he was a close and committed brother to Vincent, taking on his ambition to be a great artist as a joint project in some ways. Vincent discussed his work in great detail with Theo through his letters, more than nine hundred of which remain, but also wrote about his health and money problems. Theo, meanwhile, sent him family news, emotional encouragement, a regular allowance to buy paints and food, and even paid for Gauguin to join him in Arles, in 1888, so they could paint together. He had his own family's upkeep – a wife and son – but he was there for Vincent right until the end. Almost exactly six months after his brother's suicide on 29 July, Theo died on 25 January, at the age of thirty-three, from paralytic dementia, a brain illness connected to the late stages of syphilis, though at the time it was also associated with extreme states of sadness.

Robert Altman's film *Vincent & Theo* (1990) explores Theo's inner battles alongside Vincent's greater mental disturbance. It is a startling portrait of the brothers and as much a study of Theo as Vincent. Tim Roth plays an abrasive Vincent and Paul Rhys is Theo, the gentler, more urbane and quietly anguished brother, with an immense emotional burden of care towards Vincent. His moments of darkness are glimpsed in the cracks between Vincent's bigger breakdowns. Altman shows him to be

on the edge in all sorts of understated ways, but once Vincent dies, Theo's darkness engulfs him and his decline is rapid.

I watched this film after Fauzia's death, when I felt my own position as the 'well-adjusted' sister shifting in her absence, and wondered whether Theo would have unravelled and succumbed to illness quite so fast if Vincent had not died the previous year. Would he have carried on being the capable brother if Vincent had lived? I ask Martin Bailey, a van Gogh expert and author. He says there is little doubt that Theo was in mental anguish after Vincent's death, which must have weakened him, but we cannot know how much Vincent's dying impacted on Theo's illness. We do not even know the exact nature of Vincent's mental disorder because there has never been consensus among experts. On 14 September 2016, the Van Gogh Museum convened a symposium of specialists in a definitive attempt to name the illness. It included neurologists, psychiatrists, physicians and art historians. They reached an impasse on its exact nature. A summary of the symposium reads:

> Was he already ill before that fateful day? [when he famously cut off his ear, after a fight with the artist Paul Gauguin, on 23 December 1888]. A straightforward answer is not possible either way . . . we can certainly identify elements of borderline personality disorder, bipolar disorder, and – slightly less likely – epilepsy. Yet not to such an extent that would justify referring to an illness.

Bailey thinks it is futile to project contemporary understandings of mental illness onto the past, or onto these brothers, but what is unquestionable is that Theo was the epitome of loyal, self-sacrificing brotherhood.

In his book *Starry Night: Van Gogh at the Asylum*, Bailey says that the trigger for van Gogh's self-mutilation may have been not only his fall-out with Gauguin but also a letter from Theo, received earlier that day, announcing his plans to marry

Johanna Bonger, with whom he had had a whirlwind romance. 'Vincent was terrified of abandonment and was immediately struck with great anxiety,' writes Bailey. The prospect of losing that sibling closeness, and also the financial support that Theo had been giving him, might have pushed him further into a psychotic state. Theo, for his part, seems to feel awkwardness over his own new-found happiness, in relation to his older brother's continued pain, though Bailey does not say so explicitly. But he cites a letter, written by Theo on 16 March 1889, after it has been decided that Vincent is too ill to live independently and must be admitted to an asylum: 'It breaks my heart to know that now that I'll probably have days of happiness with my dear Jo [Johanna], you will actually have very bad days.' He wrote again to Vincent on 24 April 1889, when it was agreed he would be admitted to Saint-Paul-de-Mausole asylum, in Saint-Rémy. Bailey tells us that this was the first letter since Theo's wedding, but 'Theo wrote nothing about the big day or the honeymoon, presumably fearing that this would appear insensitive in view of his brother's plight.' Though sibling guilt – and Theo's relative good health – is not part of the two brothers' story, I sense it to be there, between the lines of the letters, and alongside Theo's undying spirit of support and sacrifice.

For a while, sibling sacrifice is everywhere. Even when I don't seek it out, it finds me and reminds me of my failings. Sometimes it creeps up surreptitiously. I am asked by the *Guardian,* where I am chief theatre critic, to review a radical retelling of the ancient Greek drama *Antigone*. It is the last of the Sophoclean cycle of Theban plays and I know it as a story of a loyal sister who sacrifices herself for a recalcitrant brother. Antigone is simultaneously a rebel for burying the body of the shamed Polynices, despite the king's ruling that he must be denied that right for waging war on Thebes, and the upholder of divine justice, for following the rule of the gods on burial rites over the king's man-made edict. Some academic conspiracies suggest

an incestuous love between Antigone and Polynices, which accounts for her fervour to give him a dignified burial.

But this revisionist version by the playwright Lulu Raczka has stripped away every character except Antigone and her sister, Ismene. There is no King Creon or dead brothers, no husband-to-be Haemon, and no doom-laden chorus. I am relieved. I have seen *Antigone* many times before and regard it as an ancient play full of ancient ideas about ill fates, divine rights and earthly transgressions. Turning it into a play about sisters feels new and fresh to me but I do not connect it to my state of bereavement or guilt. Ismene is the less important, more fearful sister who refuses to help Antigone and is sorry for it by the end when Antigone is sent to her banishment inside a cave. She has never seemed anything other than a function of the plot, but when I go back to the text, in preparation for my review, I see that the play opens with a moment of sisterly closeness, and it is clear from this conversation that they are indispensable to each other: 'O sister! Ismene, dear, dear sister Ismene. There is no pain, no sorrow, no suffering, no dishonour we have not shared together, you and I,' says Antigone, before asking her for help to bury Polynices, a request Ismene refuses.

The auditorium is shrouded in darkness when I enter and take my seat. There is a circular pit on stage and an earthy smell in the air. The pit is lumpy with something buried inside it. It takes a while for my eyes to adjust and I realise that there are two women – more girls than women – lying face down in the earth. As the lights go up, the sisters rise from the mound and burst into life. They are modern teenagers in pink, sequined dresses and Converse trainers, dancing to Destiny's Child and yearning to go to bars as their brothers wage war outside. Those bars and brothers are never glimpsed. What is captured so singularly and exquisitely is the closeness between them. They are girls teetering on the brink of womanhood and it is a captivating picture of young sisters, so tender and up close that I can see

the smoothness of their skin and the soft curve of their cheeks. Antigone is the older sister here – I am not sure Sophocles' text ever makes their age difference explicit but Antigone is certainly more dominant across the Theban plays – and Ismene is clearly in thrall to her. Even though the focus of their banter is how to meet men, their garrulous sex-talk is a childish performance for the amusement of the other, and the sexual conquests Antigone speaks about so swaggeringly contain all the naivety of a girl bragging about something she has yet to experience. It is their ardour for each other that seems like the central love affair. They giggle, tease and put glitter on each other's faces.

The mound of earth stays on stage for the duration of the play and casts a funereal shadow across it. When Antigone is led away to her banishment and death, Ismene stays, telling us how she lived out her life, after Antigone's was ended. It is an eminently ordinary existence, with a husband, children, household chores, daily delights, distractions and disappointments. The actor playing Antigone lurks in the shadows of the stage, in ghostly watch over Ismene, the sisters seeming bound to each other even in their discrete, unbreachable worlds, Antigone stalking Ismene, and Ismene drowning quietly in guilt for the actions she didn't take as a young girl.

Afterwards, when I talk to Lulu Raczka about her play, she tells me that its initial focus was teenage politics and protest. Antigone's single-minded stand-to-the-death against state injustice encapsulates youth resistance and Generation Z activism today, she says, though that original idea morphed into a study of the sisters. It is the mix of these two elements that floors me: I see the intimacy of teenagers, so intense and absolute. I see the adored sister in Antigone and the adoring one in Ismene. I see Antigone's rash passion and how it leads her hurtling into self-destruction, and Ismene's more rational calculation for survival. I see other parallels I don't want to see: their interdependence, the older sister's heroic protest against the patriarch

and proxy-father King Creon, and the younger sister's cowardice. I see her betrayal of Antigone and her survivor's guilt. I feel a lurching recognition of these themes, and these sisters: the angry, self-destructive rebel in Antigone and the law-abider in Ismene, who saves herself but is haunted by the other, in her absence, for the rest of her days. I remember Fauzia's image of me, the demon sister, and yearn to be redeemed, just as Ismene seems to yearn in this play.

There is something else in this portrait of Ismene as the wide-eyed sister that reminds me of myself. Antigone is the brave-heart who paves the way, while Ismene is the passive witness and hanger-on. Perhaps this is a universal inequality between sisters – the older always more admired by her younger sibling, and more herself. I see shades of it in my two nieces, the younger, Eva, taking slanting glances at her older sister, Martha, whenever I ask a question. She invariably waits for Martha to speak first and her answer comes in relation to her sister's words, it seems. Fauzia became her own person before I became mine. She had to find ways to survive and fend against fatherly rejection on her own. She didn't confide in me about her plan to disappear for the night at the age of thirteen, and she took someone else to see *La bohème* on her eighteenth birthday. When I flick through her diary from 2007, which I found and kept after her death, I stop and stare at the blank page on 4 August, the day of my birthday. Its emptiness galls me, even though I know it is childish, but birthdays were always big in our household, and I still circle 3 September in every diary I buy, more than four years after Fauzia's death, to mark her date of birth.

Could it be the case that I was not the most important person in her life, even at our closest, though she was most certainly mine? And could there be a misplaced self-importance bound up in my guilt? Have I given myself a more central role in Fauzia's story by assuming that if I had shown greater loyalty, and greater love, she would be alive and OK?

But then, in the midst of this recognition, I am captured by a line I have never heard in the play before. It comes after Antigone has buried Polynices and knows she must now pay the price for her defiance of the king's word. Ismene, not wanting to abandon Antigone in her final moments, says, 'I'll say we both did it. Then we can be monsters together,' making clear that she is willing to go down with her sister. But Antigone is categorical that there should be no more sibling sacrifice. Ismene should save herself: 'Go and live,' she tells her. 'I would never let you die.'

These words ring in my head afterwards and create their own slow revolution. *Go and live. I would never let you die.* There is no doubting their meaning and their fierce, sisterly protection. I look back to Sophocles' original text and the passage is there, albeit in different language: Antigone confessing to the king that she went against his wishes, Ismene coming forward to say she was also involved in the rebellious act of burial, in support of her sister. And Antigone chiding Ismene for not helping her but also suggesting that she loves her no less for it, and warning her against self-destruction: 'You shall not die with me. / You shall not claim that which you would not touch. / One death is enough . . . No, no. You live. / My heart was long since dead . . .'

My understanding of Fauzia is turned upside down after reading Antigone's words. Why hadn't I considered the possibility that Fauzia may not have wanted me to keep holding her hand as she descended further into darkness, and that, in fact, she chose to let go of mine? She might well have felt resentful because I wasn't ready to sacrifice my life in care of her, but she would never have wanted me to make that sacrifice. Those two contradictory feelings could have existed at once, alongside each other, just as they do in Antigone. She might even have *needed* Ismene to choose life, to 'go and live', as a condition of her dying, just as Fauzia may have wanted me to go into the world and do all that she wasn't able to do. Ismene's lifelong guilt seems like

foolishness now that I see Antigone releasing her from it, however gruffly she does it. But the younger sister doesn't hear Antigone's words, just as I hadn't heard Fauzia's.

I listen to a radio programme on BBC Radio 4 that dramatises addiction in connection with sisterly love and guilt. One sister is an alcoholic, the other her pained observer. 'It felt like I was throwing ropes into the void,' says the one who is trying, and failing, to help her addict sister, but it is the alcoholic woman's words that stand out: 'There was no room for my sister. No room for anyone . . . I was quick to drop a lot of people and prioritise isolation. If no one was a part of it, no one could get in the way.' Here the troubled sister was saying that she didn't want saving, that she was beyond saving, like Antigone – 'My heart was long since dead' – and that her sister wouldn't have been able to save her, however much she had tried.

After seeing Raczka's *Antigone*, I seek out other versions of the play, from David Chariandy's stark, stunning novel *Brother*, featuring two black Canadian brothers and the 'complicated grief' of the younger, who watches a white police officer shoot his older, adored brother dead, to Ali Smith's children's adaptation in which Antigone is a twelve-year-old upstart in ancient Greece. She judges Ismene for her meekness but is also able to see that Ismene has chosen life while 'It's me who chose death' and she protects her sister's decision in front of the king. These various retellings, I realise, are not just about sibling kinships but also about sibling differences. Antigone is taken to her cave to be left to die and defines her end by hanging herself. But Ismene defines her fate too, and she chooses survival. Antigone grants her permission to do this. They make different choices as sisters but there is nothing to forgive between them.

I remember a conversation I had with Fauzia a few years before she died. We were talking on the phone, raking over the past and how it had come to be that we were so removed from

each other's lives. 'Who started it?' she had said, and it had confused me because the chain of rejection and hurt seemed so complex that I had lost the thread of who had done what to whom, but now I wonder if she felt guilt-ridden for her own reasons, perhaps because she was not able to be the 'big sister' to me. Maybe there was no *one* guilty sister or sacrificing one.

When I looked through her medical notes, I came across an entry from a doctor who seemed to be assessing Fauzia's mental health, on 9 May: 'We discussed some feelings of guilt she [Fauzia] feels about her mental health . . . She currently feels hopeful for recovery medically and in her mental health.' When I read it, I felt surprise first and then sadness. Why had I never thought that she might feel guilty too? But the second part of that doctor's statement, about her hope for recovery, pains me even more. In her final weeks, Fauzia and I talked about our futures. She spoke of wanting to get back to her art, then teaching the subject after her degree. I said I could see her doing it. I told her I felt unmoored; I had not yet joined the *Guardian* but had just left a job of fifteen years at the *Independent*, along with many of its journalists, after its print edition closed. I felt unnerved not to be part of a newsroom, and a newspaper. She was perplexed and told me I should feel liberated from that 'corporate' identity. Now I could be more fully myself.

I find the last text messages between us, when Fauzia was in hospital, days before her death, and the exchanges read like a return to being the sisters we were, planning big things for ourselves and plotting the same for the other. They are full of warmth and humour; she is waving away my fears and expressing excitement at the new future she sees awaiting me. *I would be interested in reading a few extracts of your writing*, she says in one text, though she also says she no longer has enough energy for a shower. I was travelling around the country for work but offering up thoughts as to what illness she might have. *Maybe you have Crohn's disease? Look it up*, I say. *Don't worry too*

much, she replies. *I am making good progress now*.

In one of her last messages, she consoles me about leaving my old job behind: *The mourning and inner sadness doesn't go away in a week or two. You have to live alongside it.* It is tempting to give the words a magical quality – that she knew what was coming, that she was advising me on how to live with her death, wrapping her arms around me from her grave. A dream comes back to me, the one I had shortly after Fauzia's death in which I clasped her, thankful she was still alive only to realise she was cold and stiff with death: 'Leave me alone,' she had said, and I thought she was telling me not to pursue her medical case. But now the dream takes on a different meaning. By instructing me to let her go to her death, she was telling me to get on with the business of living.

Antigone seems suddenly not to be an ancient story at all. It is about how we honour the dead – how Antigone buries Polynices and how Ismene must bury Antigone. Funerals do not necessarily mark the moment a loved one is buried. Burial is a long, fraught process, but always afterwards, we must go and live.

Vincent van Gogh didn't want Theo's sacrifice, nor did he take his brother's generosity for granted. In some letters to Theo he refers to his brother's health and urges him to look after himself. In so many others, there is a cherishing of Theo, and a plan to repay him one day when – he hopes – the value of his art will rise. At one point he considers giving up using paint and switching to drawing to save Theo money, and at another he offers to find a job. In a letter from Arles in May 1888, he writes:

> I constantly reproach myself with the fact that my painting does not bring in as much as it costs, and yet one must work. You must, however, remember that if ever it should become necessary for me to go into business, in order that your lot may

be lighter, I should do so without regret . . . You must understand that I would prefer to drop my art than to think that you were slaving your life out to earn money.

In the same letter, he even warns Theo against selflessness, telling him to put himself first and speaking of the foolishness of any self-sacrificing compulsions: '. . . do you not [also] see that self-denial, and sacrifice for others is an error too, especially if it is as good as suicide, for in that case one turns one's friends into murderers'.

I find myself returning to Tai Shani's installation, *DC: Semiramis*, which I had seen in Margate and which had haunted me for its sisterly martyrdom. *That* had never been about sibling sacrifice either. I had only thought it was. Some months after I heard the recording, I started searching for it online so I could listen to it with a clear mind. I learned that it was one of twelve monologues in the *DC: Semiramis* series and listened to one of these recordings but was disappointed when the noblewoman and the martyrs weren't mentioned. I decided to email Shani, though I wasn't sure what I wanted to say. 'I heard your recording at Turner Contemporary. Was there a story about women who sacrificed themselves for someone they loved?' I wrote vaguely. Shani responded kindly, sending me the script of the recording called 'Sirens', and at first it was just as I had remembered it. It was only when I reread it, slowly, that I realised the story was different from the one I had remembered – or told myself:

Before Sirens were Sirens, they were a group of women gathering flowers, when one of them was abducted by Hades as a bride, another was so distressed that she could not keep them all safe, that she melted into water. The remaining ones asked the gods for wings so that they may search for their abducted friend and share their grief through song.

The story began to sound familiar and Shani later said it had been inspired by a scene from Ovid's *Metamorphoses,* which describes the death of a sacrificing woman:

> You should have seen her limbs become slack, the bones pliant, the nails lose their hardness. In cold water, her most tender parts became liquid first: the black hair, the fingers, the legs, the feet; and then the transformation of her other delicate limbs. Then her shoulders, back, hips, and her breasts dissolved into small streams. And, finally, into the broken veins, in the place of living blood, entered water, until nothing more remained to be grasped.

This woman's extreme mourning, ending in sorrowful self-annihilation, was what I had remembered from the gallery recording. But I saw now that the story was about the experience of death – the obliteration of the physical body – not about heroic female martyrdom, as I had thought. And when I reread the script slowly, the image of the woman's melting away into the water sounded like a warning against such sacrifice, if anything.

Only that one woman chooses to die. The others ask for the power of song to protest against Hades' abduction. And they request wings to enable the search for their lost friend. Even though Shani's monologue is impressionistic, it is clear that the Sirens are heroic figures of a different kind from the suicidal woman. They want to sing their terrible song, describing the wrong done to their abducted friend and the pain of their own lives. Maybe their story had been instructive all along for me but I had mistaken its message. These women are alive, angry, refusing to be silent. They remind me of Fauzia but I see my own endeavour in them too – how, in my modern, unmagical world, my search for my sister is granted not by wings but by words, and my grief is not a song but a story of her sadness, and my own.

11

Sorrow

We met over Fauzia's sickbed in celebration almost exactly a month before she died. It was 7 May 2016 and we were celebrating because we thought the doctors had saved her life. It was after her first stay in intensive care when she had been put on steroids, and although the medical team hadn't worked out what was wrong with her, their ministrations had led to her recovery, or so we thought. A good-natured doctor told me that some people came into ICU desperately ill and went home well again without their illness ever being given a name. The same had happened to Fauzia, we thought. A few days later she was moved out of critical care onto a ward that didn't have the same quiet tension, so we collected around her bed to mark the moment. It was a raucous affair; my brother and sister-in-law were there with my two nieces, who had dressed up in party-ish frocks. The smaller niece, not yet a year old, picked up on our festive mood and looked inordinately joyful in her pram. We drew the curtains around us but spoke loudly, took pictures, made videos.

This was a second chance: for Fauzia and I to be sisters, for my mother to see us reunited, not fighting but talking, laughing. And a second chance for Fauzia at being alive. She had been surrounded by tubes and oxygen canisters and silent, sleeping bodies in her other sickbed, but here she was, in this fresh bed and this bustling ward, back from the brink. In the photos she has a bright-eyed, surprised expression, as if she can barely believe her luck. Everybody else looks to be in a state of high excitement. We are making silly faces and my eldest niece is blowing raspberries into the camera. I can hear Fauzia's laughter in one of the

videos as she watches our high jinks and horseplay. In other pictures, us three siblings – Fauzia, Tariq and I – are posing together and we look delighted. Fauzia has one remaining tube in her nose but she has done her make-up and looks as glamorous as it is possible to be in a hospital gown. The photos are saturated with colour and light and, as fanciful as it sounds, it is as if a ray of sunlight is beaming straight at us, and we are basking in its warmth.

The hospital bed that Fauzia lay in looked much like those in my father's nursing home. These have reclining devices, electronic air mattresses and, nearby, machine-operated hoists. And even if they are sickbeds that slowly, inevitably, segue into deathbeds – every empty bed seems like a signifier of death in a home for the elderly – they hold the hope of continuing life for whichever new person fills it. They are a place of transit, too, with a mystic quality ascribed to them by some of the carers, who have told me of bells ringing in empty rooms where an elderly resident has just died, and spoken of the uncanny way in which those who move into a room resemble those who have just left it.

The picture of us all, gathered around Fauzia that day, was a triumphant tableau: a victory over the sickbed and a hospital paean to survival. It is a reminder now that not all sickbeds become deathbeds. This scene could have been one possible ending to Fauzia's illness, just like the ICU doctor had pointed out. People come in with mystery illnesses and survive them. That whooping bedside party turned into speechlessness and stillness, in another room and another ward of the same hospital, a month later, but for a while, her sickbed contained more hope than despair. It brought resuscitation, recovery, resurrection. For that short time, life trumped death and we revelled in it.

Edvard Munch was fourteen when his sister, Johanne Sophie, died of tuberculosis. She had been his favourite sister, the one to whom he felt closest. She died at the family home in Oslo

(then named Kristiania) in 1877, in her wicker chair, at the age of fifteen. Nine years earlier, their mother, Laura Munch, had died of TB. Another sister, also called Laura, would later be admitted with a mental disorder to an asylum, where she would die. In adulthood, Munch wrote about the terrors that had beset his family in early life and how he thought himself cursed by hereditary disorders: 'Disease and Insanity and Death were the black Angels that stood by my Cradle.' He depicted these terrors in his art as well, channelled them into some of his bleakest masterpieces to create visceral portraits of anguish.

If it is common practice now to chronicle family trauma with such searing rawness and psychological drama, it was revolutionary and shocking in Munch's time. He painted his siblings and parents in various states of illness, death or melancholia, but it is to Sophie he returned most often, and specifically to her death, as if he were both reliving its horror in flashbacks of oil on canvas and trying to exorcise it in colour and form. He produced six versions of the same painting, *The Sick Child,* of a hollow-eyed girl sitting in a chair in an atrophied state, with a maternal figure, broken by grief, beside her.

The first version of *The Sick Child* was completed in 1885, when he was twenty-two, by which time deathbed images of tubercular women were commonplace, from Duplessis on her sickbed (1847) to Monet's painting of his wife, Camille, on hers (1879). What gives this its extraordinary power is the trauma that Munch inserts into its artistry: the canvas is scratched and scarred, as if clawed in grief. The paint is left to drip down it, like teardrops. Sorrow is etched into form, and from the reproduced images I have seen, it looks as if the painting is crying. The poet Adam Thorpe, in an audio recording of his response to first seeing it in Oslo, describes its palpable sorrow: 'My Sophie, my sister, we can hear it scream, almost.' Tate Modern, in London, holds one version of *The Sick Child*, painted in 1907, but when I seek it out in the summer of 2020 I am told

that it is not on show and one-to-one viewings cannot take place as they normally could due to the Covid-19 crisis. What circles of contagion, I think, when epic ancient infection meets contemporary pandemic.

But there is another painting called *By the Deathbed* (1895), which is more graphic in its grief than *The Sick Child*, and I feel its dread as I stand in front of it. It shows Sophie's family by her deathbed and is part of the Rasmus Meyer Collection, housed in a wing of the Kode Art Museums and Composer Homes in Bergen, Norway. If there is a painting that screams its sorrow, it is this one, although I can also hear the numbed silence of the family watching over the dying, or dead, Sophie. It dominates the wall on which it hangs, which has two smaller, quieter paintings on each side of it. Sophie seems to be dead, though we do not know for certain because we can't see her face, and she lies in a bed, which has the sunken effect of a coffin. We see only the back of her head and the outline of her body, mummified under a white sheet, and there is a cramped perspective to the painting. She seems squeezed onto the canvas and it is her family, standing on the other side of it, who dominate its awful, deathly drama. The expressions on each of the five figures' faces make clear that this is a moment beyond all hope: whether Sophie is dead yet or not, she is irredeemably lost to them.

Frode Sandvik, from Kode, who curated an exhibition on Munch's key relationships in 2019, tells me that the artist reproduced this image in different media; in some earlier drawings and pastels, there were demons and skeletons emerging out of the shadows, and in the swirling red and black backdrop of this work I can already see the ghouls stirring, readying to bare their teeth.

A sister, Inger, stands at the back of the room, her eyes dots, her face without a nose or mouth. Munch's father, Christian, and sister, Laura, are a reddish colour, as if they are fevered and sickly themselves. A brother, Andreas, is also there, his face

in profile and as flat and featureless as Inger's. One side of the wall is in shadow while the other is the same fevered red as the father's face so that it looks as if it, too, is oozing sickness. Munch's dead mother stands at a slight remove, right at the front, looking as if she has been dug up from her grave, with sunken eyes and a greeny-white tinge to her skin. Of all these frozen portraits of grief, it is Inger's that holds me. Her back is against the wall and she stares directly ahead, holding her hands, and despite the upright posture, there is something utterly devastated about her stance.

The Norwegian writer Karl Ove Knausgård, who curated an exhibition of Munch's work in Oslo in the autumn of 2019, spoke of the power of Munch's paintings in an interview with Giulia Bartrum, who curated the British Museum's show in London the same year. It is as if they are 'coming towards you, with such a force that you can't really protect yourself against them', he said. It is true; almost every canvas in the room has a centripetal energy that draws us in and locks our gaze, but this one has the greatest gravitational pull, and its power, for me, is in the positioning of Inger at the back. We are sucked inside the painting until we are pressed up against Inger's despairing impassivity, her ramrod stance and alabaster hands, her holes for eyes, which are beyond seeing, beyond tears.

There is a universal, and epic, quality to this portrait of shocked family mourning, but also something unnerving in the odd angle that shows Sophie compressed and head first, as if the artist is seeing the scene from the top of her bed. It is a low enough perspective to be that of a child's-eye view – maybe that of the fourteen-year-old Munch, observing Sophie's death in 1877 – but it also has the glaring, distorted vision of a memory whose every detail is vivid, yet it feels kinked, dreamlike, and wrong. The painting's horror seems to expand as I look. A man sits down beside me in the gallery and becomes glued to it too. It offers a kind of communion and I see my own dead sister in

its drama, just after her ventilator was switched off. We waited to see how long her heart would beat on its own. It stopped within seconds, as if she couldn't wait to be away, and we remained frozen in the silence until we realised there was nothing more to do.

But even then we rustled in small, slow movements around the room, and I circled her bed, from head to foot, from foot to head, taking mental snapshots of the last moment, tidying her hair and smoothing her sheets. From top to bottom, from bottom to top. I felt as if I had become strangely close to her in the days leading up to her death, watching her face for the smallest movements, leaning in, learning its angles and lines again. Now I couldn't tear myself away. My mother and brother hovered too. Like Inger, we were too mortified for tears, our faces transfixed, zombie-eyed. A nurse came in and tried to usher us out so she could get on with her job. I turned to her and said, 'You *will* look after her, won't you?' and she nodded. I wavered at the door, even after my mother and brother had left, and took one final look back at Fauzia, though there was just her face visible now, a white sheet tucked under her chin and feet. It was Fauzia's face, as it had been, but with all its tension drained away, and I looked on in confusion at this surprisingly contented, final, face.

Just as that room had been a wrench to leave, so is this painting. It grows bigger, more powerful, and I want to keep looking at its frozen moment. I begin to wonder what it seeks to say, and what Munch was saying with all his portraits of Sophie. Was he trying to pin down the exact moment of her dying and, in so doing, make sense of what he called 'unfathomable death'? I begin to wonder how Sophie looked, not in this last moment when we see just the back of her head but in life, perhaps before illness took its final hold. Did she look like the girl in *The Sick Child*? That figure was someone Munch had seen in his father's doctor's surgery and it was meant to

represent Sophie, but it is an ethereal, indistinct image of a face in profile, and even then the girl's white pallor is almost dissolving into the white of the chair on which her face rests. It is as if, any minute now, she will disappear altogether. Sophie, in fact, bears the generic visual tropes of romanticised, sick femininity, from the pre-Raphaelite pale skin to the empty eyes and thin limbs. And it is not the child with whom the viewer identifies in this painting: it is the mother figure that coils over the child, clutching her in impending grief.

In another painting, *Death in the Sickroom* (1895), Sophie is in the wicker chair in which she died but has her back to us, so she is again not visible. This composition is made up of family members, in states of acute sadness, including Munch himself. They are adults now, just as they are in *By the Deathbed*, and not the children they would have been when Sophie died. 'By painting them as adults, Munch seems to suggest that the drama of this childhood memory will remain constantly alive, always vivid,' however old they become, says Frode Sandvik. Yes I think, as I look at the ashen figures in *By the Deathbed*. There is a strange sense that this moment has both aged and stayed ageless. Sophie is frozen in aspic as the eternal child but the siblings are still subject to the ordinary passing of time; the painting is about them and the tragedy in her death comes from seeing its effect on *their* faces. It is a *mise-en-scène* of Munch's sorrow, not Sophie's death. She is the subject of the painting but he is its subjectivity. As Sandvik has told me, '*By the Deathbed* is mainly about the ones who are left behind.'

It is also about Munch's art. He was in his early thirties when he painted *By the Deathbed* and far removed from the grief-stricken and powerless boy he had been when Sophie died. He was now the artist, turning his sister into the subject of his art, over and over again, and he often used theatricality to build up an image. The perspective of *Death in the Sickroom* resembles that of a stage, and he famously designed the set for Henrik

Ibsen's *Ghosts*, in which he featured a large wicker chair, like the one in which Sophie died.

'He repeats figures, they become props. There is a kind of "prop" thinking [in his work], a formula that he repeats,' explains Sandvik.

'Was Sophie a prop?' I ask.

'Well, with Munch it's always about the suffering man,' says Sandvik, a little wryly.

In recent years, some in Norway have made connections between Munch's art then and Knausgård's writing now, namely in the latter's six-part series of autobiographical novels, *My Struggle*, in which family secrets and intimacies all become the stuff of fiction. 'The most obvious similarity is the very direct way of exploring and conveying emotional states in their respective works. Maybe there is also a parallel between them in their non-compromising way of using close family in art, though Munch is more universal in his symbolism,' reflects Sandvik.

The idea that Munch's repetition and reproduction of Sophie's image was a way to honour and explore her loss is beguiling – the exemplar of a loving brother forever in mourning – but Sandvik tells me that it had an artistic purpose: his painting technique has a serial quality and it was rooted in his circular philosophy on life and death. Repetition is central to it. None of this is to take away from Munch's loss, says Sandvik. He *is* the grieving brother but he was also the clear-eyed artist, using Sophie's death as one part of his grander project to depict mortality and human suffering, with himself at its centre.

Sandvik's words make me think about, perhaps even reconsider, my own 'portrait' of Fauzia. Am I depicting her life and death or my sorrow? If it is the latter, is that sorrow made more ornate, more artful, in its articulation? And if it is the former, would she have been pleased that at last she was being better heard, the injustices of her life seen, her pain finally acknowledged? Or would she have rolled her eyes at me? A phrase from her sketch-

book comes to mind – the one written in pencil in the middle of a blank page that was filled with distrust for art that relies on traumatic autobiography: 'It's so real and gritty. I'm such an artist.' Am I that artist, in Fauzia's eyes? Is my subject matter – her life as the real, gritty thing – corrupted by the role I play in conjuring her up again, from life to death? Does she even want this Siren song sung for her? I am back to the same questions I have been asking myself in the writing of this book: is this *my* story or Fauzia's? Would she want to be described this way by her still-alive sister, and have her life so defined by her death?

In 2008 the National Portrait Gallery, in London, put on a retrospective of Annie Leibovitz's work. *Annie Leibovitz: A Photographer's Life 1990–2005* contained her celebrity portraits but alongside them were images of her partner, Susan Sontag, in the last stages of her life, in bed with tubes and monitors, then laid out in a New York funeral home. There were photographs of Leibovitz's dead father too, who died soon after. Sontag's son, David Rieff, wrote of his mother as being 'humiliated posthumously . . . in those carnival images of death taken by Leibovitz'. In an introduction to the book that accompanied the retrospective, Leibovitz explained why she had decided to include the personal pictures with the seminal, career-spanning works: 'I don't have two lives. This is one life, and the personal pictures and the assignment work are all part of it.'

To me, a stranger encountering them in the show, they seemed peculiarly documentary, as if Leibovitz had wanted to catalogue the unvarnished realities of Sontag's last days and keep a record of her partner's final, finished face. There seemed to be a distinct lack of curated drama in them and none of the staging of Munch's paintings. These were snapshots that anyone could have taken and seemed like a quiet observance of death, though I think it is not the pictures in themselves that Rieff seemed to be objecting to, but their public display.

My mother's eldest sister, my aunt Shehla, who lives in Lahore, asked for an image of Fauzia in her death. My mother had every intention of taking a photo in the funeral home and sending it to her sister but she got lost in the emotions of the day so it was never taken. This is not considered morbid or obscene in Pakistani culture as it may be in the West: it is ordinary ritual, a way in which the dead become dead. Seeing someone this way makes us see that death is a physical fact, not a notion. Facing up to death is, of course, not exclusive to Pakistanis: there are elaborate rituals in Mexico to mark, perhaps even to celebrate the dead, and Irish wakes often involve intimacy with, and visibility of, a dead body. During the Covid-19 pandemic, I heard a news report in which a Northern Irish funeral director spoke about the sadness of mourners who could not have open caskets. Because they couldn't see the body of their loved one, there was not the same kind of closure, he said. For them, death was just too big and strange to face without the evidence. Then again, a friend whose mother died some years ago said she was given the option to see her in hospital, shortly afterwards, but chose not to because she wanted to remember her as she had been in life. The blunt truth of the dead body is what some people can't bear to see but others feel they absolutely must.

Kelly Chorpening, my sister's tutor at Camberwell, says it is not unusual for artists to draw their dead. There is a rich history of such drawings – specifically *drawings* over paintings – often sketched at the deathbed as a way to 'contemplate the moment when life leaves the body'. They may not always be made public but the impulse to capture the moment is there, she says, and tells me she has known of artists who have sat and drawn their loved ones as they have died. The act of sketching pulls you into the present and demands a profound form of concentration, she says, so it makes sense for artists to represent this momentous but passing event, by trying to commit it to paper. Kelly's

words are soothing: documenting death needn't be theatre, she reminds me. It can be an artistic impulse, a meditation on mortality – or both.

John Berger drew his father in his coffin, Kelly adds, and sends me his essay about it, 'Drawn To That Moment', which first appeared in *New Society* magazine in 1976. 'To draw the truly dead involves an ever-greater sense of urgency. What you are drawing will never be seen again, by you or by anybody else. In the whole course of time past and time to come, this moment is unique: the last opportunity to draw what will never again be visible, which has occurred once and will never reoccur.' He goes on to describe the process of drawing his father: 'His life was now as finite as the rectangle of paper on which I was drawing, but within it, in a way infinitely more mysterious than any drawing, his character and destiny had emerged.'

Berger hung the portrait on the wall in front of his desk, and described how, over the years, as he stared up at his father's dead face, he saw it changing. It sounds uncanny but I feel comforted by what he says: between the lines he had drawn, he sensed others being etched and felt as if the portrait carried on drawing out the many faces of his father, from the past but also channelled from the future. Maybe, I think, Berger is continuing his communion with his father after he has died and, as a result, his understanding of him carries on growing in shade and complexity, just like the shifting sketch. Maybe committing my sister's life and death to these pages is not a pinning down but an unpinning. Drawing these lines on the page might lead to other lines emerging over time, and perhaps she will rise out of them to add to what I have said, or contest it. This is not an absolute portrait of my sister. It might change over time. It might be the beginning of a conversation rather than its end.

*

I had not thought back to 7 May 2016, when we celebrated Fauzia's recovery in hospital, until I saw Munch's painting in Bergen. Maybe it was because Sandvik had reminded me that Sophie Munch's sickbed was not without hope either, however nihilistic the vision of Inger's silent stare. *By the Deathbed* was part of the monumental and circular series *The Frieze of Life* that Munch worked on for years. It was, scholars say, an endeavour to encompass the biggest themes in human experience, love, passion, illness, death, and the paintings within it are distinct but also connected to one another.

The sequence of works in *The Frieze of Life* changed over Munch's career, but *By the Deathbed* was definitively in it. The portrait of Sophie's deathbed and the family grief that pervades it is unremittingly sad on its own, but seen within the sequence for which it was meant, it is followed by renewal and new life. 'It's a link in the chain,' says Sandvik, not in a Christian sense but in a circle-of-life sense. 'It's not conclusive because you are back to conception, and new life, in the next painting. It's like Nietzsche's eternal hourglass of existence, being turned over and over.'

Soon after Fauzia died, I find a deathbed scene among her embroideries. It seems to have been copied from a famous artwork, though I can't figure out which, but it has all the signs of a historical work depicting the final confession. There is a priest, come to read the last rites and holding his hat in the foreground, with a white-haired woman under the sheets behind him. Two figures stand over her on the other side of the bed, one of whom seems to be in sad supplication, his head bowed and his hands extended to her, but the other – a woman – is looking askance. I wonder what the story is behind this shifty glance, whether there is a whispering conspiracy between the dying woman's two visitors. There is a mood to the picture that I can't quite define, but I am captivated by its colours. The panelled room is stitched in a mix of magentas, turquoises,

mustards and bottle greens, while the bedspread is full of delicately sewn details. Beauty and intrigue are here, even in a place of death.

After she left the Royal Free Hospital in May, Fauzia went to live with our mother, in Primrose Hill, and she had a few good days. But gradually she faded again. In the last weeks, she became bedridden. My mother took food up to the room where she lay because she had become too weak to walk down the stairs to the kitchen.

After we found out that Fauzia had died of TB, her bed in Warren Street was thrown out, rather than given to charity with the rest of her furniture, for fear of carrying contagion. It felt like a peculiarly nineteenth-century thing to do and reminded me of one of the wall labels I had read above Keats's replica bed in Rome, stating that the original was burned, with all of the contents of Keats's room, after he died: it was seen to be a potential conductor of his infection. But Fauzia's sickbed in Primrose Hill stayed just as it had been. I am not even sure the bedding was thrown out, and it is oddly comforting to know that the bed is there, still. It is a prune-coloured futon I bought decades ago and left in that room. It went largely unused until Fauzia's stay in 2016. After she died, we began referring to it as *her* bed, and I'd run upstairs and peer into the room for a few moments every time I visited my mother.

There are times when I find myself returning to Fauzia's various sickbeds. It feels like a kind of meditation to remember the darkened warmth of her room in Primrose Hill where she lay sleeping, and the well-like weight of her final room in hospital, with its intimacy and its letting go. It is strange reassurance to remember Fauzia there, in her profound, velvet silence.

Three and a half years after Fauzia's death, my mother was diagnosed with breast cancer at the age of seventy-six and was told that she would need a mastectomy. She had had breast

cancer in her late thirties and a first mastectomy then. Now it was back. The prospect of another illness and hospital stay scared me so much I could barely contemplate it. My mother's surgery would be at the same hospital that had failed to save my sister and I hadn't returned to it since. Privately, I was cross that she had chosen to go there for her operation. I no longer saw it as a place of safety, and I felt dread just walking past it in the months after Fauzia's death. My mother was pragmatic, saying it was her nearest hospital. I could see she was shaken by the thought of an operation, though. I said I would stay with her in the week leading up to her surgery and moved into the spare room, and Fauzia's bed. I wasn't sure how I would feel about sleeping in it – I am a fitful sleeper at best – but the room had a strange sedative calmness and I slept more soundly there than I would ordinarily do in my own bed.

My mother's surgeon at the Royal Free was an eccentric man, in a red bandanna and matching clogs. He made my mother laugh and tried to calm her fear of the procedure to come; it was not the operation she had undergone nearly four decades ago, when she had had her first mastectomy, he told her. She could even leave hospital the same evening, he said. I pretended to believe him, but after dropping her off for the operation at the Royal Free on a Friday morning, I went back to her flat and felt suddenly drained in the minutes leading up to her scheduled time in the operating theatre. I found myself cold and quivering with exhaustion, so I went upstairs and got into Fauzia's bed. It was broad daylight but the room, the bed, seemed to embrace me with its mood of permanent night, and for the two hours that my mother lay unconscious in theatre, I sank into my own anaesthetic sleep. Afterwards, she woke up, and I woke up, and the hospital in which my sister had died had removed my mother's cancer and given her back her life.

12

Sisters Now

For several years, I carried on feeling Fauzia's presence; in thoughts, dreams and in distant glimpses on the street. Then, at some point, it became apparent that she wasn't inhabiting my space invisibly any more. The air in my home no longer felt weighted in the same way. There were no darting shadows in my peripheries, or intimations of her face in mine. I wasn't consoled by this. Instead I was unsettled. Had I stopped paying attention to my grief? Was I forgetting both it, and her? I tried to figure out exactly when the change had occurred and I realised that something had shifted after my trip to the Sistine Chapel.

Michelangelo's fifteenth-century Christian art had worked its miracle and brought me to my peace. My bitterness at her death, along with my horror, had been subsumed by the chapel's sorrows and I had been soothed by its joys. I remembered how, for a while, I had treasured the effect. It took away the internal tumult. Then, the coming-to-peace began to feel like a void. When I remembered Fauzia dying, I did so at a remove, like a recording on muted sound. She was no longer a sister, or the ghost of a sister, but a thought. If there had been distance between us in the last years of her life, a different kind of space grew now: she was pinioned to the same spot in the past while I sped on until she became an ever-decreasing dot on my landscape. Sometimes, late at night, I tried to invoke her presence by using the clichés of an ouija board medium: 'Are you there? Show me a sign.' The air never stirred. There were no mists as there had once been and no more other-worldly glimpses of her.

Some time after my father was diagnosed with frontal-lobe dementia and taken to live in a secure ward for the next two years, he began appearing in my dreams. He had transformed quickly into a painfully thin man who walked in front of traffic on his escorted trips out of hospital and became suddenly agitated and unmanageable in public. In my dreams, he would only ever be doing ordinary things, like peeling an orange or strolling in the park, but these visions of him would feel momentous because he was his old self again, as healthy and lucid as he used to be. On waking up, I'd feel both a plunging sadness for the loss of that former father, and the fresh shock of remembering all the ways his illness had changed him. Over the years his dementia has slowly built a wall around him, which has become higher and harder to breach. He seems marooned in his own faraway, unreachable land now, but these dreams, for me, were a reminder of the capable 'before' father, restored to wellness in my sleep.

My dreams of Fauzia were very different. She was rarely her old self in them. More often, she appeared as a crackle of invisible energy, aglow with fearful powers, too powerful, perhaps, to be seen. I would wake up in a state of terror. She was showing me how she had transformed, and maybe become the third, celestial, figure in her last embroidery, with the silver wings and blank face. She was almost always disembodied in this way, and she would occasionally show her presence by gusting into a room or hurling things around, like a poltergeist. I'd spend days working out what the dreams meant. Was she being playful or menacing? Was she my friend or adversary?

But these dreams also stopped. I waited but no more came. I felt as if the Sistine Chapel had brought me peace but taken something away, too. Maybe I had found Fauzia in the chapel, floating among the figures on its walls, or gazing up to the ceiling as a nineteen-year-old in awe, and decided to leave her there. But she might just as well have gone away of her own

accord. Either way, she was no longer a haunting. What did this mean, and what remained of Fauzia now?

It is the summer of 2016 and I am in the back of a minicab when the driver starts telling me about his brother's death. He is talking and I am listening. His younger brother, who was running businesses and under great pressure to succeed, had had a fatal heart attack. The driver tells me he was in his mid-thirties when he died in his sleep. I say I'm sorry to hear it but I don't tell him about my sister straight away because something in his tone makes me hesitant. He speaks in a way that suggests he doesn't expect me to understand, as if he has made a quick but definitive assessment of me.

I wonder how I appear to him from his rear-view mirror. I am returning from Sky TV after appearing on the breakfast news to review that morning's newspapers. It is a peculiar gig, starting at 4 a.m. when a taxi comes to take me to the studios in the outer reaches of West London, and ending at 9.30 a.m. when I am driven home again. I am not sure I find it particularly purposeful: almost as much time is spent with make-up artists as it is reading up on that day's news before going on air, so my face and hair still have the generic bounce and sheen of a TV presenter by the time I leave.

The driver is still talking about death and, reluctantly, I tell him that my sister died too, partly as a way to ease him out of his strange hostility, but it takes effort. It has been only a few months since Fauzia's death and there are times when I can say the words aloud but others when they get stuck in my throat, like fish bones. He becomes quiet and then resumes his brother's story, ruminating on his legacy. 'He did so much good,' he says. 'He was such a devoted father and family man.'

I smile and nod.

'All we have is our children. It is all that remains of us,' he says, in the same combative tone.

I carry on nodding, wanting to feel more sympathy towards him, but he keeps repeating phrases about the salvation of Jesus, and the salvation of children, in his injured, angry tone. I look out of the window, hoping he will take the cue and quieten, but after a pause, he asks after my sister – not how she died or when, but if she had any children.

'No,' I say, and instantly my heart sinks. This is where his hostility has been heading, I realise, perhaps from the moment I got into his car, when he must have glimpsed something of my loss behind the make-up, or smelt the grief I had brought in with me. Now his disapproval finds a firmer footing and he becomes emboldened, my silence an open platform for his reproof. It is children who give our lives meaning and stop us leading selfish lives. Everything else is pride and will perish, he says, in the stentorian tones of a street preacher.

I feel myself bristling and stop nodding. I say that it's different for everyone. No, he insists. I intend to stay quiet because this is not a new argument, but it is too soon after Fauzia's dying and I cannot tolerate the hammering insistence of his words. I am angry to be told by this stranger about his brother's meaningful life, and my sister's meaningless one. However preposterous it is, I am debating with him now, my hackles up, until I want to silence him. I can't remember what I say to make him stop but he takes a long look at me from his rear-view mirror and after that he doesn't speak.

I had the last word on it, I think, and defended my sister's choices – or lack of them – but his certainty continues to rattle me. What meaning *did* Fauzia's life have? Could I be sure it had any meaning at all when what remained of her were perishable things inside sketchbooks, boxes and bags? I had felt his words to be a moral judgement, and maybe I had spoken up not only for Fauzia but for myself and all the other childless people, dead or alive, across time. Did we need to leave our genetic imprint in the world as proof that we had

led meaningful lives? What do we amount to without this evidence?

I ask my older, childless friends and they have ready responses: 'The meaning of life is simply in its living'; 'How insecure that this man should need to sequester a corner of humanity with his DNA, and what a failed project, diluted down the generations until there are fewer and fewer molecules connecting the dead to the living'; 'For as long as we are remembered, we remain in the world.' I have heard this last justification before and I have begun questioning it ever since observing my father's dementia. His systematic forgetting has shown me the unreliability of memory. Just because he has forgotten his mother's name, does that mean he does not continue to love her? In fact, isn't it enough that he loved her when she was alive, whether he remembers her now or not? I am not sure that forgetting, or being forgotten, equates with meaninglessness or that being remembered validates our existence.

When I contacted Tai Shani about her installation in Margate, she offered me a different take. We began by talking about *DC: Semiramis* but ended up having a conversation about her itinerant family upbringing. Her Jewish grandmother had been imprisoned in a concentration camp during the Second World War, and had had a failed abortion there, she said. 'So my mum was born on June 1945, just as the camps were being liberated.' Her mother's birth was considered a miracle and the women in her family subsequently felt their lives were charmed by her grandmother's survival amid persecution and death. They led bohemian lives, moving to India for a time, none of them marrying or having children except Shani's mother. Even then, Shani's father died when she was only eighteen, so she was surrounded by a close-knit mini-matriarchy from then on.

I found it fascinating to hear about her unconventional family, but I was surprised when she said that, alongside its liberations, she feared being a woman at the end of a line of other childless

women. We spoke of loss, and grief, and as a way of comfort, I think, she sent me an audio recording of her VR installation, *Tragodia*, which was showing in an Austrian gallery at the time and imagined the deaths of an all-female childless family like her own. The recording is multi-layered and moving, again accompanied by a hypnotic soundtrack of synthesised music, different in mood to that in *DC: Semiramis*. The narrator here mourns her losses and suggests a continued cosmic existence of some kind, not in a religious or heavenly sense but as something intangible I find hard to name, but that fills me with warmth and hope.

In June 2016, when Fauzia died, my brother's younger daughter, Eva, was eleven months old. I have a photograph of her crawling around the intensive care unit's waiting room. My sister-in-law had left me in charge for a while, and Eva is on all fours, smiling like a rascal. She was a ball of mischief that afternoon and I remember how the other family in the waiting room watched her skidding around and giving me the slip as I tried to reel her in. The photograph was taken just as the sombre mood in the room cracked into momentary laughter. She is five years old now and has heard us talk about her Aunt Fauzia many times. She has been to visit her grave, in Hendon, and seen her artwork hanging around her home. But what surprises me is that she speaks of Fauzia as if she knew her, as if they were the best of friends.

'I really miss Fauzia,' she says to me earnestly, and I feel bemused every time. I have mulled over whether knowing Fauzia, for Eva, is a kind of wishful thinking, but then I recall how Fauzia remembered our *nani-jaan* in Lahore, whom she left at thirteen months old to come to London, and I wonder if Eva remembers Fauzia in the same way – a memory that lies primarily in feelings. My sister-in-law, Mary, has a sister who lives in Memphis, so Fauzia and I were the only aunts that my

two nieces had close to home. Perhaps Eva is also mourning the luxury of having had two aunts in her daily life rather than just one now. She speaks most often of Fauzia when she is sitting with her sister, Martha, who is nine, and they have their art and craft equipment scattered around them. I think back to Fauzia's visits to my brother's home, when she would sit down with the girls to paint and draw or introduce them to a new medium, like pastels, ink or charcoal. It had become a weekly ritual, which they loved, but again I wonder if Eva had been old enough ever to take part. Martha listens to Eva's words but doesn't join in even though she knew Fauzia until the age of five and must surely remember her better. I speak to Mary about this, puzzling over why she remains so quiet, thinking she may still be too sad to acknowledge Fauzia's death aloud.

'But Martha's *always* talking about Fauzia,' says Mary, and tells me how often she laughs and jokes about the finger puppets that Fauzia taught her to make.

Maybe Martha is protecting *me* in her silence. She has seen me upset at Fauzia's grave, and has soothed me while I've cried. Of the two girls, she is the one who reminds me more of Fauzia, especially in her relationship to art. Paper is what she seeks out as soon as she enters my mother's home or mine. Within minutes, she has found it and is drawing, colouring in, imagining and creating. In cafés, she scribbles on napkins. Maybe all children do this, but I have come to see it as her inheritance from Fauzia. The last time Martha began hunting for paper in my home, I handed her the empty artist's pad that Paula Rego had given me, which she began filling straight away.

Sometimes Mary will frame a drawing and send it as a gift in the post. My mother received a picture that Martha had made of a windblown tree in shades of green, its leaves streaming, like tears, across the page, and I could feel the wind in her pencil-strokes. She sent me a rabbit, drawn in blue crayon, which caught a certain tension in the rabbit's taut back and tensile ears, as if

it were sniffing the air in apprehension. She sends Eva's pictures, too, which are bold and funny and crammed with colour, and all these have become reminders of Fauzia for me. It is not children or objects or even memories that give the dead their meaning, I think. It is *this*, a passing down, and on, of something immeasurably precious, as undeniable as it is intangible. Fauzia's inheritance is there in Martha's rabbit and tree. She is learning to look at the world through her fingertips too.

I feel my own inheritance nudging at me after opening the small suitcase containing Fauzia's embroideries. As I look through her earlier pieces, in which she repeats the simplest stitches in order to learn them, I am surprised to remember *my* interest in sewing, as a teenager, at school. My mother had helped in teaching me stitches and I had made a small menagerie of stuffed appliqué animals, which became my pride and joy. But I also remember my growing unease around sewing, feeling that it was not a subject to love because of its associations with Victorian drawing rooms and domestic servitude. So at the age of sixteen, after I had sat a GCSE in textiles, I smothered my interest and stopped sewing for fun. Over the years, I had clothes professionally mended or altered when once I could easily have done it myself. It became too time-consuming and complicated a task, simply not worth doing.

But here, in Fauzia's suitcase, an opportunity presented itself: as I looked through her work, from the easiest to the most complicated, I saw an arc of learning. It sparked the idea – only whispered to myself at first – that I could try my hand at embroidery. Rather like the cooking classes my mother had given me remotely – most of them on the phone – Fauzia could be my remote teacher if I began copying the stitches from her early embroideries and, bit by bit, let myself be led by her progress. I let the thought hang. It would be nice to learn what Fauzia had to teach me, and I would do so, when I had the time to sit and sew.

One day, I pass a little sewing shop on my local high street and remember how Martha lights up every time we walk past it. The next time, I stop and stare in. I need to find an elbow patch for a lilac jumper made of soft, ancient cashmere, which is ragged with wear but which I am not yet ready to throw out. The shop assistant finds me a light grey patch, which we agree would look nice against lilac. I feel the tingle of muscle memory as I sit down at home and begin a row of blanket stitches around it. There, I think, when I have finished: not a bad job. And then another hole appears in the opposite elbow, so I go back for a second time. It is a narrow shop with a tinkling bell at the door and I have always found it too quaint and claustrophobic, so never spent longer than I needed to inside. But it is empty on this visit so I browse, straining my mind for what else might need fixing. I spot some fake fur that matches a trapper hat – another favourite possession and so old now that it is bald in parts where the fur should be. I buy a strip of the fake fur and painstakingly sew it on with a thick needle that hurts my fingers, but the mending delights me beyond measure. This time, I marvel not just at the final result but at the pleasure of the mending process.

These are small steps and perhaps I will make no further moves, but I wonder if Fauzia's suitcase of embroideries could be used as a roadmap for me to relearn my love of sewing. Is this what my late neighbour, Rosalind, meant when she said that my sister would come back to me? Had Fauzia in fact been *here*, in this suitcase of lessons, waiting for me all the time? I find myself sitting down with a blank handkerchief-sized white cloth. I lay my sister's 'starter' embroidery pieces beside it and, after a quick study, and making no promises to myself, I begin.

Once I have opened Fauzia's portfolio again, I don't know how to put it away. There is so much art and it pushes itself into a bigger existence so that the folders and bags in which it has

lain suddenly become too small when I try to pack it up. Where did it all belong now? Where was its home, beyond my already crammed walls? I leave most of the embroideries heaped on my dining table, in the hope that, one day, I will know what to do with them. When friends come round for dinner, I scoop them up and temporarily heap them somewhere else. The friends are invariably drawn to the work, peering closer, picking up a piece and plucking out a detail they like. 'This one's my favourite,' some say, or 'Look at these beautiful stitches!'

But one day, a friend stops at the table, points to an embroidery, and says she would love to have it. I smile and let the moment pass, but she returns to the embroidery on her way out and asks me what I plan to do with all of Fauzia's work.

'I don't know,' I say.

'Why don't you sell them or give them to people you know would treasure them?'

Again I smile, but I feel more anxious this time. After she has gone, I go over to the table to study the small embroidery she has asked for, which instantly seems too important to give away. It is from the most playful series of Fauzia's embroideries and I begin to see things in it that I had missed before. The series of six connected works all feature naked women who are wearing just heels and hats, with a mirror and a cat in every frame. They are often absorbed in the act of looking at their own reflection. In the one my friend picked, a large, naked woman stares directly out and her head is cocked coyly, as if she enjoys being looked at. She lies horizontal and voluptuous in the pose of Édouard Manet's lithe, languid *Olympia* (1863), although there is no maid in the background here and only a small bunch of flowers on her sideboard, rather than the enormous bouquet in the original oil painting. This woman is far from Manet's thin, porcelain-skinned model and presumed prostitute, Olympia, but she is as suggestive, wearing bright red lipstick and stroking a white cat positioned strategically between bare fleshy thighs. Her

mouth is a smirk, as if she is enjoying the saucy innuendo. There are curtains on either side of her, just as there are in Manet's painting, and the woman's posture has a touch of theatricality, as if she is on a stage.

My friend had told me she knew just the place for it on her wall. If I needed a year or two to think about it, she would happily wait, she had said. I look at the embroidery, already bereft, although nothing has been agreed. I place it against the other six images in the series and try to devise a reason not to give it away. What if Fauzia saw it as a pivotal piece in the sequence? What if I want to display all six as a set? Its absence would leave an enormous hole.

But I know it wouldn't. All this beautiful work will only ever remain unseen piles of cloth and canvas on my dining table if it stays with me. As much as I want to hold on to every single piece, I know they should all become living artworks. I think back to Fauzia's exhibition at Camberwell College and remember how lit up they seemed on the walls, how showy and in their element.

The woman in this embroidery would be separated from her naked sisters but she would be observed and admired by all the eyes that passed her in my friend's home, just as she was made to be. I put her down and begin leafing through the other pieces, making two provisional heaps: one of the works I simply can't give away, and the rest to be sent out into the world. Fauzia's collection would not lie in darkness, in a forever slumber. Like Shani's limbs in *DC: Semiramis*, its parts would be scattered, its DNA dispersed, shared, seen.

I am not certain if Fauzia has come back to me, as Rosalind reckoned she would. There have been no more dreams but I feel another shift in the air that might be imagination. Certain photographs that I have rooted out and mentioned in these pages have since disappeared. I have looked for them but they

are nowhere. I wonder if Fauzia has returned to play tricks on me or whether she might want to have a hand in curating the contents of this book. Is she making certain choices around what should be included and what she would rather I leave out?

I carry on looking for clues to questions that can never be answered. I find myself rereading her last text messages to me. They were sent in May 2016, from the Royal Free, when she was beginning to feel better and before her second, last, admission to the hospital. I come across one I have never seen before. Maybe, in my grief, I have managed not to read it until now. I am stopped in my tracks. It was not there four years ago, I am sure of it. It must be a message she has sent me since. It is memory, premonition and a force of will to remain present in the world, all at once. To see and be seen. *I have not died*, she writes, *and the world has become so colourful.*

Acknowledgements

I didn't think I could write a book about my sister in a way I'd find satisfying, until my friend Andrew Wilson introduced me to his literary agent, Clare Alexander. Clare and I met in June 2019 and began talking about siblings, opera, art, TB. Just over an hour later, I walked away with the concept of this book scribbled in my notepad, complete with chapter headings. Clare, it turned out, was not just good at shaping a narrative out of the tangle of ideas I presented to her, but she also knew a thing or two about infectious diseases, having a daughter who was a medical consultant in the field. 'We're due a pandemic', she said, at the end of the meeting and I thought it was a little fanciful, but I wrote it down anyway.

Less than six months later, that pandemic arrived, but I had forgotten all about Clare's words until I opened the notebook again in early 2021 and shivered at their prescience. I started writing the bulk of *Consumed* a few days after the first lockdown was announced in March 2020, although its research had begun from the moment my sister died in June 2016. In the subsequent months, I often felt like I was writing about one plague in the time of another, seeing parallels between the two. The terror and isolation that TB brought in previous centuries is what Coronavirus brought us in 2020, and it felt uncanny to be writing the story of my sister's TB in a state of modern quarantine.

Still, I have felt a recurring sense of good fortune and serendipity along the way. Thanks to Andrew, I met Clare. And thanks to Clare, I found the perfect editor in Juliet Brooke at Sceptre,

who was not only an astute reader and lover of embroidery, like Fauzia, but seemed to know that I didn't want to write about only grief, or family, or art and illness, but to 'embroider' – as she put it – all of those aspects together. I am especially delighted that she suggested featuring Fauzia's artwork too, which is now distributed amongst the family and some of which my brother, Tariq, kindly lent these pages. Her embroideries, etchings, collages and paintings sit alongside my words and as a result I consider it to be *our* book rather than just mine.

Writing might be a solitary occupation but it takes a team to publish a book, so a huge thanks to the generous and talented team of friends and experts who helped me: Jeremy Laurance, a former colleague at the *Independent* and health journalist, gave me invaluable guidance on the medical aspects of my sister's story, looking over notes, connecting me to experts, and talking me through the detail in his beautiful back garden. Robert Verkaik, another former member of the *Indy* family and author, gave me the equivalent of a TED talk at the beginning of the book-writing process, and another one, full of specialist insights, at the end.

Special thanks and gratitude to Kelly Chorpening, Fauzia's tutor at Camberwell College, who helped me understand my sister from her art and also, remarkably, seemed never to stop thinking of Fauzia as her student, even after her death. Kelly suggested I write about Fauzia for the accompanying catalogue of an exhibition she put on at Camberwell, showcasing Fauzia's work. That piece, from 2016, served as my first, and perhaps hardest, step towards the writing of this book. She carried on recommending artworks to see and essays to read long after that. 'I think Fauzia would have liked knowing that she has sparked an ongoing conversation between us,' Kelly wrote, after reading a draft of this book, and I think – hope – that this dialogue will continue.

I owe thanks to Keith Blackmore, a former editor of *Tortoise*

Media, for his inspired suggestion to visit Keats' grave in Rome as a way of meditating on my sister's illness and death; that trip was a defining one. I also owe Claire Armitstead for getting me to write about my late neighbour, Rosalind, who provides a way into telling my sister's story here.

Thanks to Anoushka Warden for being an honest early reader and a galvanising force, giving me art lessons alongside deadlines. Anoushka is the friend in the last chapter who suggests I sell my sister's artwork, so it can become more than stacks of cloth and canvas on my dining table, and I am building up to doing that.

Thanks too to Charlie Mounter, another early reader who stayed up half the night to finish a draft, and to Katy Guest who recommended all the right science books. Fauzia's sewing teacher, Millie Jaffe, shared her wisdom on art and embroidery, while Faiza Khan suggested we go to Keats House, in Hampstead, where the book started to come to life in my mind. Peter Aspden led me to van Gogh expert Martin Bailey, who directed me to the full online archive of Vincent and Theo's letters and sent me his gorgeous book, *Starry Night: Van Gogh at the Asylum*.

Writing this book wasn't always easy but the research brought surprising discoveries, not just of facts but of people too, who had no reason to talk to me other than the desire to help. Among them was Professor Francis Drobniewski, a TB expert at Imperial College, London, whose passion for his subject was both evident and inspiring in our conversations; also Turner prize-winning artist Tai Shani, who sent me the soundtracks and scripts to her artworks; playwright Lulu Raczka, who made me see *Antigone* so differently; opera writer and academic Dr Flora Willson, at King's College, London, who spoke of beauty – and misogyny – in 19th century operas; and art curator Frode Sandvik, who showed me around a gallery at KODE in Bergen and left me sitting, in awe, in front of Munch's *By the Deathbed*. All of these people gave me their time and expertise willingly when I called on them out of the blue.

Acknowledgements

My thanks to Chris Wiegand, the stage editor at the *Guardian*, who sent me to review Lulu Raczka's play, and then a screen version of Heidi Schreck's Broadway drama, *What the Constitution Means To Me*, both of which chimed with me deeply and became a part of *Consumed*. Chris also allowed me enough flexibility in my still new, and amazing, role as the newspaper's theatre critic to write this book in a short space of time. More generally, I am grateful to the *Guardian* for commissioning work that subsequently proved useful too.

Vital research reading included Frank Ryan's *Tuberculosis: The Greatest Story Never Told* for the history of the illness, Rene Weis's *The Real Traviata* for opera, and *Edvard Munch: love and angst*, edited by Giulia Bartrum, for my understanding of the artist. My thanks also to *Tortoise Media* for commissioning the essay on Keats in Rome, on Keith's suggestion.

Heartfelt thanks to Katherine Butler and Christina Patterson with whom I share the grief of lost sisters. They are the kindest and most trust-worthy of friends, who know how to listen and what to say; talking to them helped me find ways to express the most difficult aspects of sisterhood and loss.

Consumed presents my father in a dark light, at times. I have struggled with writing this part of the book because he is not well enough to contradict or correct me, so he has effectively had no right of reply. I know I have him to thank for being an immensely loving father to me; I am making no final judgments but trying to tell my sister's story.

Above all, I am most grateful to my wonderful mother, Bela Akbar, who dug up old letters, photographs and so many of the difficult memories she had spent half a lifetime burying, all for the sake of this book, which is from one sister to another.